The Dictionary of

BRITISH WATERCOLOUR ARTISTS

up to 1920

Volume II ~ The Plates

H.L.Mallalieu

Antique Collectors' Club

ISBN 0 902028 63 4

British Library CIP Data
Mallalieu, H L
 The Dictionary of British Watercolour Artists up
to 1920.
 Vol. 2: The plates
 1. Water-colourists — Great Britain — Biography
 I. Title II. The Antique Collectors' Club Ltd.
 759.941 ND1928

Published for The Antique Collectors' Club
by the Antique Collectors' Club Ltd.

Printed in England by
The Antique Collectors' Club Ltd., Woodbridge, Suffolk

The Antique Collectors' Club

The Antique Collectors' Club was formed in 1966 and now has a five figure membership spread throughout the world. It publishes the only independently run monthly antiques magazine *Antique Collecting* which caters for those collectors who are interested in widening their knowledge of antiques, both by greater awareness of quality and by discussion of the factors which influence the price that is likely to be asked. The Antique Collectors' Club pioneered the provision of information on prices for collectors and the magazine still leads in the provision of detailed articles on a variety of subjects.

It was in response to the enormous demand for information on "what to pay" that the price guide series was introduced in 1968 with the first edition of *The Price Guide to Antique Furniture* (completely revised, 1978), a book which broke new ground by illustrating the more common types of antique furniture, the sort that collectors could buy in shops and at auctions rather than the rare museum pieces which had previously been used (and still to a large extent are used) to make up the limited amount of illustrations in books published by commercial publishers. Many other price guides have followed, all copiously illustrated, and greatly appreciated by collectors for the valuable information they contain, quite apart from prices. The Antique Collectors' Club also publishes other books on antiques, including horology and art reference works, and a full book list is available.

Club membership, which is open to all collectors, costs £14.95 per annum. Members receive free of charge *Antique Collecting,* the Club's magazine (published every month except August), which contains well-illustrated articles dealing with the practical aspects of collecting not normally dealt with by magazines. Prices, features of value, investment potential, fakes and forgeries are all given prominence in the magazine.

Among other facilities available to members are private buying and selling facilities, the longest list of "For Sales" of any antiques magazine, an annual ceramics conference and the opportunity to meet other collectors at their local antique collectors' clubs. There are nearly eighty in Britain and so far a dozen overseas. Members may also buy the Club's publications at special pre-publication prices.

As its motto implies, the Club is an amateur organisation designed to help collectors get the most out of their hobby: it is informal and friendly and gives enormous enjoyment to all concerned.

For Collectors — By Collectors — About Collecting

The Antique Collectors' Club, 5 Church Street, Woodbridge, Suffolk

INTRODUCTION

Naturally, a volume of illustrations, however carefully constructed, is certain to irritate many of those who consult it. There are, inevitably, gaps and omissions; it is all the fault of artists, who tend to be inconsistent, and the example in the hands of the collector is certain to be very different to that illustrated here. Thus it is as well to state the criteria which have governed the present selection.

It is comparatively easy for the collector to consult the two major public collections in London, those of the British Museum and the Victoria and Albert Museum, and therefore I have not included examples from them. For the American the same is true of the Mellon Center for British Art at Yale. The present photographs are for the most part of examples which have been on the British market during the 1970s, together with items from private and museum collections when these seemed particularly appropriate, or, in some cases, little known. In the same way I have concentrated more on the work of the less well-known artists, rather than on that of the greatest men, which is readily available in other publications. A further consideration has had to be the current financial climate.

In a few cases, when further information has come to hand, I have emended names or dates, but I have changed none of the other information given in Volume One. I would, once again, be grateful for additional information and for details on any artists who may have been omitted.

My thanks are due both to the dealers, auctioneers, museums and collectors mentioned in the text and to those who have preferred to remain anonymous. Furthermore my debt of gratitude to my former assistant Sarah Williamson, then Sarah Mouat, who patiently played endless games of pelmanism with the photographs, is immeasurable.

H.L.M.

THE
PLATES

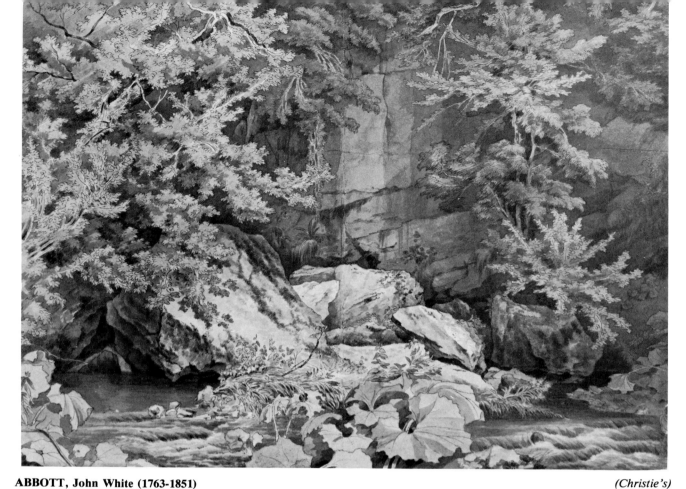

ABBOTT, John White (1763-1851)

Chudleigh Rock. *Signed and dated 1792, pen and brown ink and watercolour, 10ins. x 13⅜ins.*

A particularly fine and unusually intimate example of Abbott's work. Often he prefers broader and less particular effects in the manner of his master Towne. The flat, clear colour washes are typical in either case.

ABBOTT, John White (1763-1851)

Leather-Tor from Nanaton, Meavy, Devon. *Signed with monogram, inscribed, dated Augt. 14 1834 and numbered 26, all on reverse, pencil, pen and grey ink and watercolour, 5⅝ins. x 9⅜ins.*

Monograms and inscriptions most often occur on the reverses of Abbott's drawings.

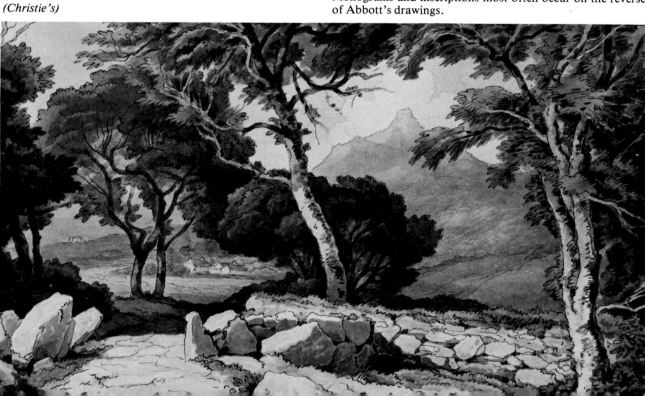

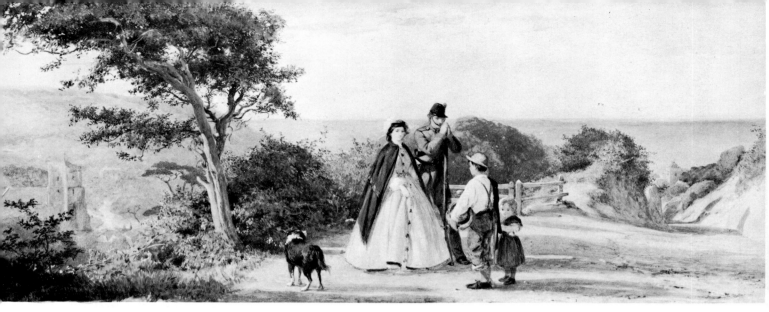

ABSOLON, John (1815-1895)
Near Dover. *Watercolour, 12¼ins. x 29¼ins.*

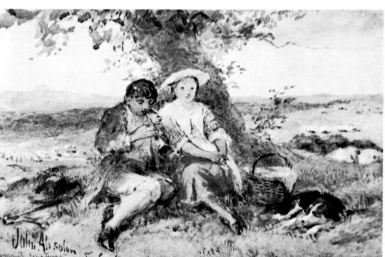

ABSOLON, John (1815-1895)
Pleasant Pastures. *Signed and inscribed, watercolour, 7ins. x 10ins.*

In some ways Absolon stands in the tradition of the eighteenth century illustrators although his treatment is often distinctly impressionistic. His figure drawing is good.

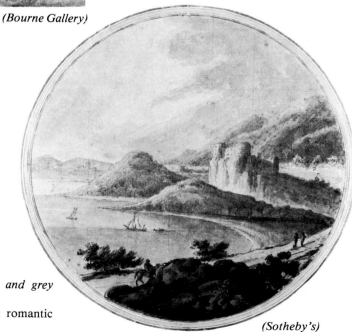

ADAM, Robert (1728-1798)
An Italian Coastal Scene. *Pen and grey wash, 8¼ins. diameter.*
Adam's work is almost always romantic and in monochrome.

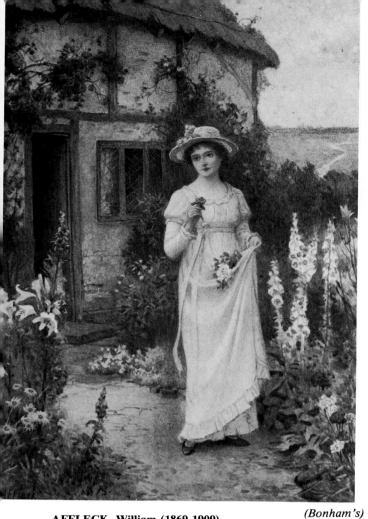

ALDIN, Cecil Charles Windsor (1870-1935)
A Fine Mount. *Signed, watercolour, 10ins. x 14ins.*
In this sort of drawing Aldin shows the direct influence of his predecessor Caldecott. At other times there is a more Japanese feeling to his work.

AFFLECK, William (1869-1909)
Rose Cottage. *Signed, watercolour, 10½ins. x 7ins.*

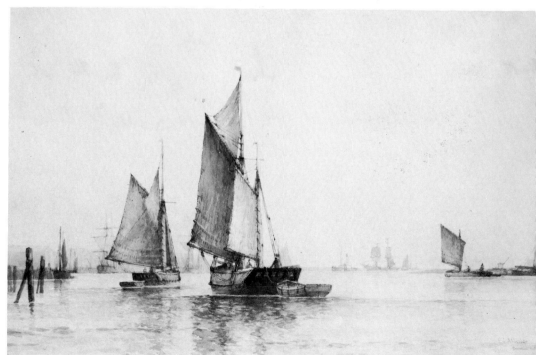

ALDRIDGE, Frederick James (1850-1933)

Shoreham Harbour. *Signed and inscribed, watercolour, 19ins. x 28⅝ins.*

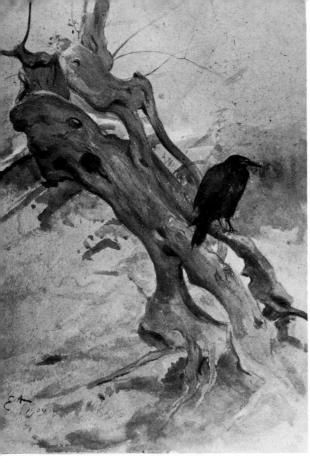

ALEXANDER, Edwin John (1870-1926)

Beach at Low Tide. *Signed with intials, watercolour heightened with white on brown paper, 7ins. x 13ins.*

Alexander's landscape and beach scenes are typical of the Scottish impressionists, although in his case there is also a French influence as well as a reflection of the current interest in Japanese art.

ALEXANDER, Edwin John (1870-1926)

Gnarled Age. *Signed with initials and dated 1904, watercolour heightened with white on brown paper, 21ins. x 14⅛ins.*

His interest in botany and animal life, together with the influence of Joseph Crawhall formed his artistic outlook. His drawings are accurate but not overloaded with unnecessary detail.

ALEXANDER, William (1767-1816)

Conway Castle. *Signed on mount, pen and brown ink and watercolour, 8¼ins. x 11¾ins.*

A typical example of Alexander's British topographical work which is in the eighteenth century tradition of tinted drawing, typified by the work of Hearne.

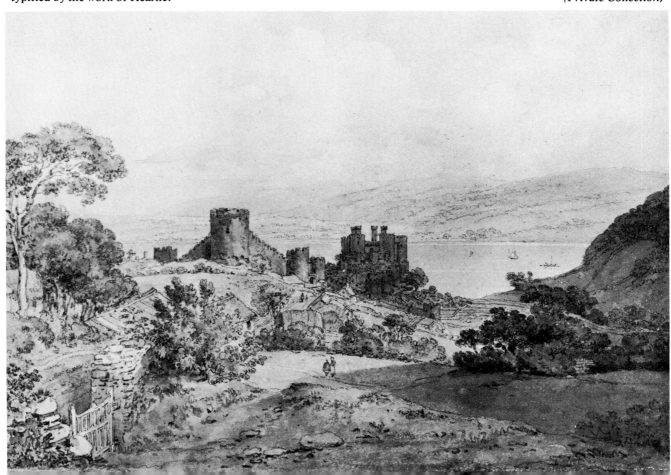

**ALKEN, Henry Thomas
(1785-1851)**

Exercising Race-horses on New-market Heath. *Pencil and water-colour, 13½ins. x 18⅞ins.*

A fine example of Alken's neat pencil work and use of clear, thin washes of colour. In his hunting subjects his riders often have their right arms raised when jumping fences — a most dangerous manoeuvre.

(Christie's)

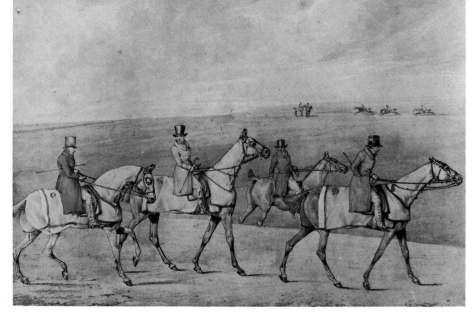

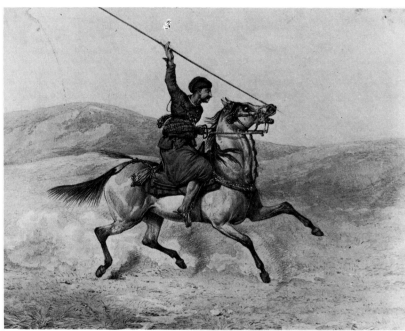

ALKEN, Henry Thomas (1785-1851)

A Turkish Horseman Charging, Lance Raised. *Pencil and watercolour, 7⅜ins. x 9⅜ins.*

Alken may have visited Persia, and in any case produced a number of these Near and Middle Eastern subjects.

(Christie's)

ALKEN, Seffrien, Yr. (1821-1873)

After the Race. *Signed and inscribed on the mount, watercolour, 6½ins. x 8¼ins.*

(Sotheby's)

ALLAN, David (1744-1796)

A Beggar Outside a Scottish City Gate. *Pen and ink and watercolour, 9¾ins. x 7⅜ins.*

In his homely Scottish subjects Allan is a precursor of Wilkie. However, his execution is poor and he used a number of conventions, most notably in his treatment of the female face, three examples of which can be seen here.

(National Galleries of Scotland)

(Private Collection)

ALLEN, Joseph William (1803-1852)

Barges on a River. *Signed and dated 1836, watercolour, 7¾ins. x 11⅜ins.*

Allen is a pleasing example of a nineteenth century drawing master under the influence of Cox.

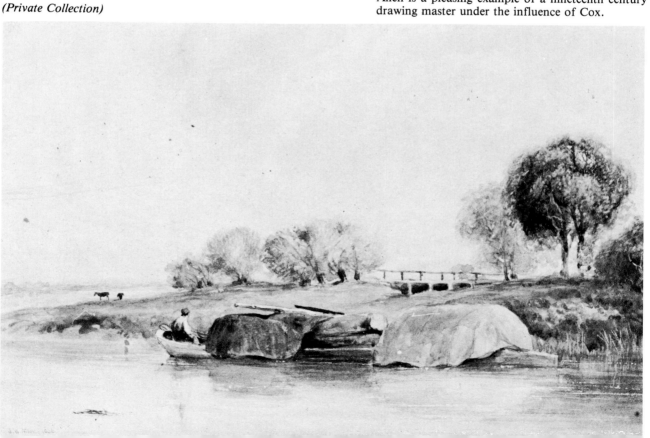

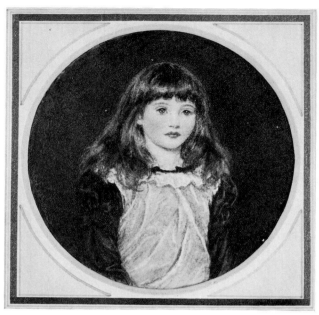

ALLINGHAM, Helen, Mrs., née Paterson (1848-1926)

Study of a Young Girl. *Signed, watercolour, 4ins. diameter.*

An excellent example of Allingham the portraitist. She appears to have concentrated on young girls.

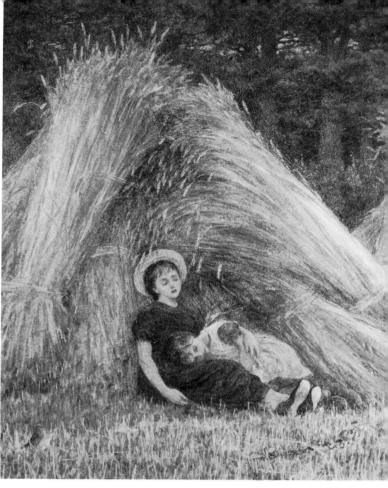

ALLINGHAM, Helen, Mrs. née Paterson (1848-1926)

Tired Out. *Signed with initials and dated '75, watercolour, 9¼ins. x 7¾ins.*

Helen Allingham was not just a painter of Surrey cottages. She also produced rustic figure subjects which are often less sugary than those of her masculine contemporaries.

ALLOM, Thomas (1804-1872)

Les Hauts Bolles in the Pyrenees. *Watercolour, 4⅞ins. x 7½ins.*

Allom's work is for the most part in brown wash and his full watercolours are comparatively rare. He travelled widely in Europe and also visited the Near and Far East. Although he is not particularly original his work is always neat, accurate and pleasing.

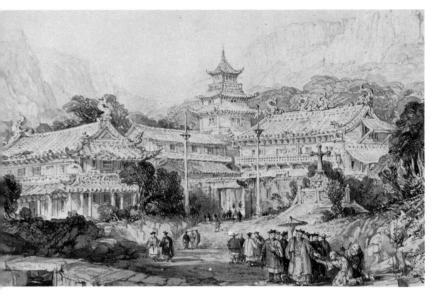

**ALLOM, Thomas
(1804-1872)**

The Grand Temple at Poo-Tow, Chusan Island. *Pencil and brown washes, 4⅞ins. x 7¼ins.*

ALPENNY, Joseph Samuel (1787-1858)

Portrait of the young Edwin Hayes. *Signed and dated 1812, watercolour, 41ins. x 29¼ins.*

When studying in London he was known as J.S. Halfpenny, but he changed to Alpenny during his stay in Ireland between 1810 and about 1824. His work is rather in the manner of his fellow Irishman Adam Buck, but not nearly so accomplished.

**ANDERSON, William
(1757-1837)**

View in Monmouthshire. *Pen and grey ink and watercolour, 8½ins. x 12ins.*

Anderson is best known as a marine painter, but he also produced landscapes such as this. He generally signed his full watercolours as opposed to monochrome drawings, although this example is unsigned. The handling of the trees shows some of the mannerisms of William Payne and that of the figures, perhaps the influence of Anderson's friend J.C. Ibbetson.

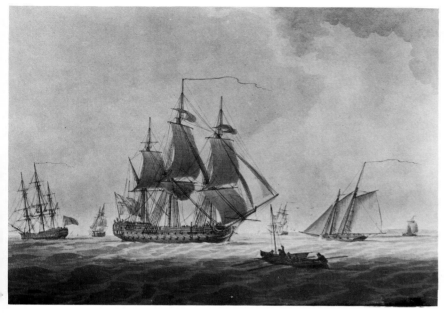

ANDERSON, William (1757-1837)

An English Two-decker before the Wind, with other Shipping. *Signed and dated 1806, watercolour, 12½ins. x 17½ins.*

In Anderson's marine work the grey ground to represent waves is rather more extensive than in that of his colleagues, such as Atkins or Owen. It is a marbled effect of green on grey.

ANNESLEY, Rev. and Hon. Charles Francis (1787-1863)

Amsterdam. *Inscribed and dated Aug. 19 1821, pen and ink and watercolour, 9½ins. x 13½ins.*

The trees on the left serve as a reminder that Annesley was ultimately a follower of Girtin. In his landscape work the influence is often more marked. He did however rely on strong outlines and his colours are marked.

ANDREWS, George Henry (1816-1898)

Lusa, Piedmont. *Signed with initials, pencil and watercolour, 5¾ins. x 7½ins.*

Andrews is best known for his marine subjects, but he also drew landscapes and other illustrations for various magazines.

ARUNDALE, Francis Vyvyan Jago (1807-1853)

A Reconstruction of the Roman Forum. *Signed and dated 1851, pen and grey ink and watercolour heightened with white, 25½ins. 38¾ins.*

Arundale was a pupil of the architectural draughtsman A. Pugin and he travelled widely in Europe and the Near East, working on drawings of antiquities to accompany his books.

(Christie's)

ASHFORD, William (1746-1824)

A River Landscape. *Signed and dated 1820, pen and ink and watercolour, 6½ins. x 9¾ins.*

Ashford's watercolour work is rather old fashioned and he was criticised for the weakness of his figure drawing and the greenish tint of his skies.

(Sotheby's)

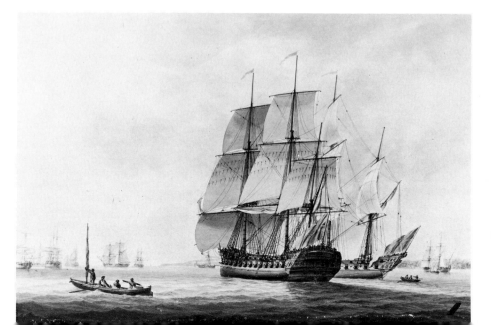

ATKINS, Samuel

H.M.S. Woodford with other Shipping Offshore. *Signed, pen and watercolour, 14ins. x 19ins.*

The signature on the balk of timber to the right is entirely typical of Atkins, as is the grey underwash in the foreground.

(Martyn Gregory)

ATKINSON, John Augustus (c.1775-c.1833)

A Baggage Train. *Pen and brown ink and watercolour, 8ins. x 11⅝ins.*

One of the best of the watercolourists who recorded the Napoleonic Wars, Atkinson's figure drawing is excellent, both in serious compositions and caricatures. He worked in Russia and the Peninsula as well as in Britain.

(Private Collection)

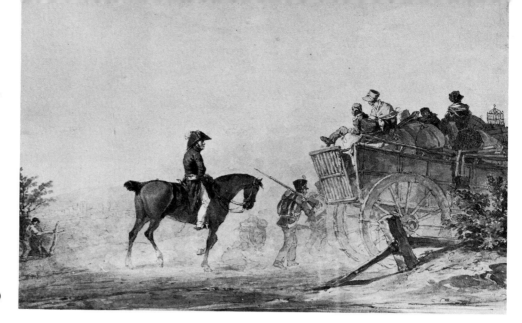

AUMONIER, James (1832-1911)

A Spanish Village. *Signed, inscribed and dated Oct 1908, watercolour, 18¼ins. x 27½ins.*

Aumonier is primarily thought of as a painter of English water meadows with sheep and cattle. However, he travelled more widely than this would indicate. He was capable, as here, of producing excellent work in the then fashionable wet technique.

(Sotheby's)

AUSTIN, Samuel (1796-1834)

Figures on the Beach at Scheveningen (?). *Watercolour, 10ins. x 16ins.*

Austin's style was derived from that of de Wint, from whom he had three lessons. There are also similarities in style and subject matter to Cox. There are often characteristic touches of red in his watercolours.

(Christie's)

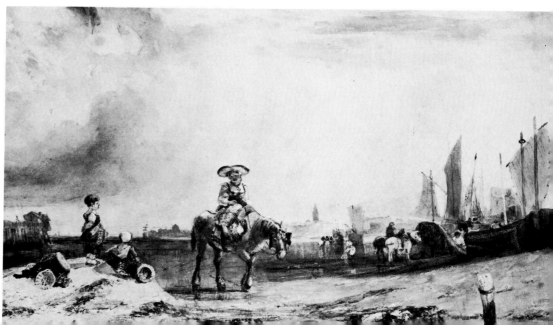

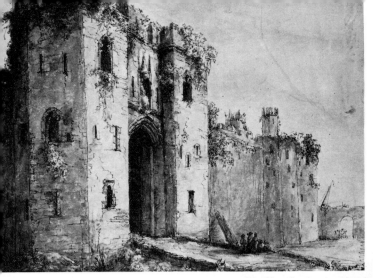

(Dudley Snelgrove Esq.)

AYLESFORD, Heneage Finch, 4th Earl of (1751-1812)

Entrance to a Castle (Possibly Caernarvon). *Pen and brown ink and brown wash, 8¾ins. x 11¾ins.*

This watercolour does not have an example of Aylesford's use of a pale red for roofs.

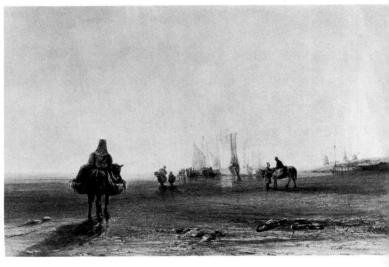

(Agnew)

AYLMER, Thomas Brabazon (1806-c.1856)

Fisherfolk on the Beach. *Signed, watercolour, 7⅜ins. x 10⅝ins.*

A very Boningtonian watercolour.

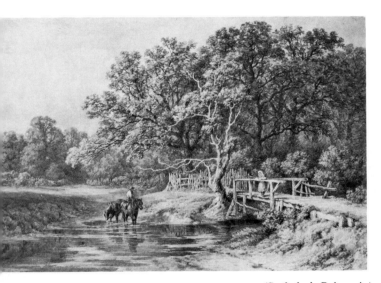

(Sotheby's Belgravia)

BAKER, Samuel Henry (1824-1909)

Temple Balsall. *Signed, watercolour heightened with white, 15ins. x 21¾ins.*

Although this example is signed in full, Baker often used initials only.

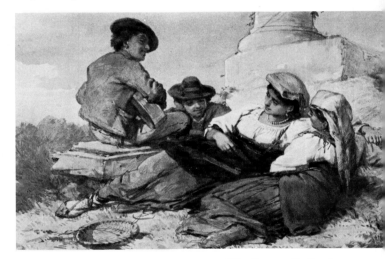

(The Bourne Gallery)

BACH, Guido R. (1828-1905)

July Hours. *Signed, watercolour, 18ins. x 26ins.*

A cosmopolitan, born in Dresden but spending much time in England, Bach painted the peasants of Italy, Bohemia and Egypt very much in the manner of the contemporary Italian School. His figures are strong, well modelled and not overly sentimentalised.

BAKER, Thomas, of Leamington (1809-1869)

Welsh Landscape. *Signed and dated 1838, watercolour, 6½ins. x 9½ins.*

Many of Baker's works, whether with or without architectural features such as the bridge to the left in this drawing, show a markedly linear technique. However, the effect is often less busy than here.

(Martyn Gregory)

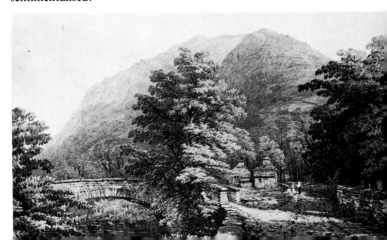

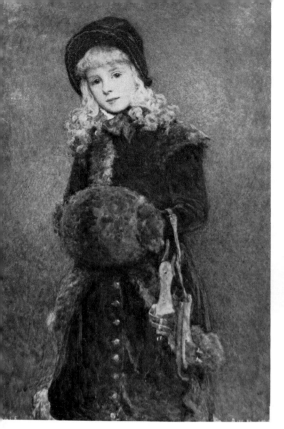

BALE, Edwin (1838-1923)

Prepared for the Weather. *Signed and dated April 1888, watercolour, size unknown.*

BALMER, George (1806-1846)

A Whale Breaking a Boat in Half. *Pencil and watercolour, vignette, 5½ins. x 8ins.*

Balmer was very much a Turner disciple. This whaling subject could almost be by Turner who planned a series of vignette illustrations for a whaling book.

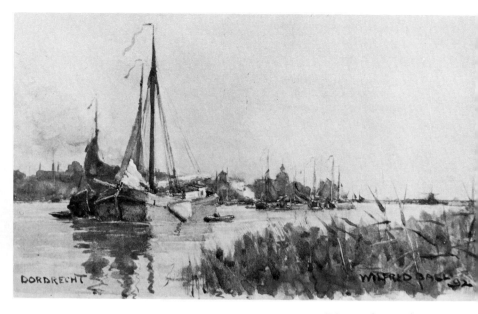

BALL, Wilfred Williams (1853-1917)

A View of Dordrecht. *Signed, inscribed and dated '92, watercolour, 6ins. x 9½ins.*

Ball painted marine subjects and landscapes, using the watery technique so popular at the end of the nineteenth century.

BARBER, Joseph (1757-1811)

Lake Scene with Cottage (Coniston Lake). *Inscribed on reverse 'Coniston Lake by Barber, 1798', watercolour, 15½ins. x 20ins.*

Barber appears to have adopted some of his techniques, such as rubbing, the building up of foliage in layers, and a wiry depiction of foreground vegetation from his fellow drawing master William Payne.

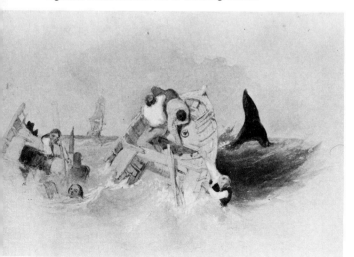

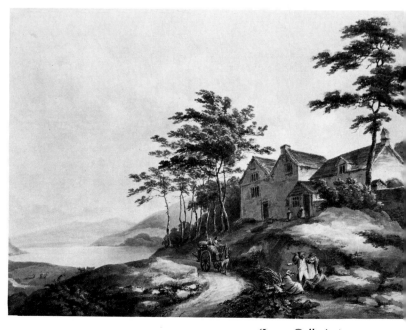

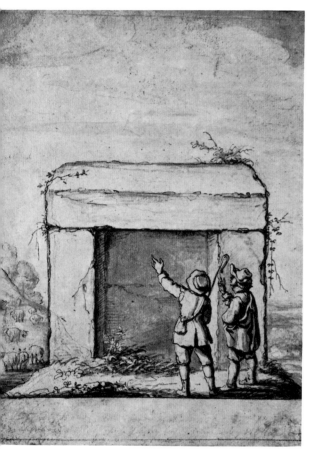

(Dudley Snelgrove Esq.)

BARLOW, Francis (c.1626-1704)

Kit's Coty, Kent. *Pen and brown ink, brown wash, 7½ins. x 8⅛ins.*

Barlow's drawings of birds and animals, often made for prints, are well known. His figure drawings are less so, and this example would indicate that they are competent and more finely drawn.

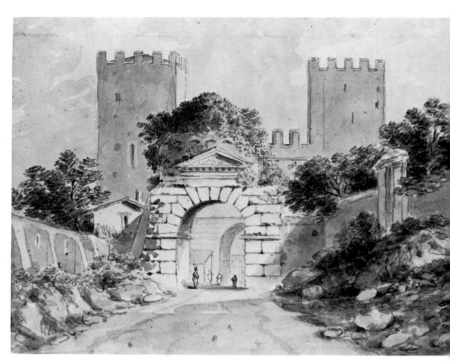

BARNARD, Rev. William Henry (1767-1818) *(Sotheby's)*

The Porta St. Sebastiano. *Pen and ink and watercolour, 9¾ins. x 12¾ins.*

Barnard tended to use brown pen outlines and a limited range of colours, which can be reminiscent of the landscape work of Sir J.J. Stewart.

BARRALET, John Melchior (c.1750-c.1787)

The Road to East Grinstead. *Signed and dated 1784, 13¾ins. x 22½ins.*

Note the feathery treatment of the bracken on the left and the fretted lines for foliage.

(Spink & Son Ltd.)

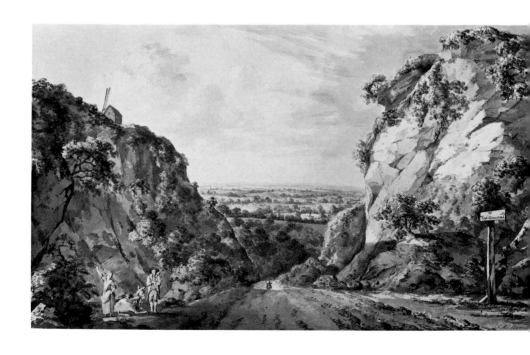
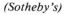

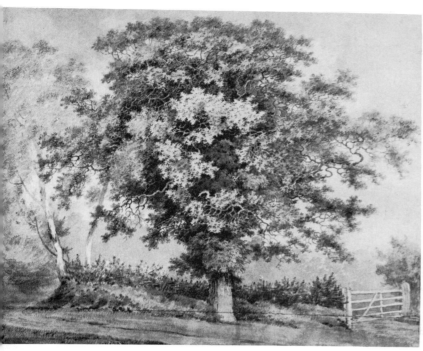

BARRET, George (1732-1784)

An Elm Tree. *Inscribed "The Stricken Tree", watercolour, 11½ins. x 9ins.*

This sketch shows that although Barret never left the eighteenth century tradition of stained drawing he was a lively practitioner of it. In general his colours are soft with much use of blues, greys and browns. He was undoubtedly a romantic.

BARTHOLOMEW, Valentine (1799-1879)

Exotic Birds and Plants. *Signed, watercolour heightened with white, 33ins. x 25½ins.*

The perfection of Bartholomew's flowers is largely due to their being reared in the conservatory.

BARRET, George, Yr. (1767-1842)

Classical Capriccio. *Signed and dated 1832, watercolour, 7⅛ins. x 10¼ins.*

Barret began as a topographer, but is best known for his Claudian compositions which are similar to those of his fellow founder member of the O.W.S., J. Cristall and their follower F.O. Finch. Sunsets were his speciality.

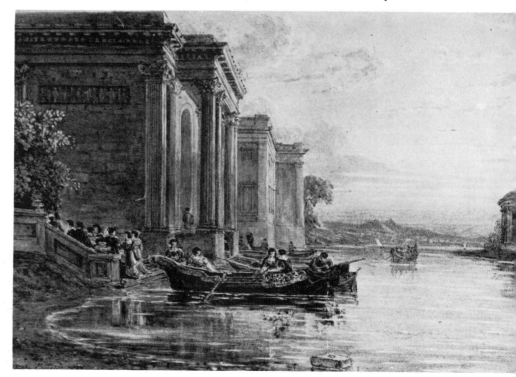

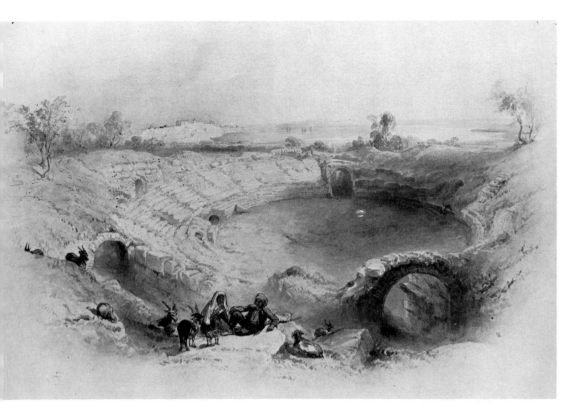

BARTLETT, William Henry (1809-1854)
The Roman Amphitheatre at Syracuse with a Goatherd in the Foreground. *Watercolour, 9¾ins. x 13¾ins.*

(Martyn Gregory)

BATCHELDER, Stephen John (1849-1932)

Leafy June — Barton Broad. *Signed and dated 1885, inscribed on reverse, watercolour, 21ins. x 29½ins.*

An unusually good example of Batchelder's typical subject matter.

(Lawrence of Crewkerne)

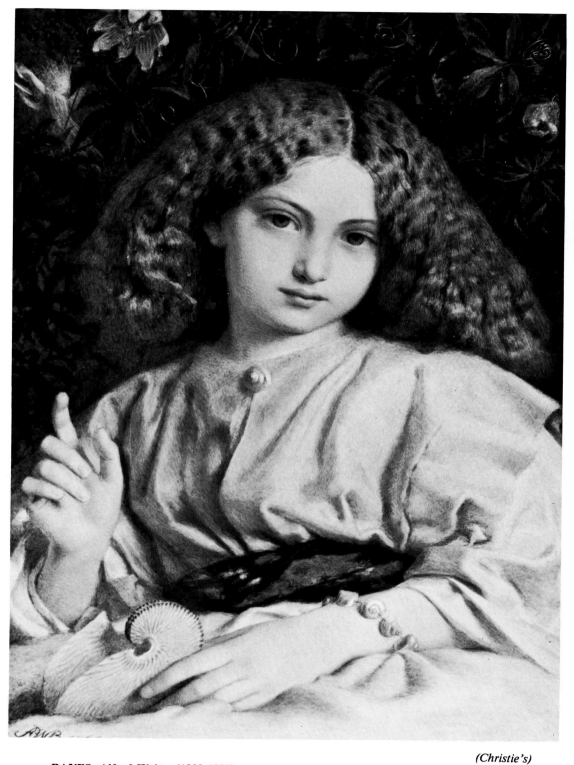

(Christie's)

BAYES, Alfred Walter (1832-1909)
Daydreams. *Signed with initials and dated 1864, watercolour and bodycolour, 15ins. x 11ins.*

BAYNES, James (1766-1837)

Norham Castle Overlooking the Tweed. *Watercolour, 13½ins. x 19¾ins.*

Unlike many of the drawing masters of his time Baynes never developed an immediately recognisable style of his own. He used many of the techniques of the time, such as stopping out, and worked rather weakly in the manner of Girtin.

(Sotheby's)

BECKER, Edmund

The Thames at Windsor. *Pen and brown ink, blue wash, 8ins. x 11½ins.*

(Dudley Snelgrove Esq.)

BENNETT, William (1811-1871)

New Abbey, Dumfries. *Watercolour, 10⅞ins. x 18¾ins.*

It is not known whether Bennett was a pupil of Cox but he certainly took his style from him. His work, in fact, is very close to that of the younger Cox and marked by a rather angular treatment of moving foliage.

(Maidstone Museum)

BENNETT, William (1811-1871)
The Deer Forest at Chatsworth. *Signed, watercolour, 24¾ins. x 37¾ins.*

(Sotheby's)

BENNETT, William Mineard (c.1778-1858)
The Forum, Rome. *Watercolour, 14ins. x 22ins.*
As well as landscapes Bennett painted portraits and miniatures.

(Sotheby's)

BENTLEY, Charles (1806-1854)
Off the Isle of Wight. *Watercolour, 5⅞ins. x 8⅝ins.*
Bentley's work is largely based on that of Bonington and W. Callow but rarely reaches the heights of the former. He made great use of rubbing for the highlights. Most of his original subjects were found around the British coast.

(Private Collection)

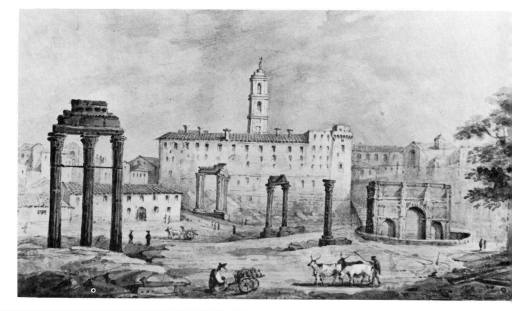

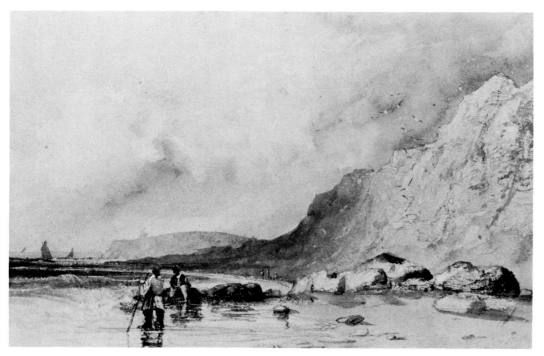

BENTLEY, Charles (1806-1854)
On the South Coast. *Signed, watercolour,
5⅞ins. x 8¾ins.*

BEUGO, John (1759-1841)
Portrait of Dr William Cullen. *Watercolour,
6⅜ins. x 5½ins.*

As well as small portraits Beugo made illus-
trations of subjects from Burns which he later
engraved.

**BEVERLEY, William Roxby
(1811-1889)**

Dover Castle. *Watercolour, 10½ins. x
16ins.*

A follower of Bonington and a pupil of
C. Stanfield. Like the former he has a
penchant for beaches and misty effects.
There are often touches of red on his
figures and he sometimes uses reddish
brown outlining.

(Martyn Gregory)

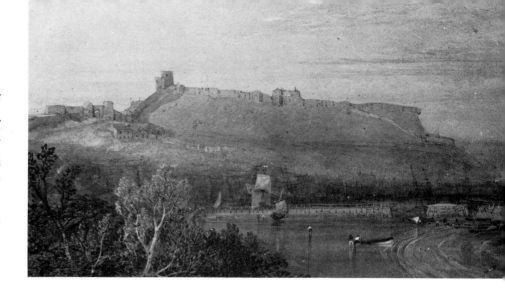

**BEVERLEY, William Roxby
(1811-1889)**

Fishing Boats. *Signed with initials,
watercolour, 8½ins. x 12⅝ins.*

(Private Collection)

**BEVERLEY, William
Roxby (1811-1889)**

Sketch of Dutch Fishing
Boats. *Pencil and water-
colour, 5⅜ins. x 10ins.*

Beverley's sketches often,
as here, inscribed with
colour notes are spirited
and surprisingly modern
in effect. They are often in
pen and brown ink.

(Private Collection)

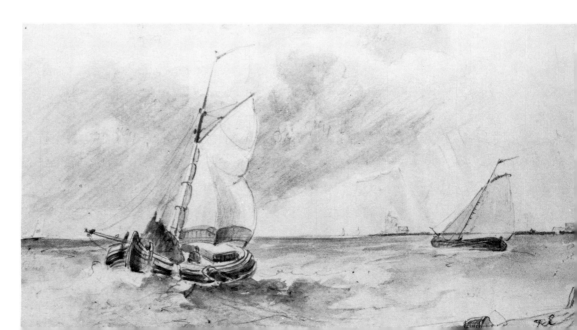

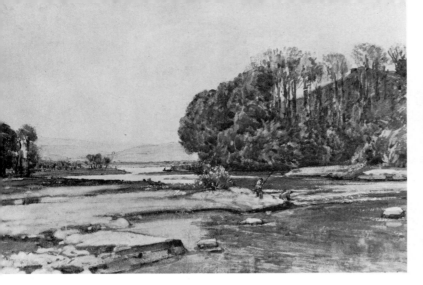

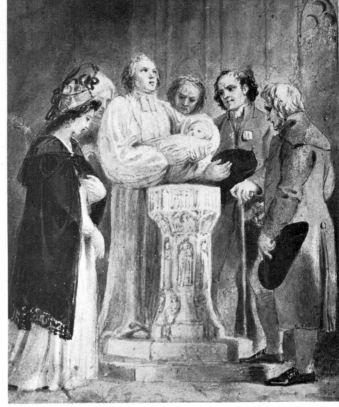

(Beryl Kendall)

BIRCH, Samuel John Lamorna (1869-1955)

The Boat Pools, Ankholme, Nr. Hanby, Lancaster. *Signed and dated 1915, watercolour.*

Birch was primarily an impressionist, concentrating on effects of light and colour. When his technique works it is very attractive but on occasions it can give rather a woolly impression, as in the middle ground of the present illustration.

BIRD, Edward (1772-1819)

A Christening. *Watercolour, 6⅛ins. x 5ins.*

Bird is best known for his historical subjects, landscapes and portraits, but he also produced figures subjects invariably taking his models from the life. His sketches of his friends are rather in the manner of Wilkie.

(Bristol City Art Gallery)

BLACKLOCK, William James (1816-1858)

Rocks by a River. *Watercolour, 8¼ins. x 12½ins.*

In his more finished work Blacklock shows the influence of the Pre-Raphaelites.

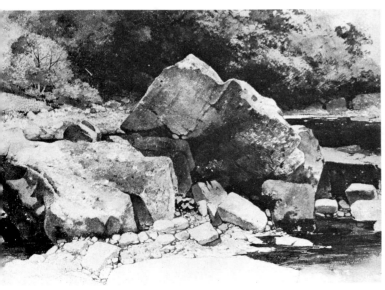

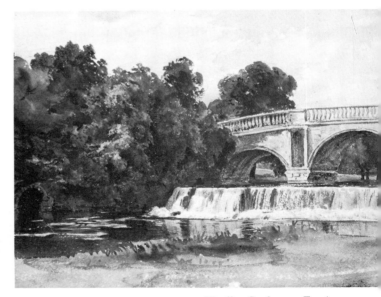

(Dudley Snelgrove Esq.)

BLAKE, Fanny

A Bridge over a River and Waterfall. *Watercolour, 10½ins. x 13½ins.*

It is a great mistake to assume that de Wint's pupils were all incompetent, since he was held to be one of the best drawing masters of his time. There is a slight crudeness in the drawing of this example but the general effect is pleasing and artistic.

(Carlisle Museum and Art Gallery)

BLAKE, William of Newhouse

View from Admiralty House, Rochester. *Inscribed on old mount, watercolour, 8ins. x 11⅜ins.*

Blake appears to have been fond of dark greens.

BOND, William Joseph J.C. 'Alphabet' (1833-1926)

Unloading the Catch. *Signed and dated '72, watercolour, 5¼ins. x 11¼ins.*

'Alphabet' Bond is best remembered for his work in the impressionist manner of Turner. Earlier in his career he was influenced by the Pre-Raphaelites. He was a keen sailor and often painted ships and shores.

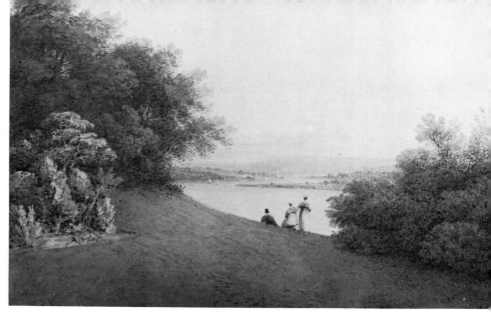

(Albany Gallery)

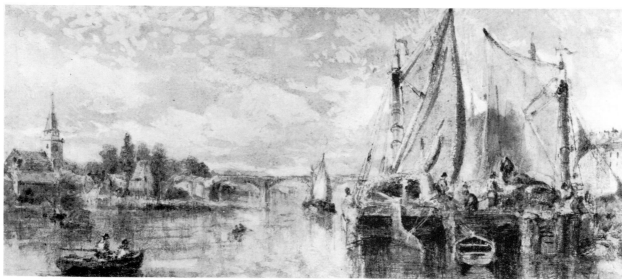

(Sotheby's Belgravia)

BONINGTON, Richard Parkes (1802-1828)

Low Tide in a French Port. *Inscribed on the reverse 'Present to Mrs Bonington', pencil and watercolour, 8¼ins. x 10½ins.*

Marion Spencer suggest that this drawing dates from 1820. It is in some ways less assured and more precise than the artists's later and more impressionist work.

(Martyn Gregory)

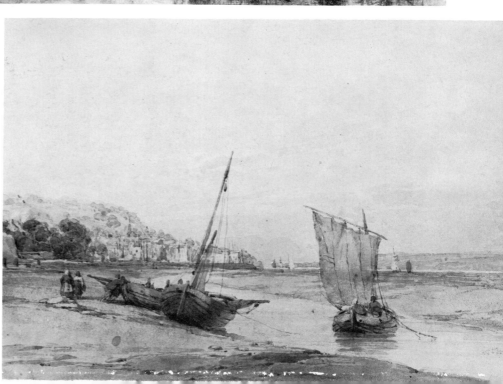

BOUGH, Samuel (1822-1878)

The Cathedral and Collegiate Church of the Holy Spirit at Millport, Isle of Cumbrae. *Signed and dated Feb 1852, watercolour, 14½ins. x 23¼ins.*

In the precision dictated by the architectural nature of the subject this work is untypical of Bough. His style is normally much freer and is closely allied to the later manner of Cox.

BOURNE, Rev. James (1773-1854)

Fourthampton Church near Tewkesbury. *Grey and blue wash, 4¾ins. x 6¾ins.*

The vast majority of Bourne's work is in one or two tones of wash, although on rare occasions he produced full watercolours. His formula for foliage drawing consists of dark blobs superimposed on lighter. His work is sometimes mistaken for that of J. Glover with whose style his has only superficial similarities. His is nearer to that of J. Robertson especially in the use of areas of highlight.

BOUVIER, Auguste Jules (1827-1881)

Going to the Fiesta, Spanish Navarra. *Signed and dated 1859, watercolour, 48ins. diameter.*

This is an unusually realistic subject for Bouvier who generally preferred anaemic nymphs and genre pieces.

BOUVIER, Gustavus A.
The Music Makers. *Signed, watercolour, 5¼ins. x 6½ins.*

(Beryl Kendall)

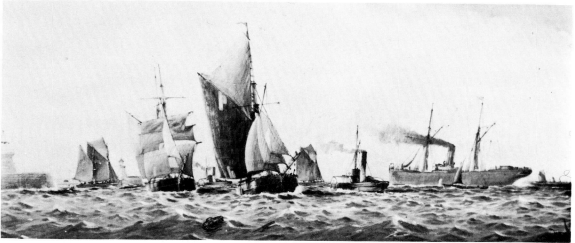

BOYCE, William Thomas Nicholas (1858-1911)
Shipping on the Tyne. *Signed, watercolour, 10ins. x 28ins.*

(The Bourne Gallery)

BOYNE, John (c.1750-1810)
Sancho Panza. *Signed, watercolour, 9ins. x 7ins.*
Boyne's most charming and amusing work is usually in this format. He also worked on a larger scale and weakly in the manner of Rowlandson.

(Martyn Gregory)

BOYS, Thomas Shotter (1803-1874)

On the Seine. *Signed and dated 1832, watercolour, 7ins. x 10ins.*

A typical example of Boys's Bonington period in which he showed all the technical hallmarks of the school: rubbing, scraping, blotting with the thumb and so forth.

(Private Collection)

BOYS, Thomas Shotter (1803-1874)

Italian Ladies and Children on a Balcony. *Signed and dated 1851, watercolour, 12¼ins. x 15½ins.*

(Sotheby's)

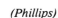

BOYS, Thomas Shotter (1803-1874)

The International Exhibition Building of 1862 at South Kensington. *Pencil and watercolour, heightened with bodycolour, 8⅞ins. x 21¼ins.*

Although, towards the end of his career, Boys concentrated less upon architecture and more upon landscapes, he still produced architectural subjects such as this in order to survive financially.

(Phillips)

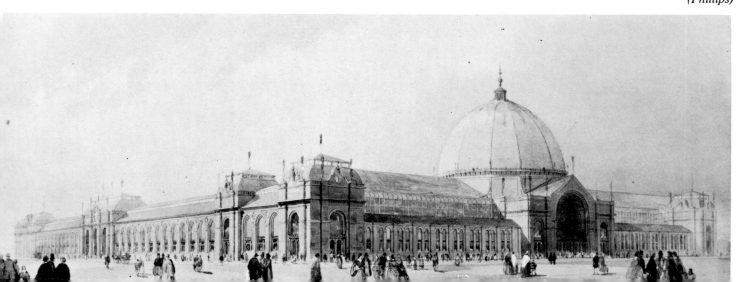

BRABAZON, Hercules Brabazon (1821-1906)

Mouth of the Grand Canal. *Signed with initials, pencil and watercolour heightened with white, 4⅞ins. x 7¾ins.*

Brabazon formed a link between Turner and the late nineteenth century impressionists. He was much more a colourist than a draughtsman and his drawings were usually completed very quickly and on the spot. The unevenness of his work can be accounted for partly by this and partly by the fact that he was usually accompanied on his travels by a group of disciples including Madame Bodichon and her sisters. Many of the initials on early drawings were added towards the end of his life.

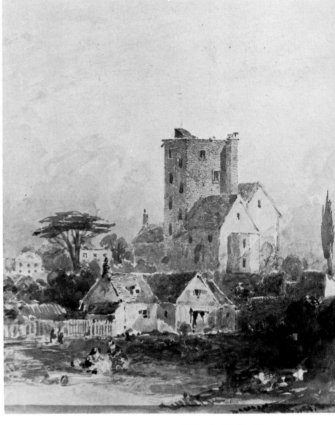

BRANDARD, Robert (1805-1862)

Cannonbury Tower, Islington. *Watercolour, 7¼ins. x 5¾ins.*

This is an example of Brandard's overcrowding in his compositions.

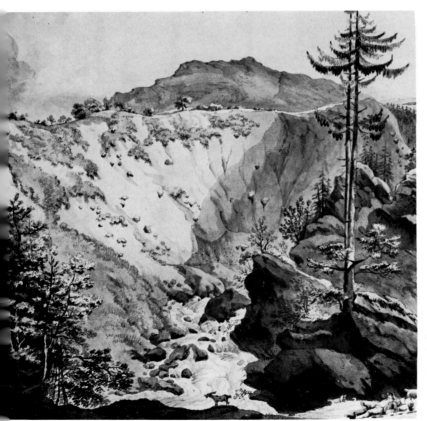

BRANDOIN, Michel Vincent Charles (1733-1807)

Near Chamonix. *Inscribed on mount 'Saut de L'Arve pres des Glaciers de Chamounix en Savoye', pen and grey ink and watercolour, 11⅛ins. x 11ins.*

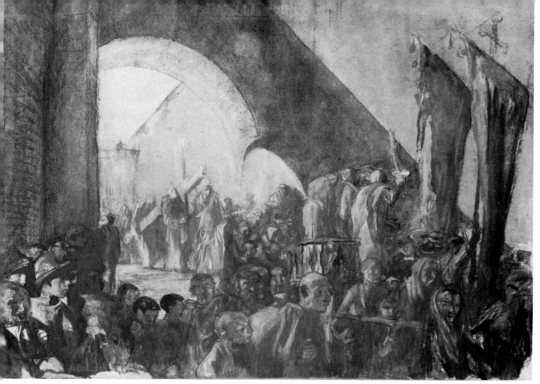

BRANGWYN, Sir Frank William (1867-1956)

The Way of the Cross. *Pencil and watercolour heightened with white, 25¾ins. x 30¼ins.*

The freedom of Brangwyn's style owes much to the early influence of the Newlyn School. He began by working in grey monochrome and added more and more colour throughout his career.

(Beryl Kendall)

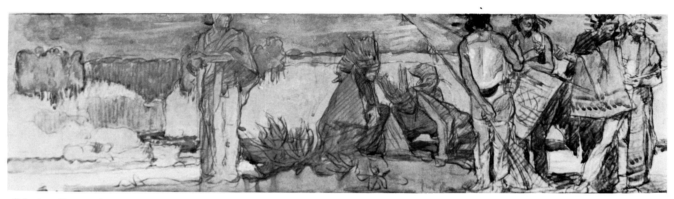

(Martyn Gregory)

BRANGWYN, Sir Frank William (1867-1956)

Red Indian overlooking a Canyon - design for one of the decorative panels in the offices of the Canadian Great Trunk Railway. *Pencil, watercolour and bodycolour, 8½ins. x 28½ins.*

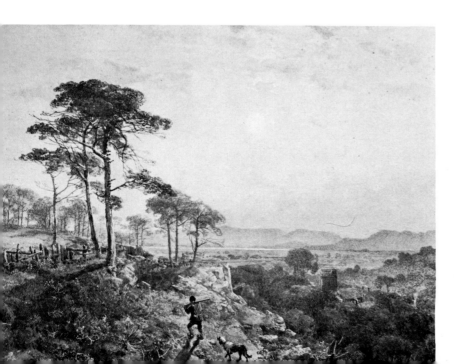

BRANWHITE, Charles (1817-1880)

Early Moonrise. *Signed and dated 1867, watercolour heightened with white, 17ins. x 24ins.*

Branwhite was a romantic and late member of the Bristol school and his work is characterised by a lavish use of bodycolour.

(The Bourne Gallery)

BRICKDALE, Eleanor FORTESCUE- (1871-1945)
Heroes and Hero Worship. *Signed with initials, watercolour, 14¼ins. x 10½ins.*

BRIGHT, Harry

The Lord of the Manor. *Signed, inscribed and dated 1883, watercolour, 18ins. x 12¼ins.*

The chief point about Harry Bright is that he was not Henry Bright. Many of his studies of birds are very much more sentimental than the present example, but he also produced excellent small impressionist studies of pigeons and the like which are reminiscent of some of the work of E.J. Alexander. Examples of these can be seen in the British Museum.

BRIGHT, Henry (1810-1873)

Hever Castle, Kent. *Pencil and watercolour, 13ins. x 19½ins.*

The many slightly garish mixed media drawings which Bright produced in his later years, and for which he is most remembered, have tended to obscure the excellent qualities of his earlier work in pure watercolour.

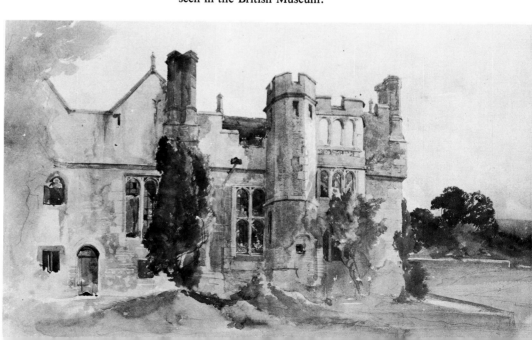

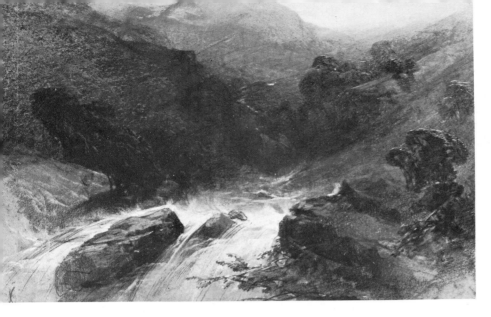

BRIGHT, Henry (1810-1873)

A German Mountain Torrent. *Signed and inscribed on the old backing, board, coloured chalks, 11½ins. x 8ins.*

A typical example of Bright's later mixed media manner in which charcoal and coloured chalks are often used with white heightening. Sometimes the paper is tinted.

(Dr. C.R. Beetles)

BROCAS, James Henry (c.1790-1846)

Old Boats Bridge, Limerick. *Pen and ink and watercolour.*

(National Gallery of Ireland)

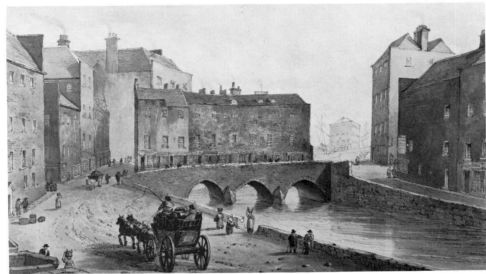

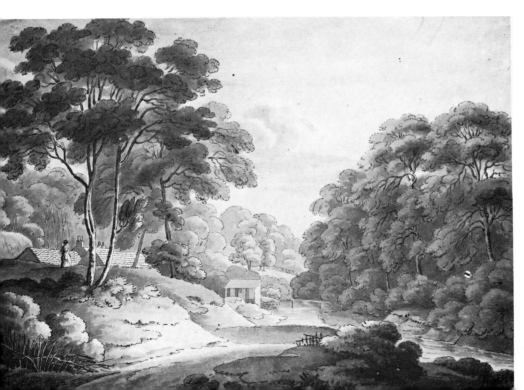

BROWN, William

Landscape with Croxdale Paper-mill, Durham. *Pen and brown ink and watercolour, 7½ins. x 10ins.*

(Dudley Snelgrove Esq.)

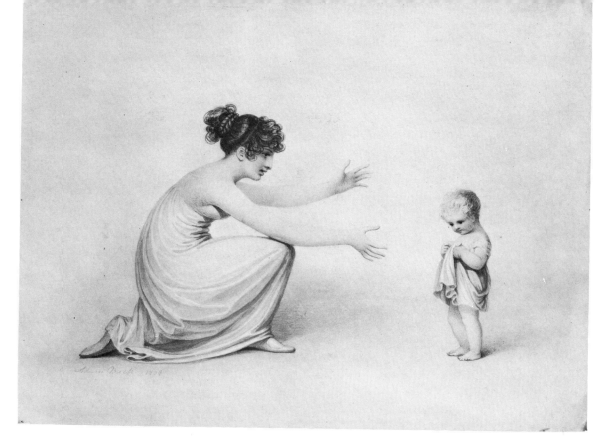

BUCK, Adam (1759-1833)

First Steps in Life. *Signed and dated 1808, pencil and watercolour, 8⅛ins. x 9⅝ins.*

BUCK, Adam (1759-1833)

Portrait of Henry West Betty, The Young Roscius. *Watercolour, 13¼ins. x 10¼ins.*

Buck's portraits are very much in the manner established by Edridge although generally less strong. He also produced occasional illustrations.

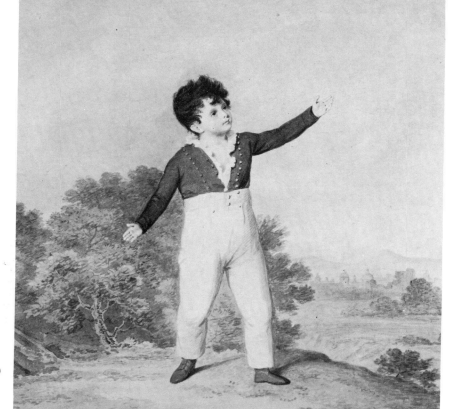

(Sotheby's)

BUCKLER, John (1770-1851)

Latimers, Bucks. *Signed and dated 1838, watercolour, 9ins. x 12ins.*

For a period of almost 100 years the Bucklers, father and son, produced portraits of country houses in a manner which varied very little. Often only the signature distinguishes between the works of the two. The architectural drawing is always neat, with careful outlines, and the predominant colours of the landscapes are mellow greens.

(Bonham's)

BUCKLER, John (1770-1851)

St. Mary's, Shrewsbury. *Pen and ink and watercolour, 16½ins. x 23½ins.*

BUCKLER, William (1814-1884)

Portrait of a Gentleman. *Signed, watercolour, 15½ins. x 11¾ins.*

William Buckler painted portraits between about 1836 and 1856. By the end of this period entomology had become his main interest and his later drawings are generally of larvae.

(Sotheby's)

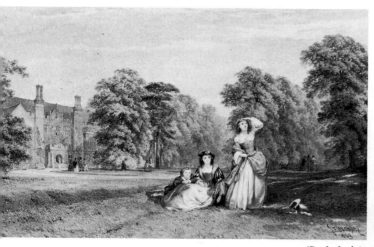

(Sotheby's)

BUCKLEY, J.E.

Mapledurham, Oxfordshire. *Signed and dated 1863, watercolour, 13ins. x 21¼ins.*

Buckley specialised in Tudor and Stuart figures in well-drawn, if sometimes overcoloured, country house settings.

BURGESS, William, of Dover (1805-1861)

Dover from the Terrace of the Governor's Garden 1846. *Watercolour, 8¾ins. x 11¼ins.*

Most of Burgess's known work includes views of the Castle and town of Dover. However, since he by no means always signed it is probable that subjects from other parts of Kent by him go unrecognised. On the whole his watercolours are rather weak and his perspective can be awkward.

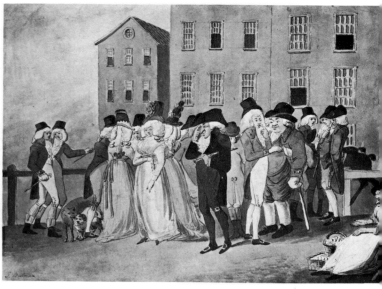

(Michael Bryan)

BULMAN, Job (c.1740-)

View of the Cliff at Scarborough 1789 "with some known portraits". *Signed and dated with initials on reverse, watercolour, 10¼ins. x 14½ins.*

Bulman's landscape and topographical drawings are distinctly amateur, although based on the Sandby convention. They can be very close to those of Francis Grose, with whom he sketched, and some of them have been noted with a fake signature, N. Pocock, which belongs to the group discussed under Thomas Sunderland.

BURGESS, John, Yr. (1814-1874)

Le Lieutenance, Honfleur, Nr Le Havre. *Watercolour, 8ins. x 14ins.*

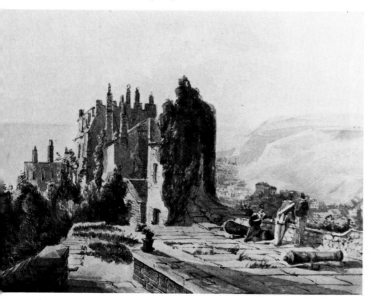

(Sotheby's Belgravia)

(Spink & Son Ltd.)

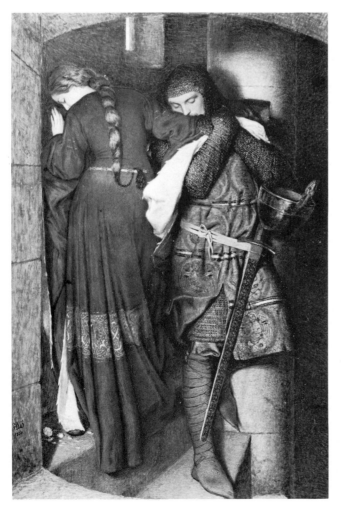

BURNEY, Edward Francis (1760-1848)

Amateurs of Tie-wig Music. *Pen and grey ink and water-colour, 18¼ins. x 27¾ins.*

As well as his splended large satirical watercolours Burney made many charming vignettes and book illustrations, often in grey wash with light touches of colour.

BURTON, Sir Frederick William (1816-1900)

Meeting on the Turret Stair. *Signed with initials and dated 1864, watercolour, 37ins. x 24ins.*

(National Gallery of Ireland)

BUSHBY, Thomas (1861-1918)

Carlisle Town Hall. *Signed and dated 1897 and inscribed, watercolour, 9⅝ins. x 14ins.*

Bushby was generally a topographer, and as well as in the Carlisle area, he sketched in Norway, France, Switzerland, Holland and Italy.

(Carlisle Museum and Art Gallery)

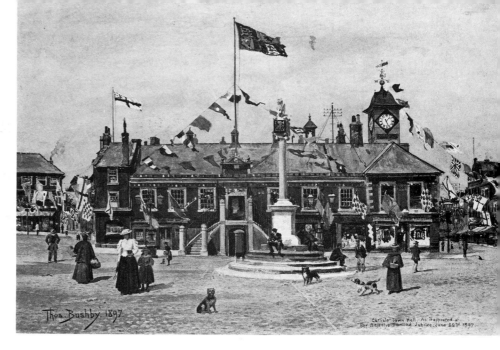

BUTTERSWORTH, Thomas

A Review of the Fleet. *Signed, watercolour, 6½ins. x 9ins.*

(Sotheby's)

BYRON, William, 4th Lord (1669-1736)

A Horseman near a ruined wall in a Wooded Landscape. *Pencil and watercolour, 6⅞ins. x 8¾ins.*

(Christie's)

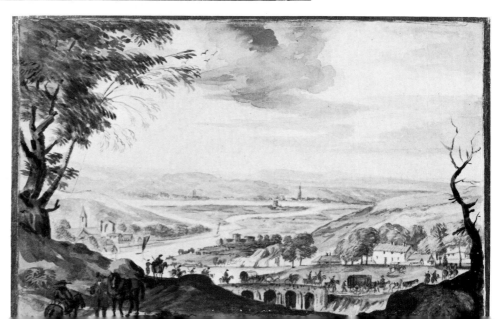

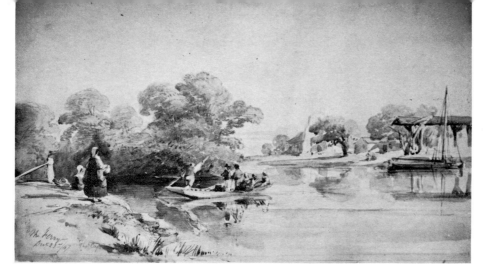

CAFE, Thomas Yr. (1817-1909)
Twickenham Ferry. *Signed and inscribed and dated Decr 23rd/47, pencil and watercolour, 8ins. x 14ins.*

(The Bourne Gallery)

CAFE, Thomas Smith (1793-c.1841)
Fishing Boats at Folkestone. *Signed on a previous mount, inscribed and dated July 1841 on the reverse, watercolour, 7¼ins. x 10¼ins.*

(Martyn Gregory)

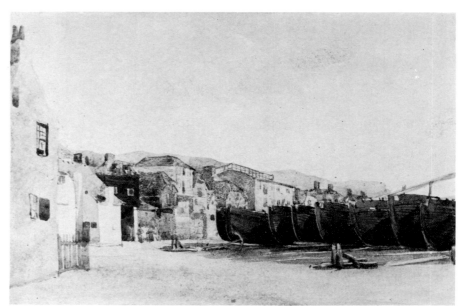

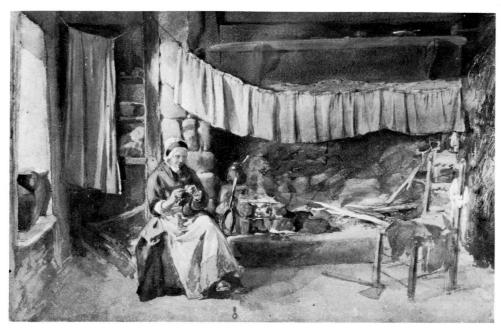

CAFE, Thomas Watt (1856-1925)
An interior of a Fisherman's Cottage in Jersey. *Watercolour heightened with white, 12ins. x 18ins.*

(Sotheby's)

326

CAFFIERI, Hector (1847-1932)
A Breton Fishergirl. *Signed, watercolour, 28ins. x 20ins.*
Caffieri is most remembered for his watercolours of French fisherfolk, but he also produced landscapes, flower and sporting subjects, and was a war artist.

(The Bourne Gallery)

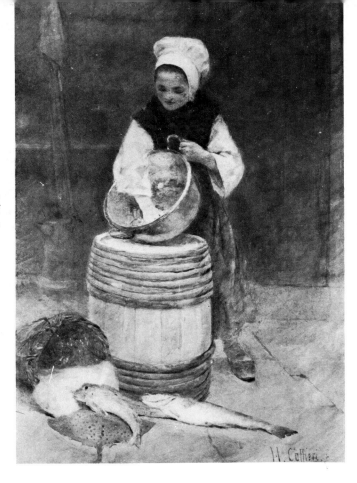

CALLCOTT, Sir Augustus Wall (1779-1844)
View in a North Italian Town. *Signed, watercolour, 4¾ins. x 5½ins.*
During his lifetime Callcott was bracketed with Turner: he has suffered from the comparison.

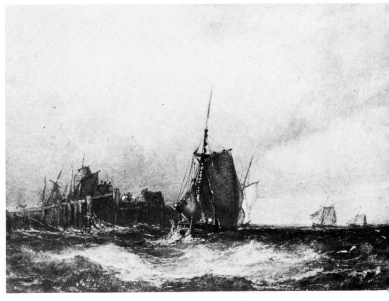

(Martyn Gregory)

CALLCOTT, William James
Shipping off a Pier. *Signed with intials, watercolour, 9ins. x 11½ins.*
Callcott continued the traditions of Bonington and Bentley.

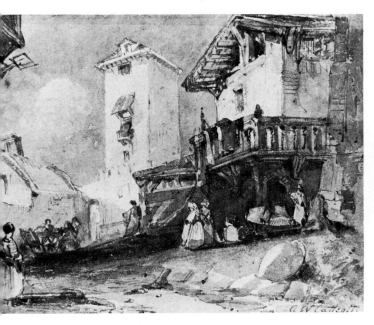

(Martyn Gregory)

327

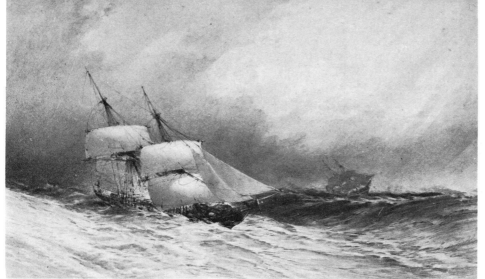

CALLOW, John (1822-1878)

In the Bay of Biscay. *Signed, watercolour, 11ins. x 17ins.*

Callow's style was largely based on that of his brother, but he sometimes allows his colours, especially his blues, to escape from control. He is at his best with marine subjects such as this, and also painted landscapes. Like his brother he disapproved of bodycolour.

(The Bourne Gallery)

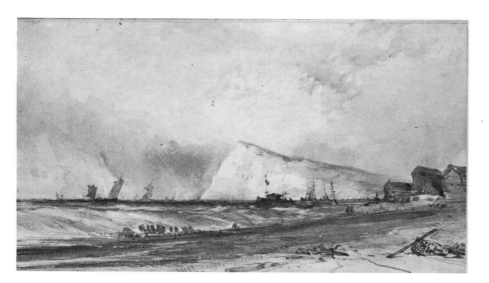

CALLOW, William (1812-1908)

A View of Shakespeare Cliff from Dover Beach. *Signed with initials, watercolour, 6⅛ins. x 10ins.*

A very early work (perhaps painted in 1835) by Callow showing the strong influence of Bonington.

(Christie's)

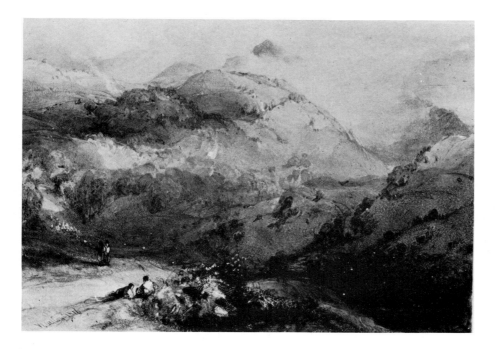

CALLOW, William (1812-1908)

In the Lower Pyrenees. *Signed and dated 1836, watercolour, 6¾ins. x 9¾ins.*

A drawing from one of Callow's walking tours in France at a time when he had inherited Boys's Paris studio and had many French and English pupils.

(Private Collection)

CALLOW, William (1812-1908)

A Riverside Church and Houses. *Signed, watercolour, 6¼ins. x 9¼ins.*

A work from Callow's middle years showing his characteristic techniques of rubbing, blotting and the use of horizontal hatching.

(Private Collection)

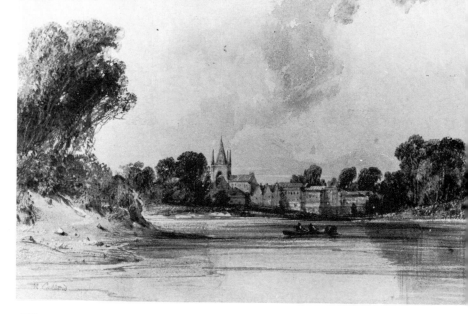

CALLOW, William (1812-1908)

Off Hastings. *Signed and dated 1902, watercolour, 9¾ins. x 13½ins.*

An unusually strong work for Callow's late period which still shows some of the mannerisms such as the horizontal lines on the houses which he had obtained seventy years before from Bonington and Boys.

(Private Collection)

CALVERT, Charles (1785-1852)

View of Ripon and the Cathedral. *Signed and inscribed on back paper, watercolour, 10ins. x 15½ins.*

(Martyn Gregory)

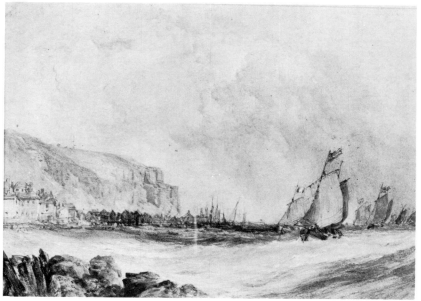

CAMPBELL, John Henry (1757-1828)

View of the Head of Howth across Dublin Bay. *Signed water-colour, 25¼ins. x 31⅛ins.*

Campbell's work is usually on a smaller scale than this example but for style and subject matter this is entirely typical. He had two conventions for rendering foliage, the blob-on-wash seen on the left, and the horizontal hook seen on the right. His work is in the eighteenth century tradition and that of his daughter C.M. Campbell is very similar to it.

(National Gallery of Ireland)

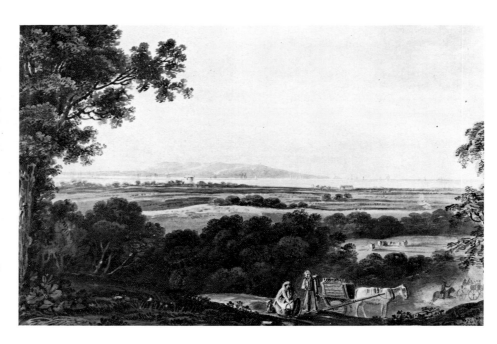

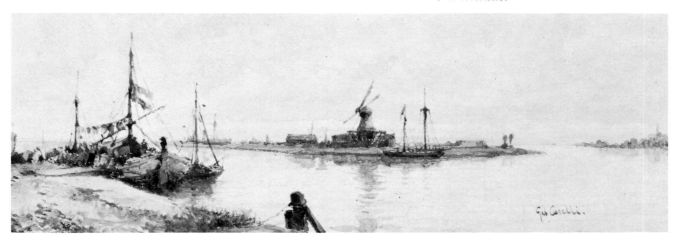

(Dr. C.R. Beetles)

CAMPION, George Bryant (1796-1870)

The Rising Sun. *Signed, watercolour, 13ins. x 18ins.*

Although best known for his military subjects, often on buff paper (see cover of Volume One), and in a combination of chalk and watercolour, Campion also did straight-forward watercolours of civilian subjects and landscapes. In all cases he tends to make good use of bare paper. His figure drawing is usually admirable.

(The Bourne Gallery)

CARELLI, Gabriel (1821-1900)

The Approach to Zaandaan. *Signed, watercolour, 4¾ins. x 13½ins.*

The signature 'Gab Carelli' is entirely characteristic.

CARTER, Henry Barlow (1803-1867)

Beaching a Fishing Boat in a Storm. *Signed with initials, watercolour, 5ins. x 6⅛ins.*

Carter is best known for stormy coastal subjects such as this, but also produced landscapes. His style derives in part from Turner, in part from Cox, with his strong impressions of wind, and in part from Callow and the Bonington followers. Like the last he was fond of rubbing to show reflections and flying spray.

(Private Collection)

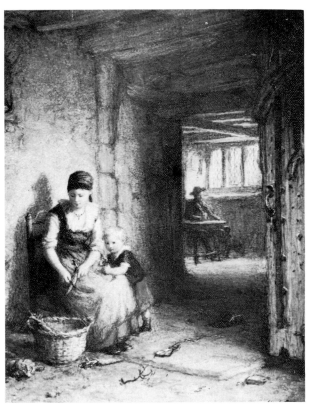

(The Bourne Gallery)

CARTER, Hugh (1837-1903)

Cutting Carrots. *Signed, watercolour, 17ins. x 12ins.*

CARTER, Joseph Newington (1835-1871)

Robin Hood's Bay near Scarborough. *Signed, watercolour, 6½ins. x 9½ins.*

In style a close imitator of his father H.B. Carter, although his work is rarely as good.

(Martyn Gregory)

CATTERMOLE, Charles (1832-1900)
Guns to the Fore. *Signed, watercolour, 16ins. x 23ins.*

(Beryl Kendall)

CATTERMOLE, George (1800-1868)
Alms for the Poor. *Signed with monogram, watercolour, 19½ins. x 15ins.*
Cattermole's monogram, which can be clearly seen in this illustration, is worth notice since it often goes unrecognised in his Cox-like landscape watercolours.

CHALON, Alfred Edward (1780-1860)
Portrait, believed to be of Count D'Orsay. *Signed, inscribed 'Jour à Gauche' and dated 1840, watercolour, 15ins. x 10ins.*
As well as the graceful portraits for which he is best known, Chalon produced historical and literary subjects and brown wash caricatures.

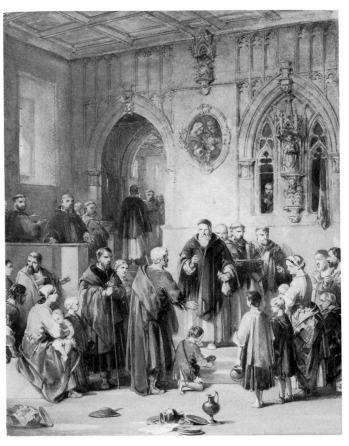

(Sotheby's)

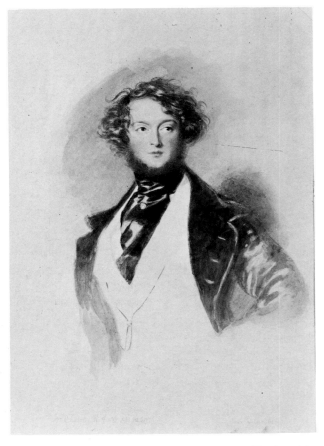

(Bonham's)

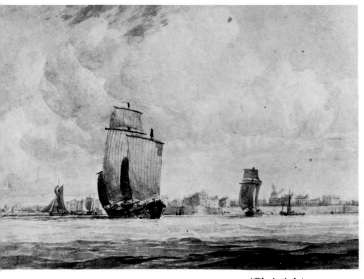

CHAMBERS, George (1803-1840)
Shipping off a Town on the South Coast.
Watercolour, 6⅛ins. x 8⅜ins.

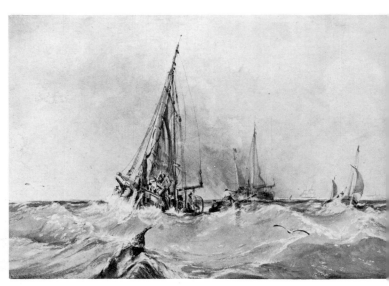

CHAMBERS, George (1803-1840)
Shipping Offshore. *Signed and dated 1837, watercolour, 8¾ins. x 13ins.*

At his best Chambers is one of the most striking British marine painters and despite being self taught he is rarely if ever totally bad. Technically he is always accurate owing to his practical experience as a sailor. His painting of ships and water in motion has rarely been equalled.

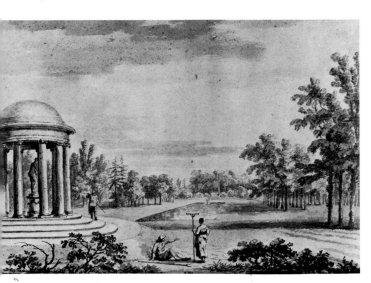

CHATELAIN, John Baptist Claude (1710-1771)
A View of the Rotunda in the Gardens at Stowe.
Pencil, pink, brown and grey washes, 9ins. x 12ins.

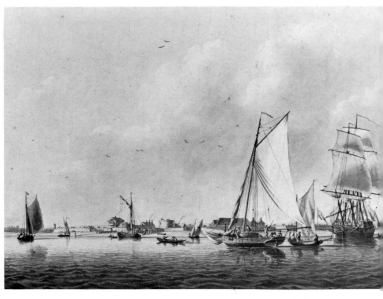

CLEVELEY, John, Yr. (1747-1786)
Frigates, Fishing Smacks and Dinghies off a Spit.
Signed, watercolour, 9½ins. x 13¼ins.

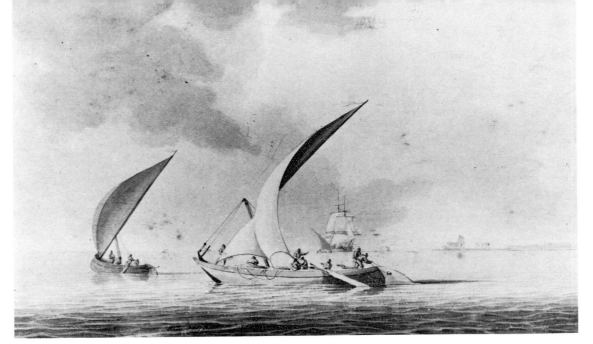

CLEVELEY, Robert (1747-1809)

Belem Tower on the Tagus. Signed and dated 1792, pen and grey ink and watercolour, 9⅝ins. x 15⅛ins.

The influence of Sandby is evident in the work of Cleveley, transmitted to him by his twin brother John. He often worked on a large scale and produced drawings of London and other towns in which a topographical element is added to the usual nautical. He shared with his brother a mannerism of showing water rather like ribbed sand.

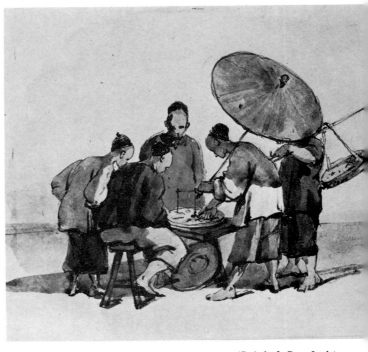

CHINNERY, George (1774-1852)

Chinese Coolies Gambling. Watercolour, 4½ins. x 5¼ins.

CHINNERY, George (1774-1852)

An Indian Soldier by the Side of a River. Pen and sepia ink and watercolour, 5¼ins. x 6⅜ins.

Although Chinnery's colouring is consistent throughout his years in the East, with the predominance of ochre, during his Indian period his figure drawing was less stylised than it was to become in China. He is always fond of rather harsh areas of highlight.

(Spink & Son Ltd.)

CHINNERY, George (1774-1852)

The Praya Grande, Macao with Figures and Boats on the Shore. *Inscribed with artist's shorthand and dated 13th May '40, pencil and sepia ink, 11ins. x 17ins.*

Chinnery's ink and pencil studies can generally be told from those of his followers by their inherent strength, as well as by his shorthand notes and a concentration on the domed and shaved heads of his Chinese subjects. This last is also true of his Chinese watercolours as will be seen in the two other illustrations here.

CHINNERY, George (1774-1852)

A Junk and a Sampan. *Pen and sepia ink and watercolour, 6⅜ins. x 5½ins.*

(Spink & Son Ltd.)

COCKBURN, Edwin

Whitby Harbour. *Signed and dated 1864, watercolour, 11ins. x 19ins.*

Cockburn appears to have been a Whitby man and throughout his career he returned to views of its harbour and shipping. They are often quietly coloured.

(Martyn Gregory)

COCKING, Thomas

St. Mary's Abbey, Drogheda. *Pen and ink and watercolour.*

Cocking was the personal servant and draughtsman to Francis Grose, the antiquary, and it is often very difficult to tell their work apart, although on the evidence of this drawing Cocking was the better architectural draughtsman. In both cases the figure drawing is poor.

(Royal Irish Academy)

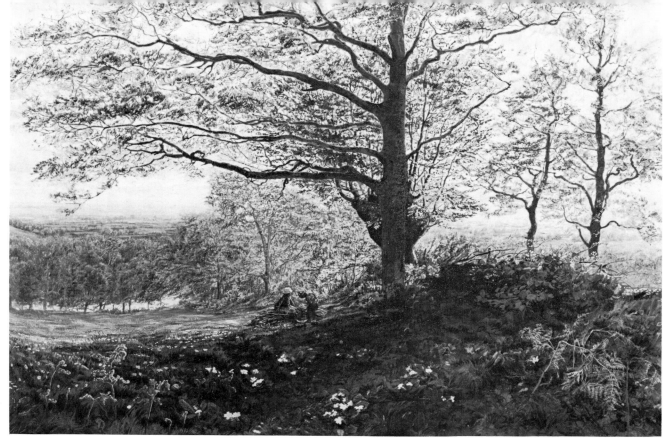

(Christie's)

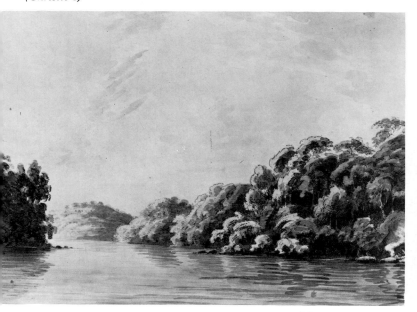

(Martyn Gregory)

COLE, George Vicat (1833-1893)

Springtime, Holmwood, Surrey. *Signed and dated '60, water and bodycolour, 13½ins. x 13⅜ins.*

Cole was not primarily a watercolourist and his early work, often views in Surrey and on the Wye, is the best. Strong sunlight was one of his fortes.

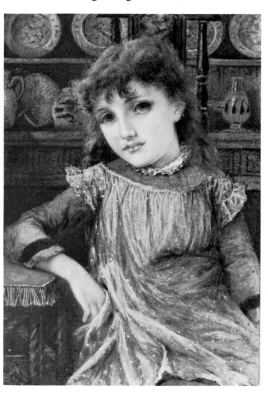

COLEBROOKE, Lieutenant Robert Hyde (1762-1808)

Interior part of Port Cornwallis, Andaman Islands. *Signed and dated 1790, and inscribed in wash line border, pen and brown ink and water-colour, 13¼ins. x 18¼ins.*

COLEMAN, Rose Rebecca (c.1840-)

Thoughtful. *Signed, watercolour heightened with white, 11½ins. x 8ins.*

Perhaps because she was a designer of heads on pottery Rebecca Coleman tended to paint the heads in her watercolours out of scale.

(Sotheby's Belgravia)

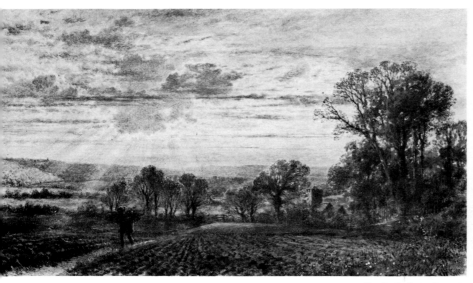

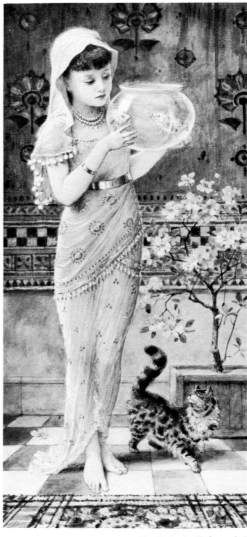

COLEMAN, William Stephen (1829-1904)

Returning Home at Sunset. *Signed with initials, watercolour heightened with white, 6ins. x 11ins.*

W.S. Coleman was a very eclectic artist. Here he is evidently influenced by Linnell and the followers of Constable.

COLEMAN, William Stephen (1829-1904)

The Goldfish. *Signed, watercolour heightened with white, 18ins. x 8ins.*

The fashionable neo-classicism of Albert Moore was slavishly followed by Coleman in many of his works, although his figures are nearly always small girls with rather crudely painted faces.

COLEMAN, William Stephen (1829-1904)

The Fisherman's Children. *Signed and dated 1866, watercolour heightened with white, 9ins. x 17½ins.*

An example of Coleman at his most Foster like.

COLEMAN, William Stephen (1829-1904)

A Cottage Garden. *Signed, watercolour, 10ins. x 13ins.*

Coleman worked in a number of styles including sub-Albert Moore, sub-Birket Foster and the present sketchy impressionism. The most consistent feature is the signature. His drawing can be a little weak.

(Beryl Kendall)

COLKETT, Samuel David (1800-1863)

A Lock near Cambridge. *Signed and dated 1860 and inscribed 'Near Cambridge 1860' on the reverse, watercolour, oil and bodycolour on paper, 9½ins. x 18½ins.*

(Sotheby's)

COLLET, John (c.1725-1780)

The Lion-taiied Macacque from Southern India. *Pen and ink and watercolour, 6¼ins. x 8¾ins.*

A caricaturist as well as a landscape and figure draughtsman, Collet is generally a rather clumsy artist. He often uses a thick black pen outline and rather harsh colours.

(Sotheby's)

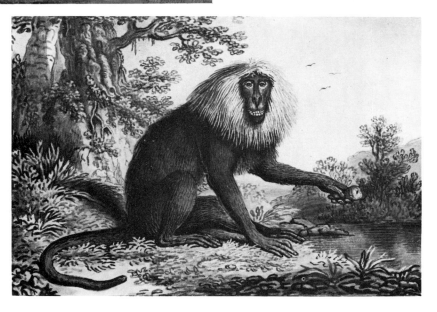

COLLIER, Thomas (1840-1891)

Moel Siabod. *Signed and dated 1881, pencil and watercolour.*

The greatest of the followers of Cox. He was happiest painting empty moorland, generally in a splashy style which is very close to Cox, although with less effect of wind. His handling of the colours of grass, gorse and heather can be very poetic.

(Private Collection)

COLLINGWOOD, William (1819-1903)

Morning: Dent du Midi. *Watercolour, 8⅜ins. x 5½ins.*

From about 1856 Collingwood specialised in Alpine and mountain subjects. He was loosely a follower of Turner and would appear to have been influenced by Ruskin, to whom his son was secretary.

(Private Collection)

COLLINS, Charles (-1744)

A Guinea Hen. *Signed and dated August 1743, watercolour heightened with white, 15ins. x 21ins.*

(Dudley Snelgrove Esq.)

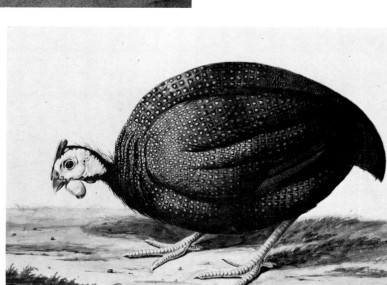

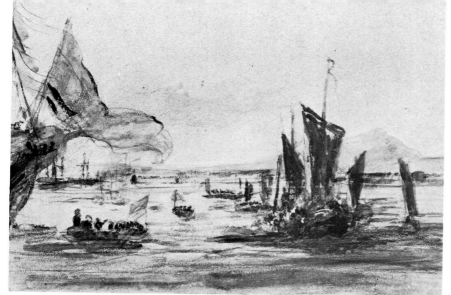

COLLINS, William (1788-1847)

A sketch for George IV landing at Leith.
Water and bodycolour on blue paper.

In general the work of Collins is much more precise than in this example. The beach scenes of the young Bonington were justly compared to his but he has little of the younger man's poetry. In much of his subject matter he resembles the genre painter Mulready and he was a careful and pretty draughtsman if a rather unoriginal one.

(National Galleries of Scotland)

CONSTABLE, John (1776-1837)

Bletchington, Near Brighton.
Pencil, pen and black ink and watercolour, inscribed and dated Nov 5 1825, 4½ins. x 7ins.

An excellent example of Constable's watercolour sketching technique at its most free and dashing. When I first saw this watercolour (some years ago) I thought for a moment that it was by John Piper.

(Christie's)

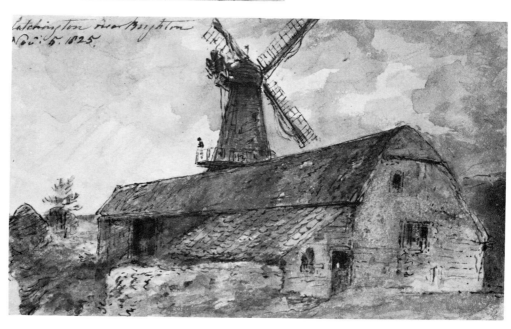

CONSTABLE, John (1776-1837)

A View of South Stoke, Sussex.
Inscribed and dated July 12 1834, pencil and watercolour, 5⅜ins. x 9⅛ins.

Many of Constable's sketches show this combination of soft pencil or chalk drawing, often rubbed, and thin washes of colour. There are so many sketches and more finished works in the national collections that it is possible to date his movements fairly exactly for much of his career, especially in conjunction with his letters and journals.

(Andrew Wyld)

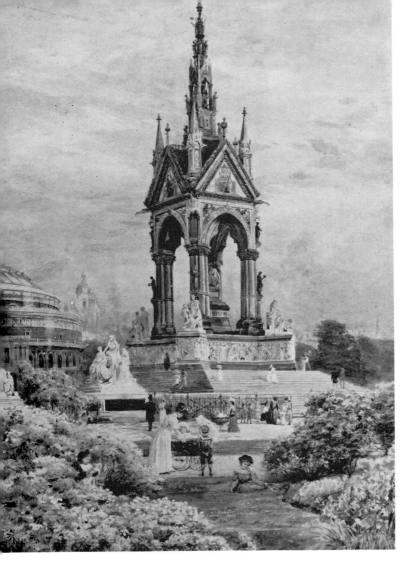

COOK, Ebenezer Wake (1843-1926)
The Albert Memorial, Kensington Gardens, 1893.
Signed, watercolour, 18¾ins. x 13¼ins.

(The Fine Art Society)

COOKE, Edward William (1811-1880)
An Approaching Storm, with Frigate and other
Vessels at Sea. *Watercolour, 9¼ins. x 13¼ins.*
Although the frigate in this drawing shows
Cooke's draughtsmanship and artistic sense at its
best, the details of the surrounding composition
are a little weak by his standards. His drawing,
whether in pencil or in watercolour, is normally
very accomplished indeed. In later life he also
produced humorous drawings which show a great
deal of imagination.

(Martyn Gregory)

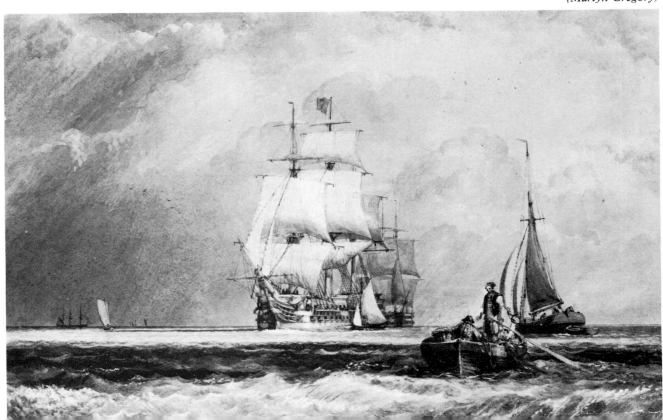

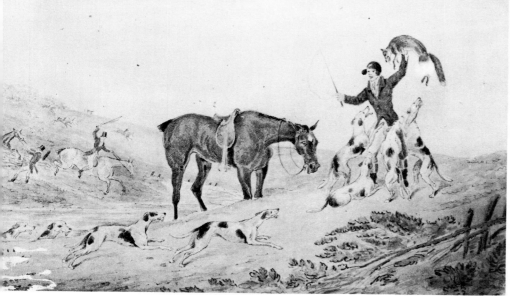

COOPER, Edwin W. (1785-1833)
Fox Hunting. *Signed and dated 1825, watercolour, 7ins. x 11ins.*
A weak member of the Alken School.

(Sotheby's)

COOPER, George
The Market Stall in front of the Pantheon, Rome. *Signed and dated 1825, watercolour, 11½ins. x 13½ins.*

(Sotheby's)

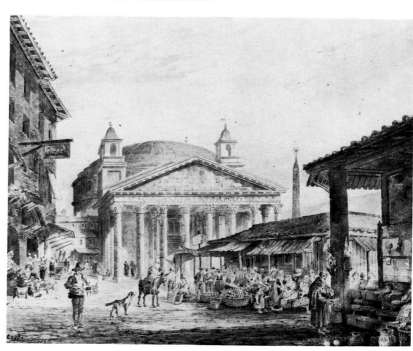

COOPER, Richard, Yr. (1740-c.1814)
Castelnuovo, a view taken about ten miles from Rome. *Inscribed on the mount, pen and brown ink, brown wash, 11½ins. x 18⅞ins.*

Cooper's drawings are often in a distinctive yellow-brown wash but he also produced a few full watercolours. A characteristic, as here, is his use of strongly contrasted area of light and shade producing an effect of clouds and sunlight.

(Christie's)

COOPER, Thomas Sidney (1803-1902)

Cows by a River. *Watercolour, 7¼ins. x 11¾ins.*

An unusually free rendering of the artist's favourite subject. It must be remembered that whatever can be said against Cooper, technically he was very good indeed in his chosen sphere. This is not always the case with his forgers and imitators. Very often his cows or sheep are grouped by a willow on the marshes near Canterbury. His handling of fleece and hide is excellent.

(Private Collection)

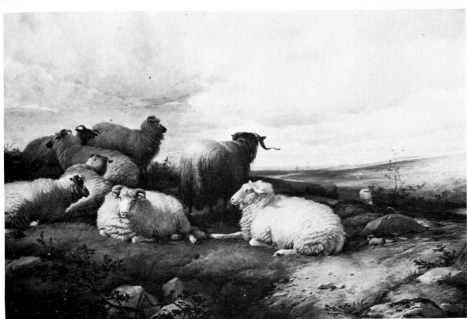

COOPER, Thomas Sidney (1803-1902)

Sheep. *Signed and dated 1853, watercolour, 19ins. x 27ins.*

(Christie's South Kensington)

CORBOULD, Edward Henry (1815-1905)

Medieval Festival Scene with King Cophetua and the Beggar Maid. *Signed and dated 1841, watercolour, 43ins. x 53ins.*

(Bonham's)

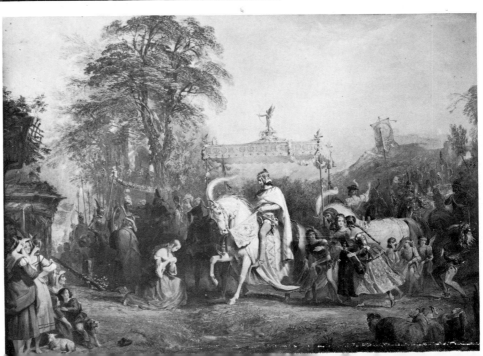

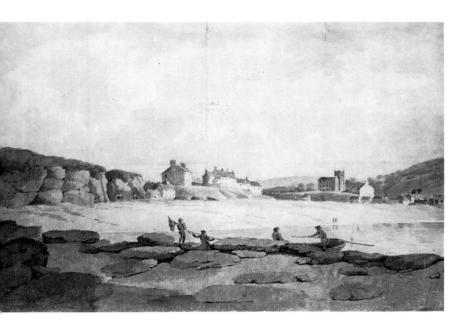

CORNISH, Hubert (c.1700-1832)

Coastal Scene with Red Cliffs. *Pen and black ink and watercolour, 9⅛ins. x 14⅜ins.*

Cornish was an amateur painter of both shipping and landscapes.

(Dudley Snelgrove Esq.)

COTMAN, Frederick George (1850-1920)

Romsey. *Signed and dated 1889, pencil and watercolour, 6ins. x 11ins.*

A characteristic of F.G. Cotman's work in its many forms is the use of russet.

(Martyn Gregory)

COTMAN, John Joseph (1814-1878)

Figures in a landscape. *Signed, watercolour, 5⅞ins. x 11⅛ins.*

(Castle Museum, Norwich)

(Castle Museum, Norwich)

COTMAN, John Joseph (1814-1878)

A Composition. *Signed, pencil and watercolour, 9ins. x 19½ins.*

(Private Collection)

COTMAN, John Sell (1782-1842)

Mont St Michel. *Signed and dated 1818, watercolour, 9⅛ins. x 16¾ins.*

One of several versions of this subject which are in the harsh blue, red and gold manner usually associated with Cotman's work in the 1830s. It shows, however, his mastery as an architectural draughtsman and his preoccupation with pattern and form.

COTMAN, Miles Edmund (1810-1858)

Marine View. *Pencil and watercolour, 9ins. x 12½ins.*

(Castle Museum, Norwich)

COTMAN, Miles Edmund (1810-1858)
Britcher's Boat House, Carrow. *Signed and dated 1853, pencil and watercolour, 11½ins. x 18½ins.*

(Castle Museum, Norwich)

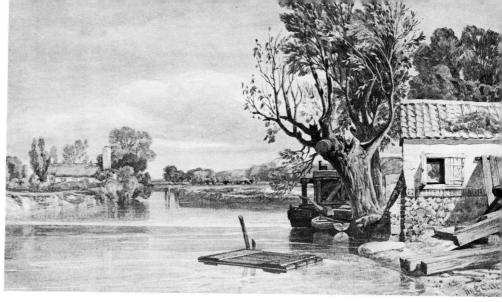

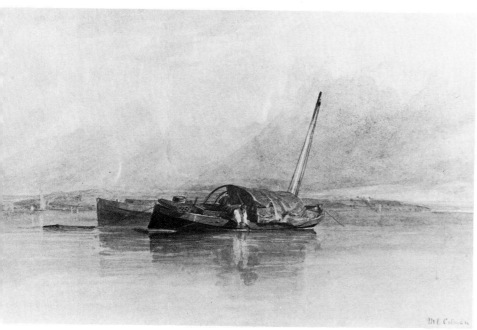

COTMAN, Miles Edmund (1810-1858)
River Scene. *Signed, pencil and watercolour, 6ins. x 9½ins.*

(Castle Museum, Norwich)

COWEN, William (1797-1861)
Como. *Signed and dated 1828, and inscribed on back paper, pencil and watercolour, 7ins. x 10½ins.*

(Martyn Gregory)

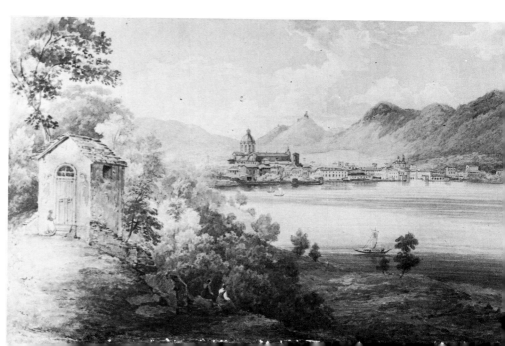

COWPER, William
View on the River Aar, Lac de Thun. *Signed and dated 1793 and inscribed on the original mount 'from a sketch taken in 1778', watercolour, 10½ins. x 15½ins.*

(Martyn Gregory)

COX, David (1783-1859)
Sydenham Common 1810. *Watercolour, 7¼ins. x 10⅝ins.*
This work is typical of Cox at the period, being taken from the area near his home at Dulwich and showing the landscape conventions of John Varley from whom he had taken lessons. In particular the rather weak figures owe much to Varley. The handling of the sky however foreshadows the great atmospheric works of Cox's later periods.

(Private Collection)

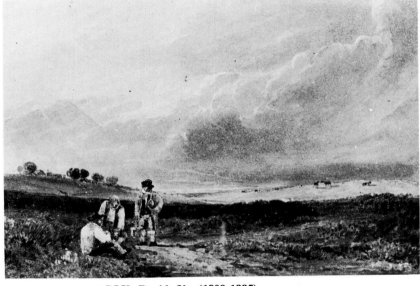

COX, David, Yr. (1809-1885)
The Seafront near Worthing. *Signed and dated '58, watercolour, 9½ins. x 13¾ins.*
The younger Cox's style is closely based on that of his father but rarely approaches it in effectiveness. The details in particular are often rather crude. In fact he is at his best when being most himself.

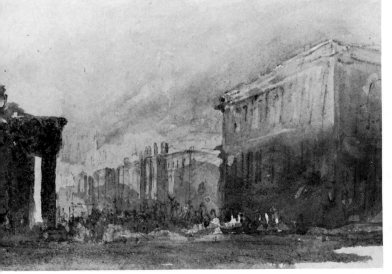

(Martyn Gregory)

COX, David (1783-1859)
Whitehall. *Black chalk and watercolour, 6ins. x 9ins.*
This rapid sketch shows Cox at his most impressionistic.

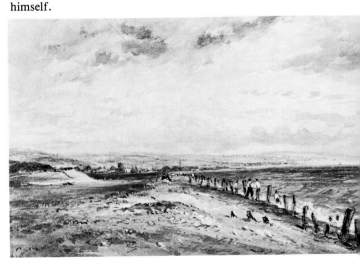

(Andrew Wyld)

COZENS, Alexander (c.1717-1786)
A Mountain Landscape. *Sepia wash on buff paper, 9½ins. x 12½ins.*

(Sotheby's)

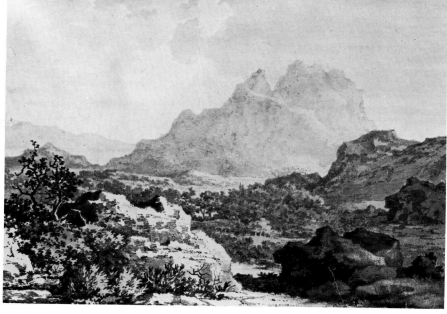

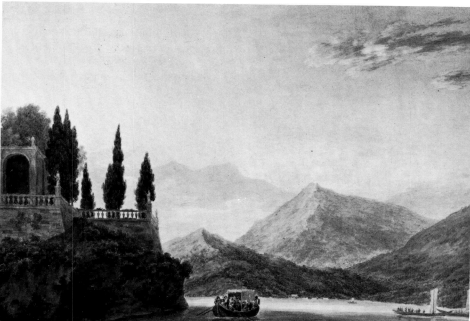

COZENS, John Robert (1752-1797)
Isola Bella, Lake Maggiore at Dusk. *Watercolour, 17¼ins. x 24¼ins.*

The romanticism of Cozen's earlier work is achieved with simple compositions and a very limited palette, usually blues, greys and greens.

(Sotheby's)

COZENS, John Robert (1752-1797)
An Extensive View of London from Greenwich. *Signed twice and dated 1791, watercolour, 19⅝ins. x 27ins.*

One of several versions of this subject by Cozens and one of his last works before his madness. He was perhaps the greatest of the eighteenth century tinted draughtsmen and this work shows many of his mannerisms in particular his love of distance, although it is perhaps more detailed than the drawings of earlier in his career.

(Christie's)

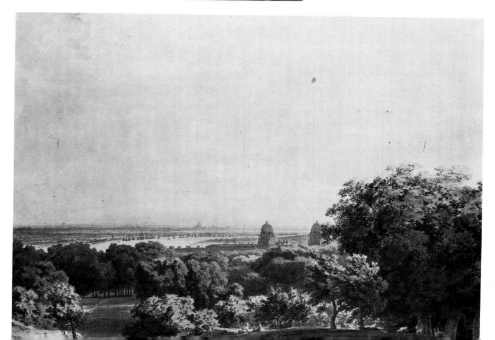

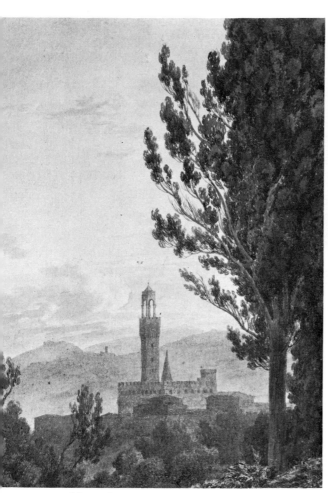

(Agnew)

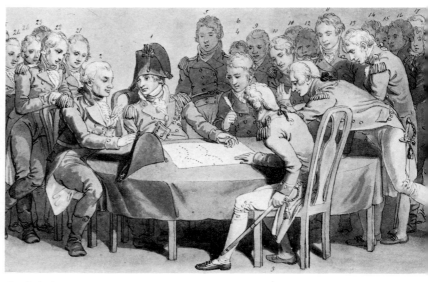

(Sotheby's)

CRAIG, William Marshall (c.1765-c.1834)
England Expects Every Man To Do His Duty.
Pen and ink and watercolour, 6½ins. x 10¼ins.

Craig is best known for small idealised landscapes in a rather pointilliste manner. This shows a grander and more ambitious side of his work.

COZENS, John Robert (1752-1797)
The Palazzo Vecchio. *Pen and grey ink and watercolour, 14¾ins. x 10¼ins.*

This drawing was copied by Turner while with Dr. Monro; it is therefore quite possible that versions by Girtin and other members of the school exist.

CRAMPTON, Sir John Fiennes Twistleton (1805-1886)

A St. Petersburg Driver Asleep. *Inscribed and dated Aug 29th /29, pencil and watercolour, 3½ins. x 6¾ins.*

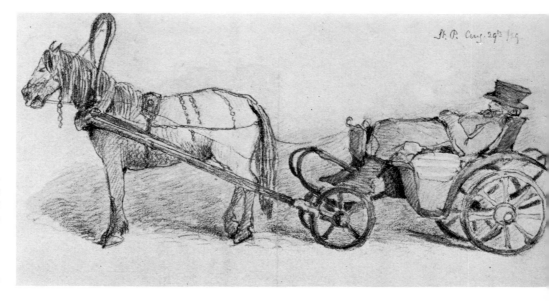

(Private Collection)

(Martyn Gregory)

CRANE, Walter (1845-1915)

Harlech Castle. *Signed and dated '87, watercolour, 7½ ins. x 10¼ ins.*

Crane's watercolour work includes his well-known illustrations *à la mode de* Greenaway, and fine grey wash studies in the New Forest.

CRAWHALL, Joseph, Yr. 'Creeps' (1861-1913)

The Race between the Tortoise and the Hare. *Watercolour, 7¾ ins. x 5½ ins.*

This shows both the Japanese elements and the impressionism of Crawhall's work.

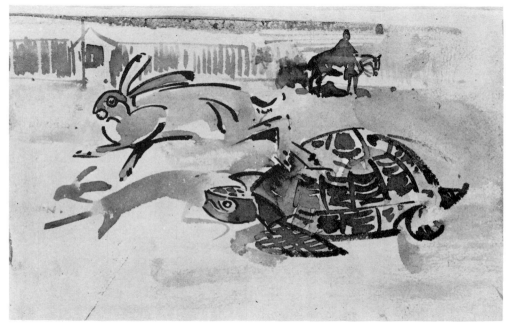

(Sotheby's)

CREASY, John L.

Waterloo Bridge. *Watercolour, 5½ ins. x 8½ ins.*

Creasy also painted ship portraits of Indiamen and other vessels on the Thames.

(Agnew)

351

CRESWICK, Thomas (1811-1869)
Barge on the Thames. *Signed, watercolour, 6ins. x 9¼ins.*

(Martyn Gregory)

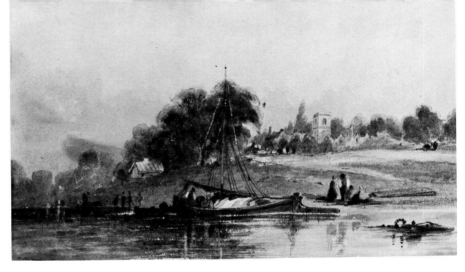

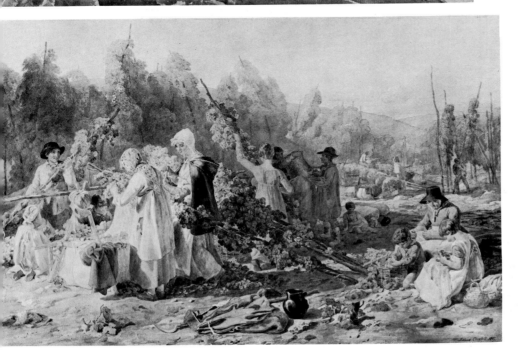

CRISTALL, Joshua (1767-1847)
Figures on a Beach, with Nets Drying. *Signed and dated 1807, watercolour, 7⅛ins. x 11⅞ins.*

A sketch by Cristall, perhaps at Hastings, which shows the stylistic simplicity of which he was capable in his early years. This style then has affinities with those of Cox and Prout and derives ultimately from that of Girtin, perhaps through his friend J.S. Hayward.

(Christie's)

CRISTALL, Joshua (1767-1847)
Hop Picking. *Signed and dated 1807, watercolour, 25¼ins. x 38½ins.*

By contrast with the previous illustration this highly finished drawing from the same year shows Cristall as a master of composition and figure draughtsmanship.

(Sotheby's)

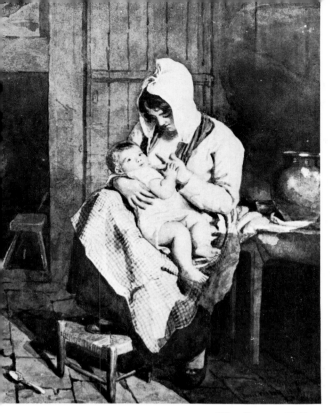

CRISTALL, Joshua (1767-1847)

The Young Mother. *Signed and dated 1808, watercolour, 13ins. x 10ins.*

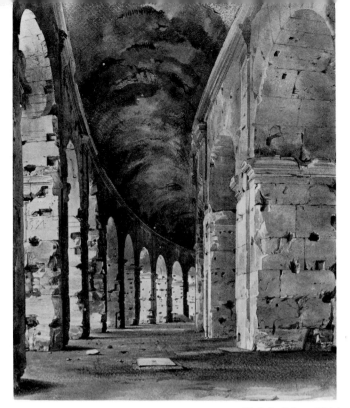

CROMEK, Thomas Hartley (1809-1873)

The Outer Colonnade of the Colosseum, Rome. *Signed and dated June 18th, 1847, watercolour, 15ins. x 11¾ins.*

CROTCH, Dr. William (1775-1847)

Westminster Abbey. *Signed with initials and inscribed and dated 1809, pencil and watercolour, 3⅜ins. x 6ins.*

Crotch's drawings owe much to his Oxford friend Malchair, with much grey pencil or wash underdrawing and light colours. He was a copious writer of inscriptions.

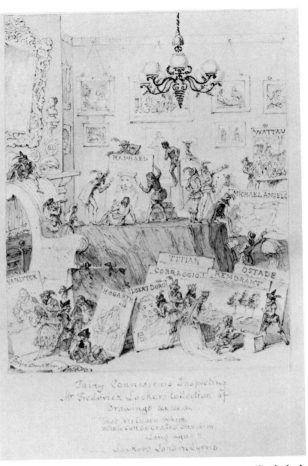

CROUCH, William *(Beryl Kendall)*
Rome. *Watercolour, 4ins. x 5ins.*

CRUIKSHANK, George (1792-1878)
Fairy Connoisseurs Inspecting Mr Frederick Locker's Collection of Drawings. *Signed and inscribed, watercolour, 7ins. x 5ins.*

(Sotheby's)

(Sotheby's)

CRUICKSHANK, William
Bird's Nest with Eggs and an Apple Bough. *Signed, watercolour on ivory, 3ins. x 4½ins.*
Cruickshank painted exactly the same subjects in exactly the same style on paper.

CRUIKSHANK, Isaac (1756-1811)

A Vestry Dinner. *Pen and black ink and watercolour, 7ins. x 9½ins.*

Cruikshank's drawing is not nearly as accomplished as that of Rowlandson, although his works have sometimes acquired fake Rowlandson signatures. On the whole his line is smoother and much weaker and he made much use of blues, greys and reds. His women are often weak.

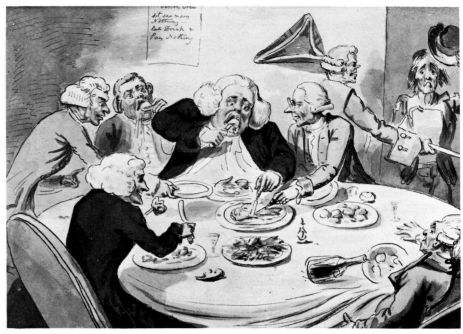

(Christie's)

(Dr. C.R. Beetles)

CUIT, George (1743-1818)

Richmond Castle, Yorkshire. *Twice signed, inscribed and dated 1788, bodycolour, 17¼ins. x 21⅛ins.*

A very typical work and subject for the artist whose style is attractive but generally naïve in detail.

DADD, Richard (1817-1886)

Sketch to illustrate the Passions — Suspense or Expectation. *Signed, inscribed and dated June 2nd 1855, watercolour, 14½ins. x 10¼ins.*

The oddities of Dadd's subject matter are well known, his style too has its idiosyncracies. Owing to his enforced isolation it remains the product of the 1830s with soft, clear cold colours verging on the monochrome in his later years. He has a pointillist method of painting the sea and sometimes works with the precision of a miniaturist.

(Sotheby's)

DADE, Ernest
Evening Light off Whitby. *Signed and dated '90, watercolour, 18ins. x 24ins.*

(Bourne Gallery)

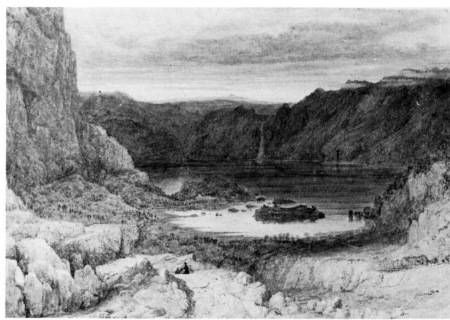

DANBY, Francis (1793-1861)
View of a Mountain Lake with a Waterfall. *Signed, watercolour, 7½ins. x 10⅜ins.*

Danby was one of the leading and most interesting members of the Bristol school. He not only painted landscapes and marine subjects but also visionary masterpieces in the manner of Martin. His watercolours are often badly faded. He uses a neat block capital signature.

(Private Collection)

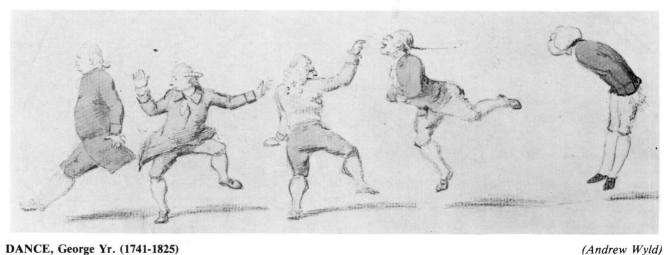

DANCE, George Yr. (1741-1825)

(Andrew Wyld)

Dancing Men. *Pencil and watercolour.*

Dance made his living as an architect and painter of small portraits in chalk or watercolour in the manner of Downman. He was also an elegant caricaturist and produced a number of these punning references to his own name.

DANIELL, Samuel (1775-1811)
Study of South African Tribesman. *Pencil and wash, measurements unknown.*

An excellent example of Daniell's simplicity and power as a sketcher.

(Christie's)

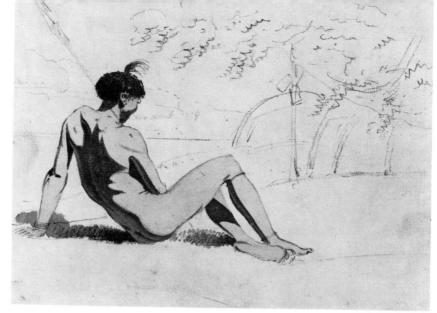

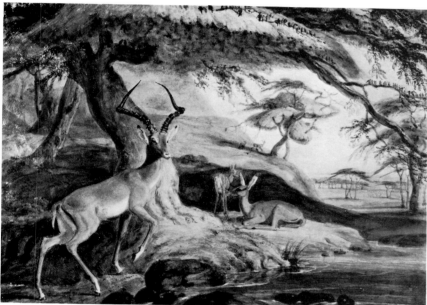

DANIELL, Samuel (1775-1811)
Pallah Deer in an African Landscape. *Pencil and watercolour, 13ins. x 18ins.*

Daniell was the most considerable artist of his family and he broke away from the tinted topographical traditions of his Uncle Thomas and his brother William. In both his finished watercolours and his pencil sketches his draughtsmanship is excellent. At times his colouring is a little sombre, doubtless as a result of his subject matter. He sometimes uses a form of the split-brush technique.

(Christie's)

DANIELL, Thomas (1749-1840)
View of the Temple at Permador. *Inscribed on reverse 'Hindoo Temple at Permador, April 11th 1792', pencil, grey and pink washes, 14¾ins. x 21¾ins.*

The pencil and wash drawings which Daniell made on the spot in India were sometimes worked up into full watercolours, but more often used as memoranda for later studio work and for prints.

(Christie's)

DANIELL, William (1769-1837)

Entrance to the Harbour of Loch Ranza, Arran. *Inscribed and dated June 24 1811 verso, pen and grey ink and watercolour, 5¾ins. x 8½ins.*

Daniell's technique did not alter greatly throughout his career, it consisted of laying on a ground of grey wash with colours and highlights superimposed. His washes are usually rather flat as is to be expected since many of the drawings were made for aquatinting.

(Martyn Gregory)

DAVISON, William

Fishing Port. *Signed and dated 1833, watercolour, 6½ins. x 9⅝ins.*

(Agnew)

DAY, William (1764-1807)

The Cotton Works and Bridge at Cromford, Derbyshire. *Signed and dated 1789, pen and ink, watercolour, 13¾ins. x 18¾ins.*

Even in this technically fairly conventional eighteenth century topographical watercolour Day's passion for geology is very evident.

(Sotheby's)

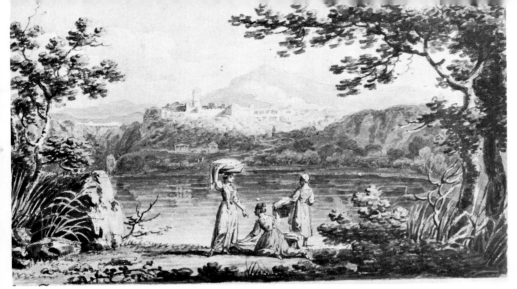

(Private Collection)

DAYES, Edward (1763-1804)

Lake Nemi. *Signed and dated 1791, pen and grey ink and watercolour, 3⅜ins. x 5⅝ins.*

Dayes worked primarily in blues, greys and browns. He had a mannerism of drawing loopy branches and foliage and there is a horizontal feeling to much of his work. His classically composed landscapes of this sort were closely imitated by the young Turner and Girtin, as was his topographical work and it is often difficult to tell which is the true author of a work. He also produced larger and more colourful watercolours of elegant London society.

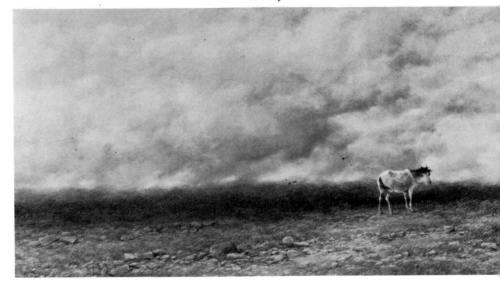

DEAKIN, Peter

Out in the Wind. *Signed, watercolour, 15½ins. x 27½ins.*

A sketching companion, friend and executor of Cox, Deakin naturally worked in the windy manner of the master.

(E. Thomson)

DEANE, William Wood (1825-1873)

A Pergola at Capri. *Inscribed, pen and ink and watercolour, 9⅛ins. x 12½ins.*

Deane's early work is that of an architectural draughtsman. From about 1856, however, he widened his scope to become an accomplished painter in a free and atmospheric manner, which has been compared to that of Holland and even Turner.

(Private Collection)

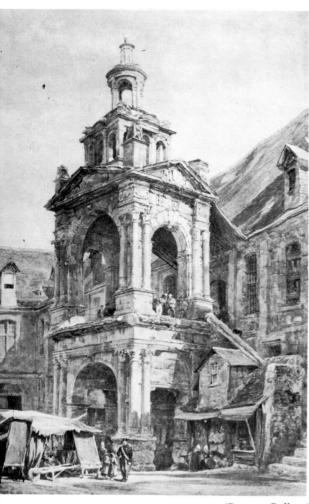

(Bourne Gallery)

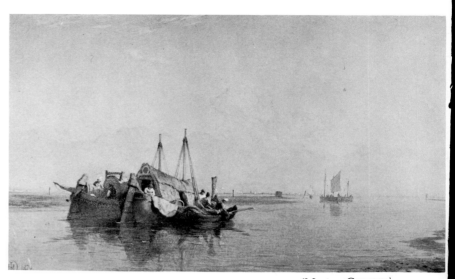

(Martyn Gregory)

D'EGVILLE, James T. Hervé (c.1806-1880)

On the Venetian Lagoon. *Signed with a monogram and dated 1870, watercolour, 12ins. x 20½ins.*

DEANE, William Wood (1825-1873)

The Monument of St Romain, Rouen. *Signed, watercolour, 27ins. x 18ins.*

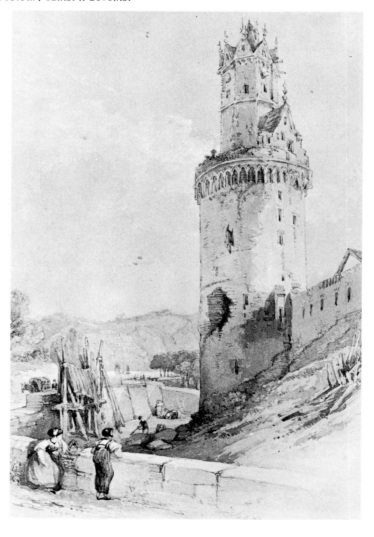

DELAMOTTE, William Alfred (1775-1863)

A Tower near the Rhine. *Signed, pencil and watercolour, 14½ins. x 9½ins.*

Despite the length of his career Delamotte's style altered very little. He was very much a drawing master, making careful outlines in soft pencil or pen and adding thin, even washes of colour. His drawings have the air of being done for the lithographer, even when this was not the case.

(Private Collection)

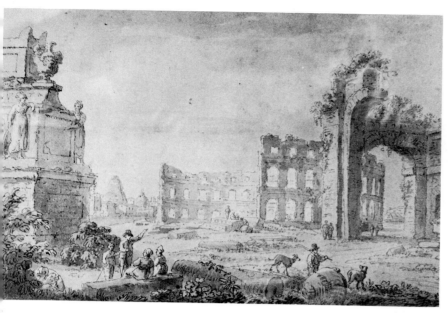

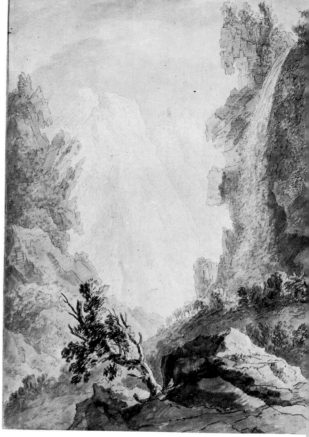

DEVIS, Anthony (1729-1817)

Classical Ruins. *Pen and grey ink and wash, 8¾ins. x 12¼ins.*

Devis's characteristic banana bunch foliage is visible in the left foreground of this drawing. His Italianate drawings for the most part date from the middle of his career. The skimpy legs of the dog in the right centre of the composition are reminiscent of the stick-like convention which he used for sheep in his English drawings.

DE TABLEY, Sir John Fleming Leicester, Bt., 1st Lord (1762-1827)

Alpine Waterfall. *Signed and dated 1787 on the reverse, pen and brown ink, brown and grey wash, 20½ins. x 14½ins.*

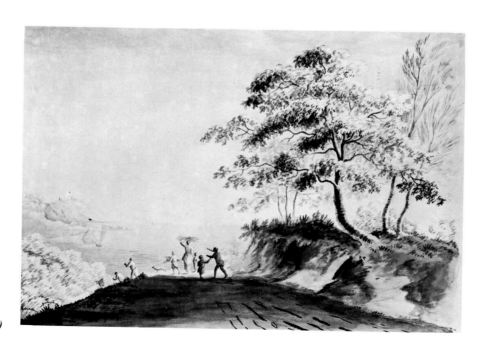

DEVIS, Anthony (1729-1817)

Distant View of Dover. *Pen and grey ink and grey wash, 14½ins. x 20½ins.*

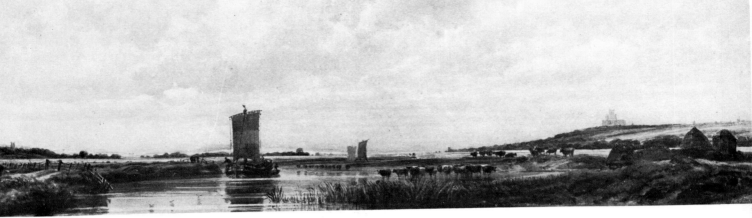

DE WINT, Peter (1784-1849)

Distant View of Lincoln. *Watercolour, 10⅝ins. x 34¼ins.*

Although this is an unusually finished and detailed work by the artist, De Wint's style is much the same here as in his more impressionist watercolours. It is mainly a question of building up masses and tones by superimposing layers of colour. In his earliest work, however, he produced brown wash drawings which are very similar to those of Cox and Cotman, and later there is a kinship to Norwich artists such as Thirtle. He often uses a broad, shallow panorama or a St. Andrew's cross composition.

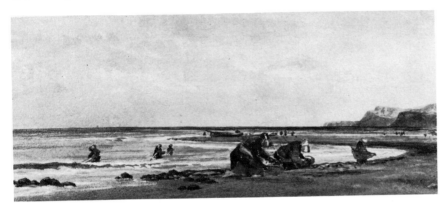

DE WINT, Peter (1784-1849)

Shrimpers on the Shore. *Watercolour, 5¾ins. x 12¼ins.*

(Christie's)

DIBDIN, Thomas Richard Colman (1810-1893)

Bayswater. *Signed with initials, watercolour, 4½ins. x 6ins.*

This very free watercolour dates from 1831, the year in which Dibdin became a professional artist. Both its style and the cool colours may indicate a few lessons from Linnell who lived at Bayswater. At this time Dibdin also painted in a rather eighteenth century manner.

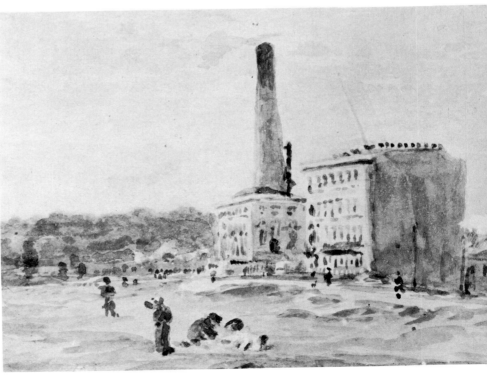

(Private Collection)

(Christie's, South Kensington)

DIBDIN, Thomas Richard Colman (1810-1893)

Arras. *Signed, inscribed and dated 1872, water-colour, 21ins. x 30ins.*

Dibdin is usually thought of as a high Victorian painter of Continental towns in a spirit similar to that of Prout in his later years. In this later work he is fond of a rather busy hatching and outlining for stone and buildings and of touches of white heightening.

DIGHTON, Phoebe, Mrs. Denis

Still Life with Fruit, Glass Goblet, Butterfly and Snail. *Signed, watercolour, 18½ins. x 22¾ins.*

See under Dighton, Denis, in Volume One.

(Sotheby's)

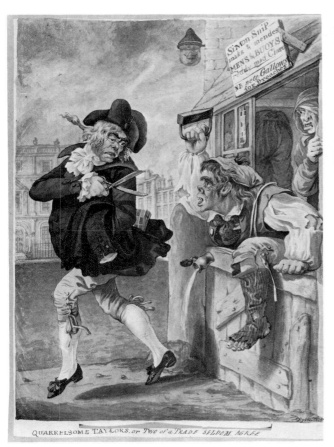

DIGHTON, Robert (1752-1814)

Quarrelsome Taylors or Two of a Trade Seldom Agree. *Signed and inscribed, watercolour, 13¾ins. x 10ins.*

(Sotheby's)

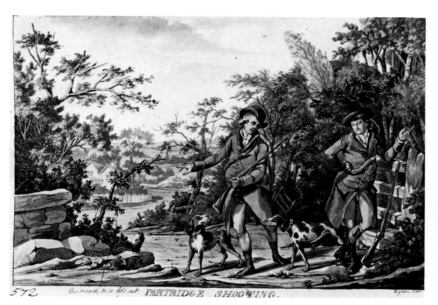

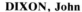

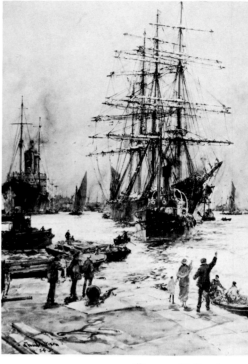

DIGHTON, Robert (1752-1814)

Partridge Shooting. *Signed, inscribed and numbered 572, pen and ink and watercolour, 10½ins. x 14½ins.*

A hallmark of Dighton's style is his way of applying his washes in sharply defined planes. He used much grey undertinting.

DIXON, Charles Edward (1872-1934)

Below the Pool. *Signed and dated '34, watercolour, 30ins. x 22ins.*

Dixon's style is a mixture of freedom and technical accuracy. Much of his work was inspired by the Pool of London and the Thames estuary but he also painted historical marine subjects.

DIXON, John

The Quadrangle of New College from the South West Corner. *Pen and grey ink and grey wash (1793 Almanack), 11⅜ins. x 17⅜ins.*

Dixon worked as clerk and draughtsman to the architect James Wyatt between about 1772 and 1794 and this experience is very evident in his watercolours. See under Dixon, J., in Volume One.

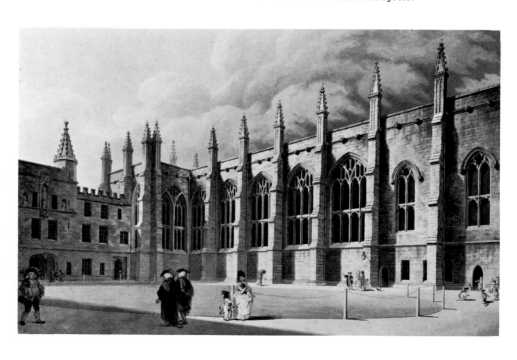

DOBBIN, John (1815-1888)
Notre Dame, Antwerp. *Signed and dated 1853, watercolour heightened with white, 21¾ins. x 16ins.*

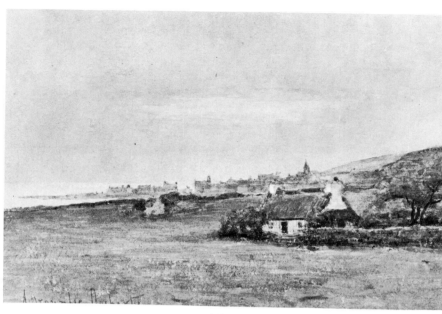

DOCHARTY, Alexander Brownlie (1862-1940)
East Coast Town. *Signed, watercolour, 4⅞ins. x 7¼ins.*

DODD, Charles Tattershall (1815-1878)

Old London Bridge. *Signed and dated 1844, watercolour, 20½ins. x 30ins.*

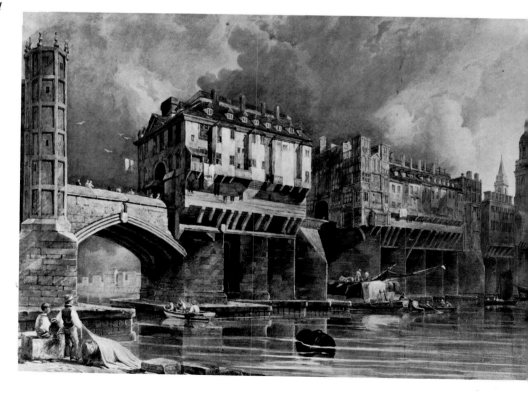

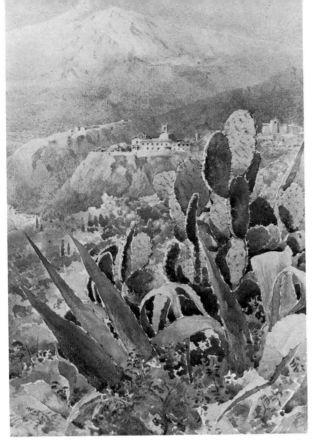

DONNE, Colonel Benjamin Donisthorpe Allsop (1856-1907)

Etna from Taormina. *Inscribed on the reverse, watercolour, 13¼ins. x 8½ins.*

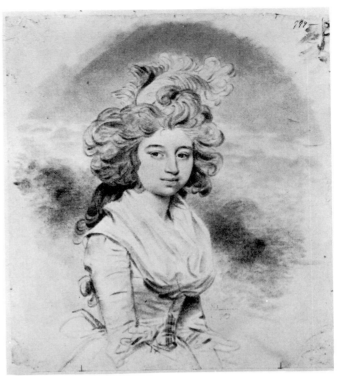

DOWNMAN, John (1750-1824)

Portrait of Penelope Welby aged 19. *Signed and dated 1789, pencil and watercolour, 8ins. x 6½ins.*

Downman was one of the most delicate of the late eighteenth century portraitists. His colours are usually lightly applied over black chalk or charcoal, but sometimes for an added effect of softness they will be found on the back of the paper. He often wrote comments on his sitters underneath his characteristic oval mounts. His landscape drawings are on the spot sketches from his tours of Italy between 1773 and 1775, and the Lake District in 1812. In these his pen line is rather fussy and his colours light.

DOUGLAS, Sir William Fettes (1822-1891)

Lundin Tower. *Signed with initials and dated 1885, watercolour, 7ins. x 10½ins.*

Douglas began as a Pre-Raphaelite subject and landscape painter, but later in his career concentrated on small watercolour landscapes such as this, which are akin to those of the followers of Cox.

DOYLE, Richard (1824-1883)
When the Moon is High.
Watercolour, 8¼ins. x 13ins.

(Sotheby's Belgravia)

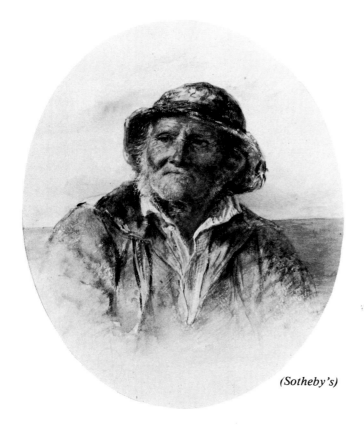

(Sotheby's)

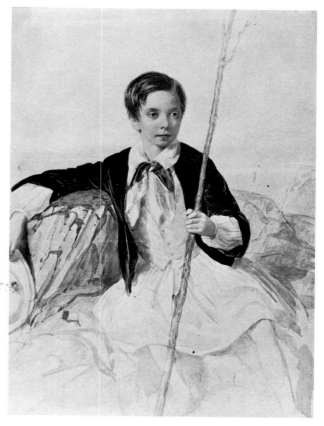

(Beryl Kendall)

DRUMMOND, James (1816-1877)
A Portrait of a Fisherman. *Signed and numbered 169, watercolour, oval 12ins. x 9½ins.*

Apart from his portraits of fishermen and peasants, which are loosely handled, Drummond painted large historical works with a great attention to detail.

DRUMMOND, William
Portrait of a Young Boy. *Watercolour, 17¾ins. x 14ins.*

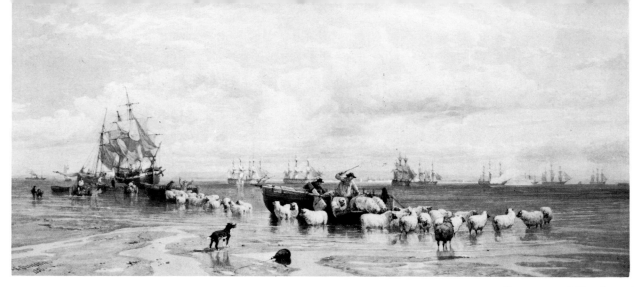

DUNCAN, Edward (1803-1882)
Landing Sheep on Ryde Sands, Isle of Wight. *Signed and dated 1856, watercolour, 18ins. x 36ins.*
This is possibly the artist's masterwork.

DUNCAN, Edward (1803-1882)
The Shore at Port Madoc, North Wales. *Signed, inscribed and dated 1862, and with artist's stamp (L84Z), watercolour, 13½ins. x 19¼ins.*

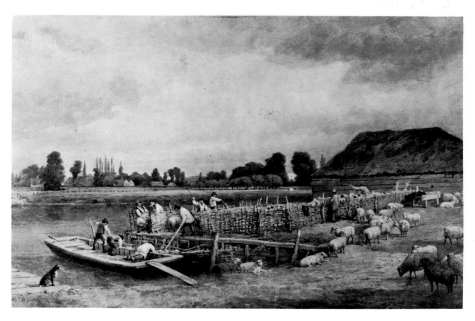

DUNCAN, Edward (1803-1882)
Sheep Washing near Moulsford. *Signed and dated 1879, with the studio stamp (L84Z), pencil and watercolour heightened with white, 13¼ins. x 19¾ins.*

**DUNTHORNE, James, Yr.
(c.1758-c.1793)**

A Musical Entertainment. *Pencil, pen and grey ink and watercolour, 12⅝ins. x 19⅜ins.*

The 'Colchester Hogarth' was more perhaps a 'Colchester Nixon'.

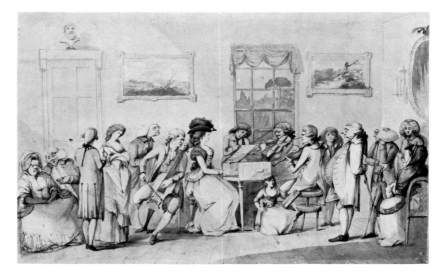

(Christie's)

(Ashmolean Museum)

DYCE, William (1806-1864)

Mountainous Landscape on the Isle of Arran. *Pencil and watercolour, 8⅝ins. x 13¾ins.*

In the freedom of drawing and brightness of colour Dyce's watercolour landscape sketches are very close to those of Landseer. He also enjoyed sketching old buildings.

EAGLES, Rev. John (1783-1855)

L'Orage. *Signed, watercolour, 11¼ins. x 16ins.*

(Christie's)

369

EARP, Henry (1831-1914)
Wells Cathedral. *Signed, watercolour, 25ins. x 38ins.*

(Bourne Gallery)

(Bourne Gallery)

EARLE, Charles (1832-1893)
A Rustic Bridge. *Signed, watercolour, 17ins. x 12ins.*

Despite his sometimes rather violent colouring, Earle had enough in common with Birket Foster both in subject matter and his somewhat pointillist technique for one to suspect that his works may have occasionally acquired the Foster monogram.

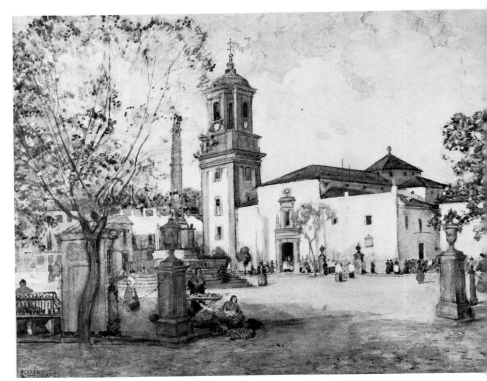

EAST, Sir Alfred (1849-1913)
Algeciras. *Signed, watercolour, 22ins. x 28ins.*

(Kettering Borough Council)

EDRIDGE, Henry (1769-1821)
Bushey Mill. *Watercolour, 10¼ins. x 14ins.*
The beginnings of the knotty, Prout-like drawing of Edridge's late Gothic works can be seen here.

(Sotheby's)

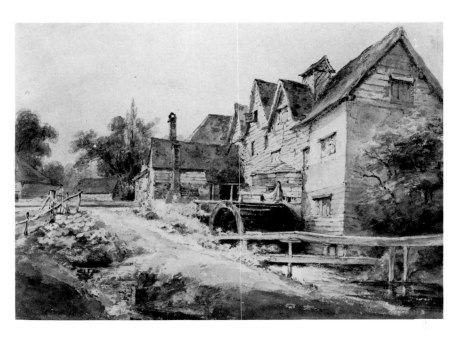

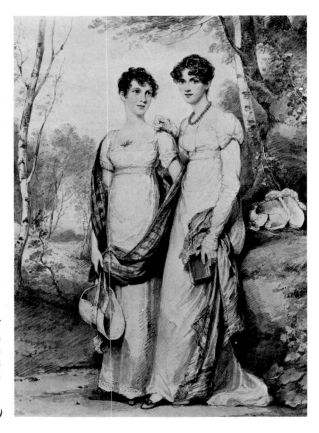

(Martyn Gregory)

EDRIDGE, Henry (1769-1821)
On the Outskirts of a Village, probably in North East France. *Signed and dated 31 Mai 1811, pencil, pen and ink and watercolour, 9½ins. x 15ins.*

EDRIDGE, Henry (1769-1821)
Mary and Elizabeth Constable Ashburner, Daughters of William Ashburner, standing in a landscape. *Signed and dated 1812, watercolour, 13¾ins. x 10ins.*
The period from about 1790 to about 1820 was the great age of the small full-length watercolour portrait. Among its practitioners Edridge ranks very highly, although it should be noted that his strength is usually in the pencil underdrawing rather than in his thin and flat colour washes. In this he is very different from his fellow master, John Jackson.

(Leger Galleries Ltd.)

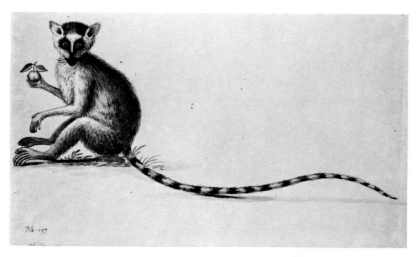

EDWARDS, George (1694-1773)
A Ring Tailed Macauco. *Inscribed, watercolour, 12ins. x 9ins.*

(Dudley Snelgrove Esq.)

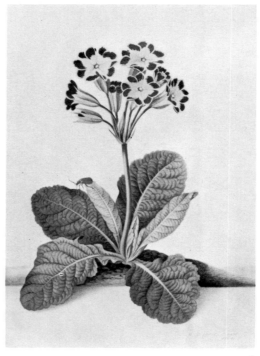

(Christie's)
EHRET, Georg Dionysius (1708-1770)
A Polyanthus, with a Beetle on one of the Leaves. *Signed and dated 1764, watercolour and body-colour on vellum, 9ins. x 6¼ins.*

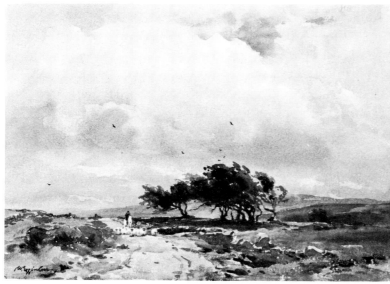

(Private Collection)

EGGINTON, Wycliffe (1875-1951)
Sheep Crossing a Moor. *Signed, watercolour, 10½ins. x 14⅝ins.*
A typical wet technique drawing of the later followers of Cox and de Wint.

ELLIS, Edwin John (1841-1895)
Towing Wreckage off the Yorkshire Coast. *Signed, watercolour, 15ins. x 29ins.*

(Stephen Furniss)

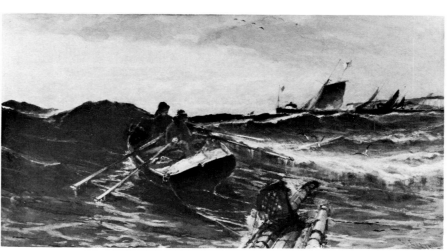

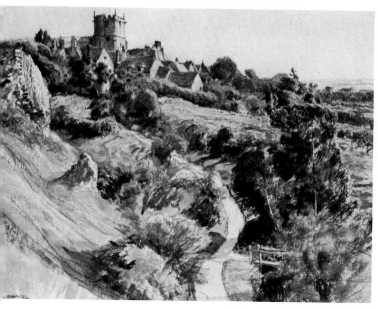

(Private Collection)

EMANUEL, Frank Lewis (1865-1948)
A Cotswold Village. *Signed, watercolour, 6ins. x 8ins.*
A painter in the De Wint tradition who also produced sea pieces which can be reminiscent of those of Henry Moore.

EVANS, William of Bristol (1809-1858)
View of Snowdon. *Signed and dated 1843, watercolour, 9ins. x 12½ins.*
Evans was a great technician, soaking, pumping, scraping, scratching his paper and using its texture to offset his rich colours. He was not a prolific painter.

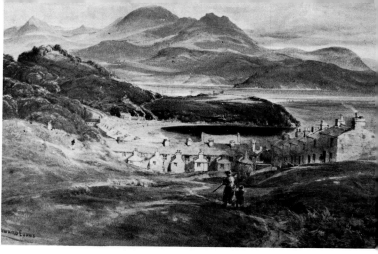

EVANS, Bernard Walter (1848-1922)
A Fishing Village in North Wales. *Signed, watercolour, 14ins. x 21ins.*
Evans was a traditional landscape painter working in a manner more typical of the first half of the nineteenth century than his own time.

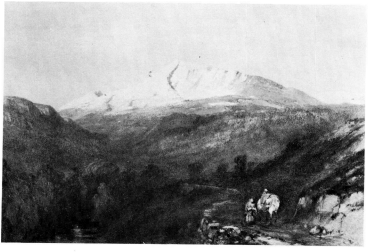

(City Art Gallery, Bristol)

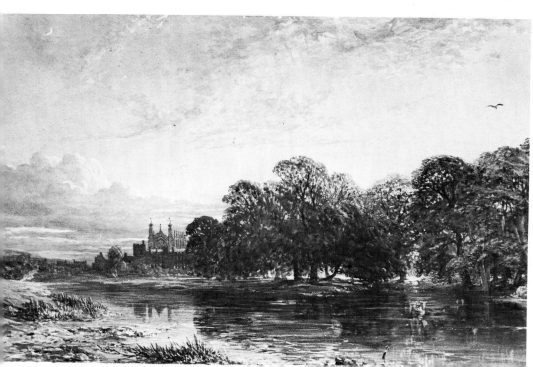

EVANS, William, of Eton (1798-1877)
Eton College from Fellows Eyot. *Watercolour, 18½ins. x 27ins.*

(Private Collection)

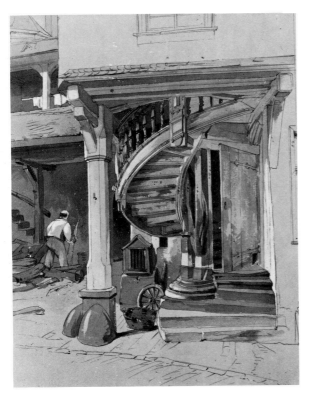

EVERITT, Allen Edward (1824-1882)
A Wooden Stairway at Bacharach. *Pencil and water-colour heightened with white, 13⅞ins. x 10½ins.*

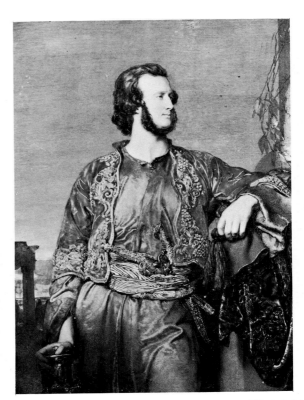

FAED, John (1819-1902)
Portrait of a Gentleman in Greek Costume. *Watercolour on ivory, 13½ins. x 9⅞ins.*
Faed moved from painting miniatures to larger portraits and genre scenes in the manner of Wilkie. His wash drawings are especially Wilkie-like.

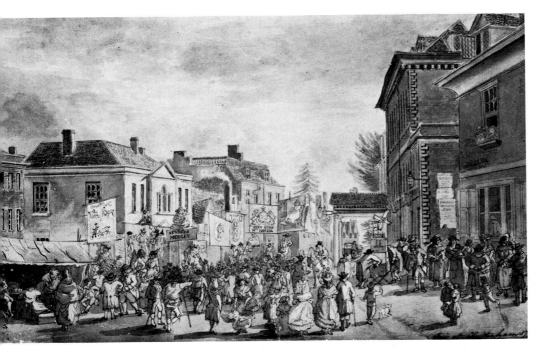

EYRE, Edward
A Fair at Cheltenham. *Signed and dated 1791, inscribed and dated 1775, watercolour, 9¼ins. x 14½ins.*

Although this example is signed in full on one of the posters, Eyre often used a monogram which can easily be confused with that of Edward Edwards.

(Spink & Son Ltd.)

FARINGTON, Joseph (1747-1821)

A Mill Pond with Cottages Beyond. *Pen and ink and grey wash, 12¾ins. x 16¾ins.*

Farington's style remained rooted in that of his master Wilson throughout his long career, and his later work has a distinctly old-fashioned air. His finished topographical work is carefully outlined in pen and black or brown ink, and washed over in grey, brown or blue wash. There is usually light pencil underdrawing. The pencil work tends to be fussy. His sketches and memoranda are often more dashing.

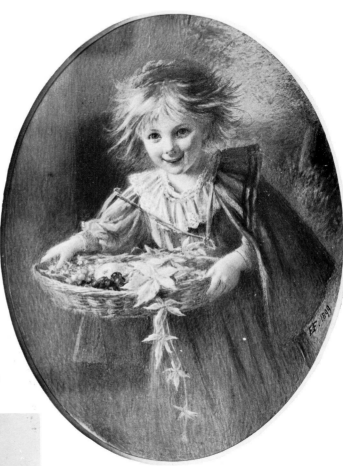

FARMER, Emily (1826-1905)

A Basketful. *Signed with initials and dated 1899, watercolour, 16ins. x 12ins.*

A genre painter who continued and debased the tradition of William Henry Hunt, whose technique of small hatching she employed.

(Bourne Gallery)

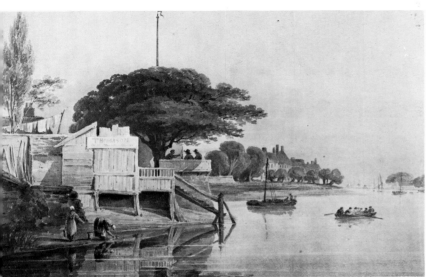

FARNBOROUGH, Amelia, Lady (1762-1837)

A Boathouse beside the Thames. *Signed and dated 1810 on reverse, watercolour, 10¾ins. x 17ins.*

Lady Farnborough was an eclectic amateur: she was the favourite pupil of Girtin and also worked in the manners of Varley, as here, and Doctor Munro. Many of her subjects are taken from North Kent.

(Christie's)

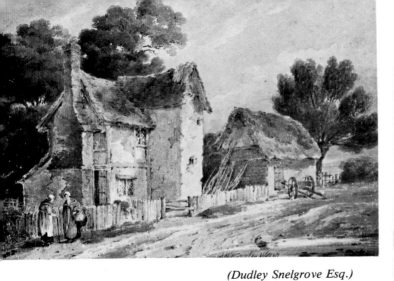

FARNBOROUGH, Amelia, Lady (1762-1837)
Farmstead and figures. *Watercolour, 9¾ins. x 14½ins.*

FIELD, Walter (1837-1901)
A Marshy Moorland Scene. *Signed and dated 1878, watercolour, 9¾ins. x 13¾ins.*

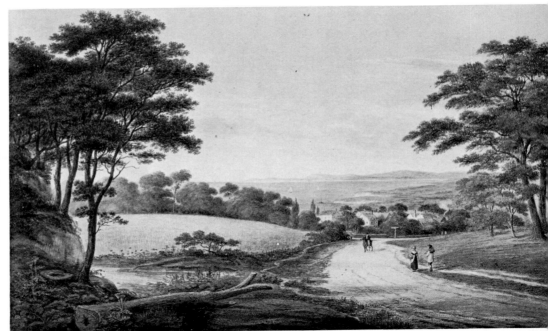

FIELD, John (1771-1841)
The Kentish Coast. *Watercolour, 6¾ins. x 11ins.*

FIELDING, Anthony Vandyke Copley (1787-1855)
The Junction of the Wye and the Severn. *Signed and dated 1817, watercolour, 6ins. x 8⅜ins.*
Fielding's earlier work is less to a formula than his later, although traces of his later manner of foliage drawing can be seen in this example. His characteristic signature at this time was C.V. Fielding.

FIELDING, Newton Smith Limbird (1799-1856)

Barnyard Fowl. *Watercolour, 9½ins. x 13ins.*

Fowl and small animals were Fielding's forte. In general his drawing of them is accurate, although the backgrounds are sketchy and impressionistic. He also enjoys dabs of bright colour as on the wattles of cockerel.

FIELDING, Anthony Vandyke Copley (1787-1855)

The Isle of Wight from Bow Hill. *Signed and dated 1842, watercolour, 10½ins. x 15¼ins.*

A fine example of the mature Fielding showing his excellent feeling for space and distance. The drawing of the trees and the track winding away from the viewpoint of the artist are typical of his formula. There is often evidence of dry brush dragging in his foregrounds and middle distance.

FIELDING, Theodore Henry Adolphus (1781-1851)

Haweswater near Mardale, in Westmoreland. *Signed and dated 1833, watercolour, 11½ins. x 14½ins.*

FIELDING, Thales (1793-1837)

Early Morning near the South Coast. *Signed and dated 1837, watercolour, 9ins. x 12ins.*

Many of Fielding's most typical English and Welsh landscapes feature groups of cattle as here. He also produced figure studies of gypsies, fishermen and so on and occasionally attempted classical or literary themes.

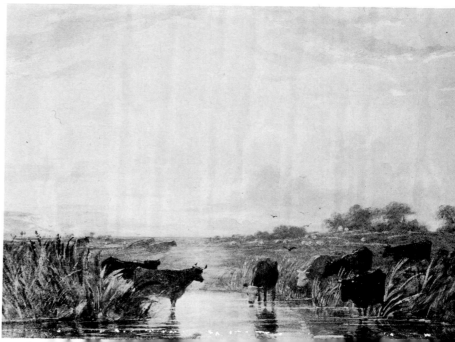

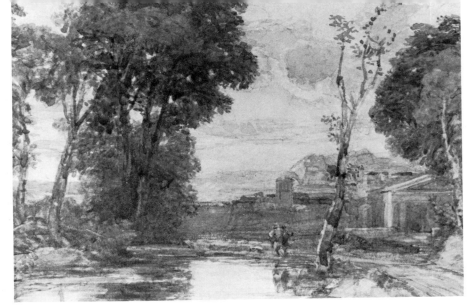

FINCH, Francis Oliver (1802-1862)

A Classical Capriccio. *Pencil and watercolour, 5ins. x 6½ins.*

Finch was a poetic landscapist who continued the quiet romantic school typified by the younger Baret and Christall. After a stroke in 1857 he was limited to making pencil copies of his earlier works.

(Private Collection)

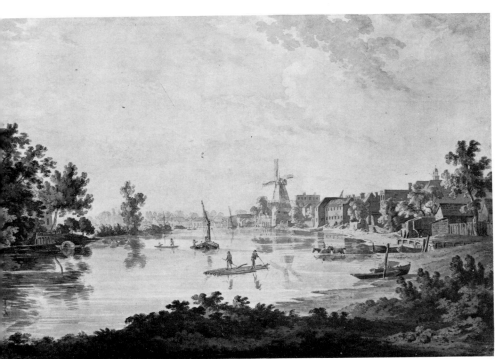

FISHER, Sir George Bulteel (1764-1834)

A View on the Thames at Brentford. *Pen and grey ink and watercolour, 13½ins. x 19¾ins.*

(Andrew Wyld)

FISHER, John, Bishop of Salisbury (1748-1825)

Barnard Castle, Durham. *Pen and grey ink and grey wash, 9½ins. x 13¾ins.*

Despite his well-known friendship for and patronage of Constable, the Bishop's own style was resolutely of the eighteenth century. He had a particular dislike of stormy skies.

(Dudley Snelgrove Esq.)

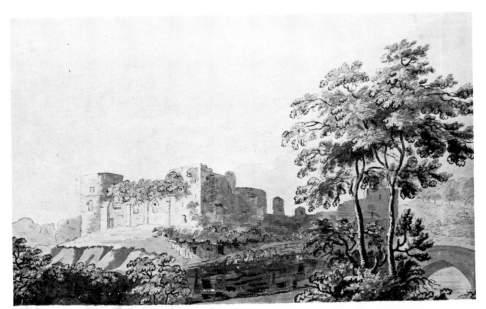

378

FISHER, Thomas (1782-1836)
Old Front of Luton Hoo, Bedfordshire. *Inscribed, watercolour, 11¼ins. x 17¼ins.*

(Christie's)

FORREST, Thomas Theodosius (1728-1784)
The Back of a Flour Mill. *Pen and grey ink and watercolour, 12ins. x 18¾ins.*

(Dudley Snelgrove Esq.)

FOSTER, Myles Birket (1825-1899)
Children Angling in a Punt on the Thames. *Signed with monogram, watercolour heightened with white, 14ins. x 24ins.*

(Christie's)

FOSTER, Myles Birket (1825-1899)
A Sussex Scene. *Signed with mono-gram, watercolour, 5ins. x 8ins.*

(Bourne Gallery)

FRANCIA, Louis Thomas (1772-1839)

Dawn; an open river landscape with distant spire. *Signed and dated 1825, water and bodycolour, 4½ins. x 9¼ins.*

Despite its comparatively late date this shows Francia, who was an eclectic stylist, at his most Girtinesque.

(Martyn Gregory)

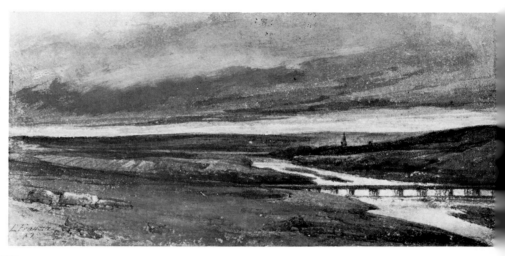

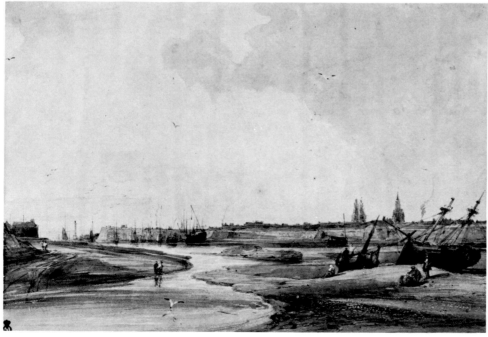

FRANCIA, Louis Thomas (1772-1839)

The Harbour at Calais — Low Tide. *Signed, watercolour, 8¼ins. x 11¾ins.*

Here Francia is in the mood which either influenced the young Bonington, or was in-fluenced by him.

(Christie's)

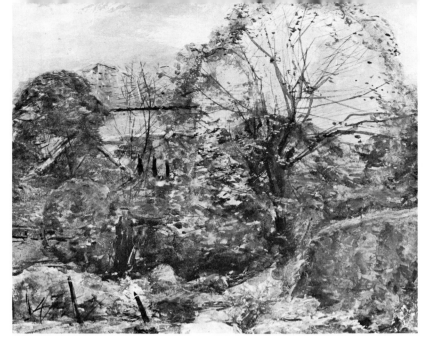

FRASER, Alexander (1828-1899)

November's Workmanship — Fine as May.
Watercolour, 9½ins. x 10¾ins.

A painter of landscapes, still-lifes and interiors whose work became progressively less detailed and more impressionistic.

(National Galleries of Scotland)

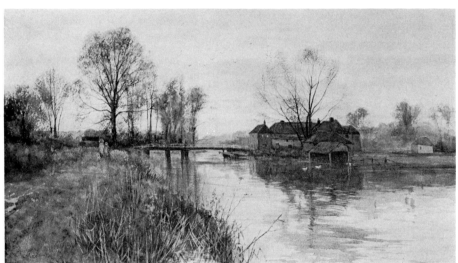

FRASER, Robert Winter

Bedfordshire Mill. *Signed and dated '86, watercolour, 10½ins. x 18ins.*

Much of Fraser's work is harsher than this example and more like that of his brother W.G. Fraser. See under Fraser, William Gardener in Volume One.

(Mr. and Mrs. S. Pocklington)

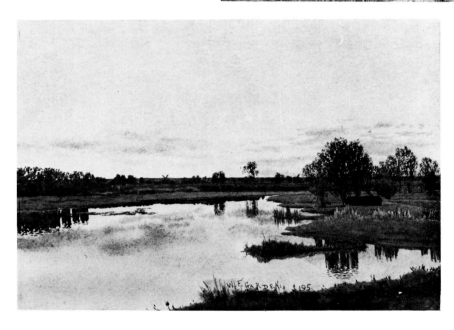

FRASER, William Gardener

View from the Inn, Holywell. *Signed 'W.F. Garden' and dated 1895, watercolour, 5½ins. x 7¾ins.*

(Martyn Gregory)

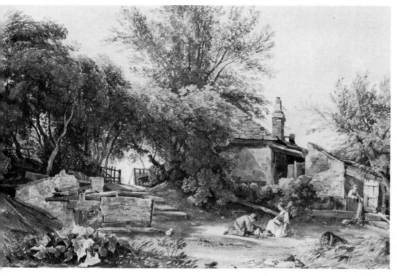

(Sotheby's)

FRIPP, George Arthur (1813-1896)
A Kentish Homestead. *Signed and dated 1842, watercolour, 14ins. x 20½ins.*
A work from Fripp's early Old Watercolour Society period, in which he worked in a manner derived from that of Cox.

FRIPP, Alfred Downing (1822-1895)
Clanmacnoise, Ireland, 1846. *Signed, inscribed and dated, watercolour, 9½ins. x 14ins.*

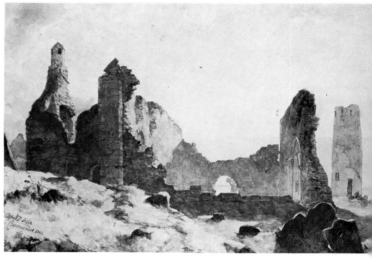

(Dudley Snelgrove Esq.)

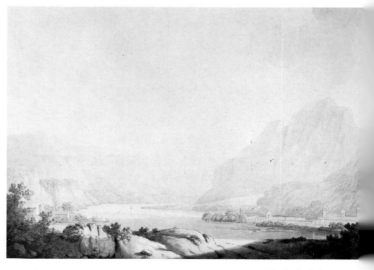

(Phillips)

Above:
FRIPP, George Arthur (1813-1896)
View of West Coast of the Island of Sark. *Signed and dated 1884, pencil and watercolour heightened with white, 23¼ins. x 37⅜ins.*
Fripp worked in many styles beginning with landscapes in the manner of Cox, passing through a Pre-Raphaelite period and at the end of his life employing a rather old-fashioned manner with greens and yellows over careful pencil drawing.

Below:
FREEBAIRN, Robert (1765-1808)
Part of Innsbruck on the River Inn, Tirol. *Pen and brown ink, brown wash, 13¾ins. x 19½ins.*
Both Freebairn's status as a pupil of Wilson, and the influences of his journey to Italy between 1782 and 1792, are evident in this drawing. The style is a slightly weaker varient of that of Warwick Smith, with careful outlines and subdued washes.

(Sotheby's)

FROST, George (1734-1821)

Harrow on the Hill. *Signed with initials, inscribed and dated 1810, watercolour, 10¼ins. x 13⅝ins.*

A rare example of Frost's work in watercolour; especially rare in that it is not an East Anglian subject. He is best known for his black chalk and grey wash drawings in imitation of Gainsborough. In his watercolours he often uses a characteristic purplish red.

(Private Collection)

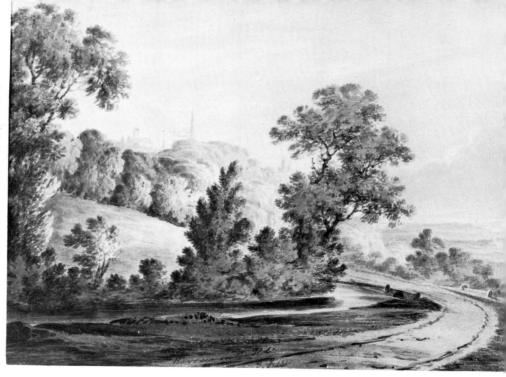

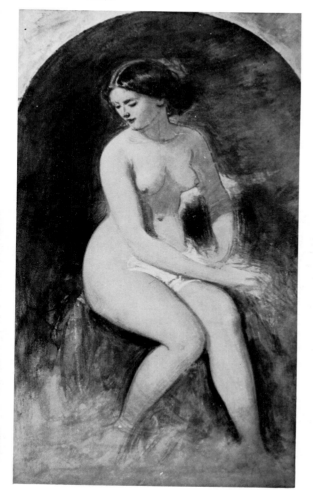

(Bourne Gallery)

FROST, William Edward (1810-1877)

Study of a Nude. *Watercolour heightened with white, 7ins. x 4ins.*

Frost's ladies are virtually all the same with long sensuous reddish brown outlines drawn with the pen or brush, glowing pink complexions and discreetly placed draperies. In this he inherited the mantle, as it were, of William Etty. Before the 1840s he also painted portraits.

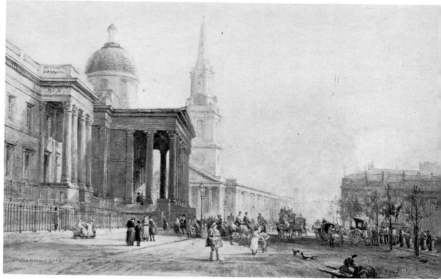

(Sotheby's)

FULLEYLOVE, John (1847-1908)

The National Gallery. *Signed and dated 1883, watercolour, 13ins. x 20ins.*

Fulleylove's style is a mixture of precision of certain details and an overall broadness of effect. He produced many excellent watercolours of the major streets of London and was also prompted to work at his best by his visits to Jerusalem and the Near East.

383

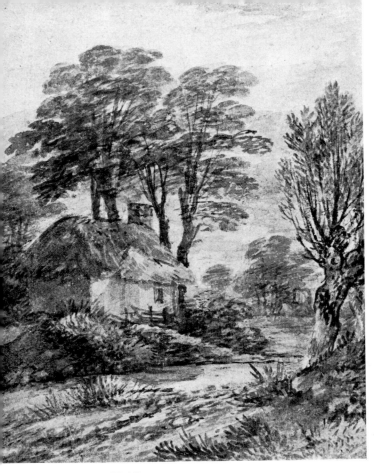

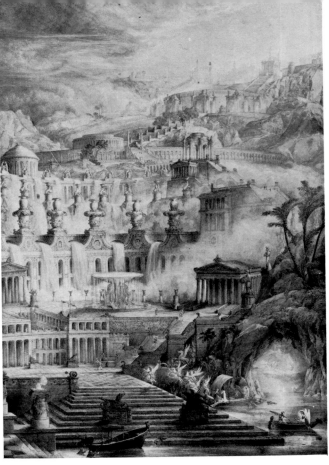

(Andrew Wyld)

(Christie's)

GAINSBOROUGH, Thomas (1727-1788)

A Cottage by a Woodland Pool. *Signed or inscribed with initials on the mount, water and bodycolour, 9¾ins. x 7⅝ins.*

Dr. Hayes dates this watercolour to the latter part of the 1760s. Colour is unusual in Gainsborough's drawings. He worked in a variety of media, including pencil, black and white chalk, and monochrome washes, often combining several of these in one work.

GANDY, Joseph Michael (1771-1843)

An Idea of the Staircase leading to the Gates of Heaven. *Watercolour, 41ins. x 27ins.*

An architect who produced mystical, neo-classicist watercolours in a similar vein to John Martin.

GANTZ, Justinian Walter (1802-1862)

View of a House near Madras. *Signed and dated 1835, watercolour, 13⅝ins. x 21¼ins.*

See under Gantz, John in Volume One.

(Leger Galleries Ltd.)

GARDNOR, Rev. John (1729-1808)

River Landscape and Farmstead. *Pen and grey ink and watercolour, 9¾ins. x 15ins.*

The excellent quality of Gardnor's drawing, which can be seen particularly in the houses on the right, is due to his having been a drawing master before taking the cloth. His later work shows less reliance on outline than the present example.

(Dudley Snelgrove Esq.)

GASTINEAU, Henry G. (1791-1876)

Landscape with a Church and a Castle. *Watercolour, 8¼ins. x 12⅛ins.*

An example of Gastineau in his quieter mood, when his style is a mixture of those of Cox and Copley Fielding. His Highland subjects often show a greater sense of drama.

(Fitzwilliam Museum, Cambridge)

GENDALL, John (1790-1865)

Sutton Pool, Plymouth. *Watercolour, size unknown.*

A topographer and landscape painter. His work can have an affinity with that of Turner who admired it, but he is sometimes rather weak and messy as a colourist. He was trained as an architectural draughtsman and here he sometimes mixed accuracy of detail with a pleasing looseness of style.

(Royal Albert Memorial Museum, Exeter)

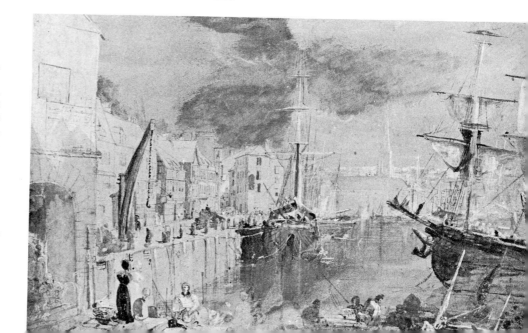

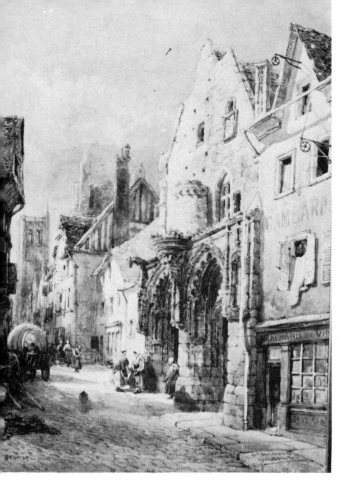

GEORGE, Sir Ernest (1839-1922)
A Street in Orleans. *Signed and inscribed, water-colour, 16ins. x 11ins.*
An architect whose watercolours are in the tradition of Prout and show a keen eye for the picturesque.

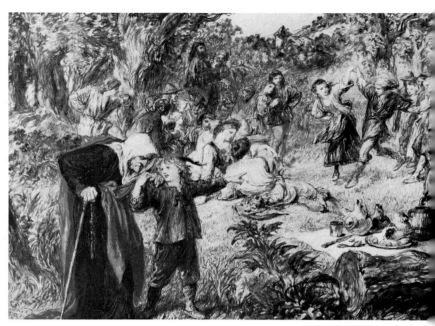

GILBERT, Sir John (1817-1897)
Under the Greenwood Tree. *Signed and dated 1861, water-colour, 5¾ins. x 7¾ins.*

GILLIES, Margaret (1803-1887)
The Annual Haymaking at Hillside, Highgate. *Signed with initials, watercolour, 5ins. x 12ins.*

This is almost certainly Gillies' masterwork. Her style might best be described as a mixture of the flat planes of colour which are typical of Lady Waterford, and the sympathetic figure drawing of John Absolon. In her early days she painted miniatures, and later larger portraits, which can be very appealing.

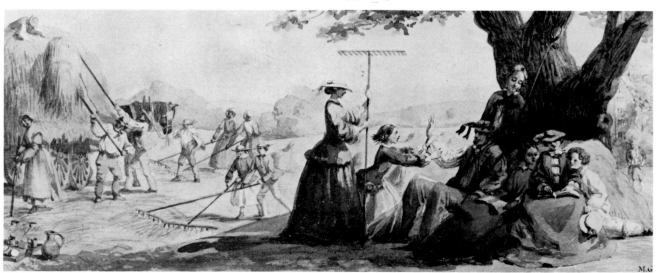

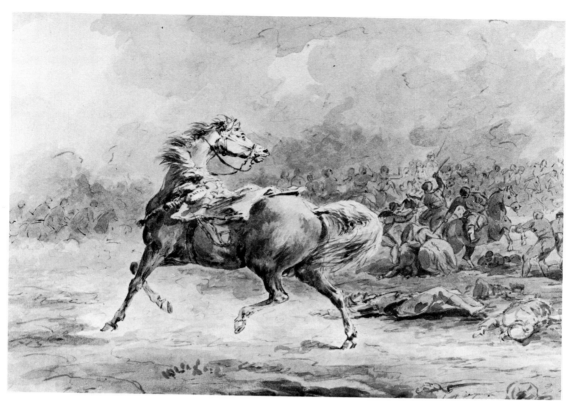

GILPIN, Sawrey (1733-1807) *(Sotheby's)*

A Riderless Horse. *Bears signature and date 1796, sepia ink and grey and sepia washes, 12¼ins. x 17¼ins.*

Gilpin's speciality was horse painting and he may have collaborated with other artists, such as his family protegé Warwick Smith. The signature on this drawing appears to be one of the fakes discussed by Williams (page 16) and shown in more detail here under Thomas Sunderland.

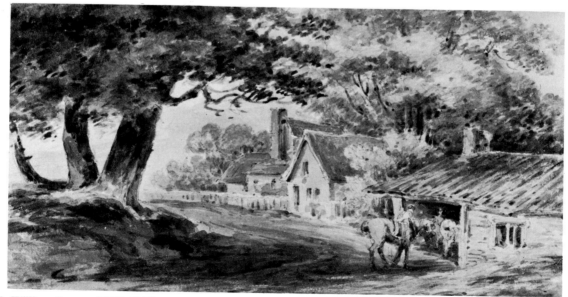

GILPIN, William Sawrey (1762-1843) *(Martyn Gregory)*

Near Oxford Turnpike. *Signed and inscribed on mount, pencil and watercolour, 4ins. x 7ins.*

An eclectic painter who worked in a number of styles at different periods of his career. At times he is close to Nicholas Pocock, at others to Humphrey Repton and later to Girtin. He was fond of rich dark greens and ochres and he often uses a stylised brown tree which could have come from a Varley drawing.

GIRTIN, Thomas (1775-1802)
The Village of Jedburgh, Roxburgh. *Signed and dated 1800, watercolour, 11⅞ins. x 20½ins.*

(Christie's)

GIRTIN, Thomas (1775-1802)
A Tumbledown Farmhouse. *Water-colour, 11¾ins. x 16¼ins.*

(Private Collection)

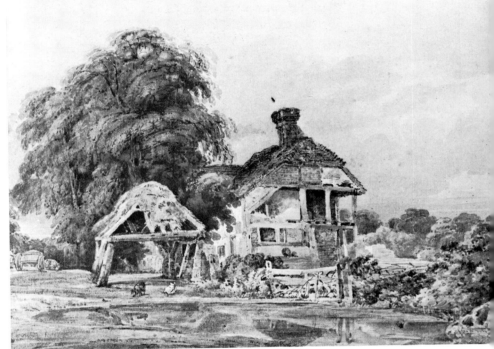

GISBORNE, Rev. Thomas (1758-1846)
Basingwerk Abbey, Flint 1789. *Water-colour, 11½ins. x 16¼ins.*

An amateur topographer who was influenced by Wright of Derby and J.'W'. Smith. He also met the Rev. W. Gilpin and may have painted in his more romantic matter.

(Derby Museum and Art Gallery)

(Martyn Gregory)

GLOVER, John (1767-1849)
On the River Conway near Bettws, North Wales.
Inscribed on old backing paper, watercolour, 7½ins. x 10ins.
Glover's characteristic split brush technique can be seen particularly in the trees on the right, and this watercolour also illustrates his habit of highlighting the water by the far bank of a river.

(Sotheby's Belgravia)

GLOAG, Isobel Lilian (1865-1917)
For there was never yet fair woman but she made mouths in a glass. *Watercolour, 14½ins. x 11¼ins.*

GLOVER, William
Hampstead. *Signed and inscribed on old mount, watercolour, 8⅛ins. x 12⅜ins.*

William Glover used his father's split brush technique, not only for foliage, but also for foregrounds. This can sometimes cause unevenness because the background colours have faded making the hatching stand out too much.

(Christie's)

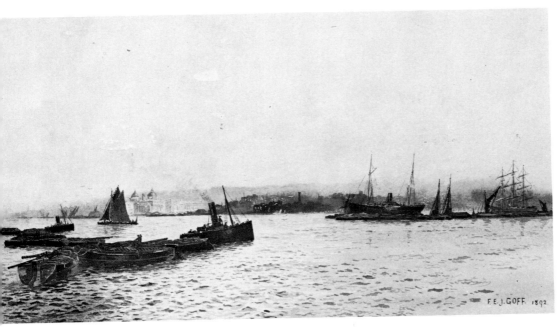

**GOFF, Frederick E.J.
(1855-1931)**
Greenwich. *Signed and
dated 1892, watercolour,
9ins. x 16ins.*

(Sotheby's)

**GOFF, Colonel Robert Charles
(1837-1922)**
Venice. *Signed and dated 1903, pencil
and watercolour, 3ins. x 6ins.*

As an amateur Goff reflected the
fashionable styles of his professional
contemporaries. He seems to have been
most at home with the wet paper tech-
niques of the end of the nineteenth
century.

(Martyn Gregory)

GOOCH, J.
Twickenham High Street.
*Signed, inscribed and dated
1832, watercolour, 5ins. x
6½ins.*

This primitive watercolour is by
the Norwich John or James
Gooch who was working from
about 1825 and should not be
confused with Oxford John
Gooch of some 40 years before.

(Sotheby's)

GOODALL, Edward Angelo (1819-1908)
Right Siege Train Camp, Winter 1854/5,
Sebastopol. *Inscribed on the artist's label,
pencil and watercolour heightened with
white, 10ins. x 19¾ins.*

(Christie's)

GOODALL, Walter (1830-1889)
Sorting the Catch. *Signed and dated 1865,
watercolour, 13ins. x 18ins.*

(Bourne Gallery)

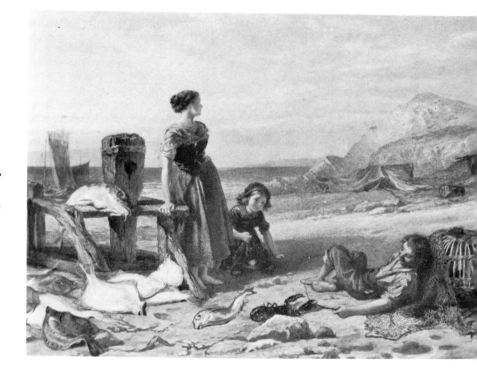

GOODWIN, Albert (1845-1932)
Matlock Bath, with Travellers on a Road.
*Signed with monogram and dated '71,
watercolour heightened with white, and
pen and black ink, 10ins. x 14ins.*

An example of the way in which Goodwin
added touches of pen and ink to an
apparently finished watercolour can be
seen in the grasses in this foreground.
Through his patron Ruskin he was greatly
influenced by Turner, both in techniques
and inspiration.

(Christie's)

GOODWIN, Albert (1845-1932)

Wells: 'Oh Fountains Bless Ye the Lord
Praise and Exalt Him above all for ever'

Signed with monogram, dated '91 and inscribed on original mount, watercolour with touches of pen and brown ink, 9¾ins. x 13¾ins.

An example of Goodwin's idiosyncracy of composition as well as of style. The border may have been designed by his brother Charles.

Above:

**GOODWIN, Harry
(-1925)**

A Walk in a Park. *Pen and ink and watercolour, 21ins. x 14ins.*

An illustration of the closeness in style between the brothers Harry and Albert. Harry's work is generally the weaker, and he often used an H.G. monogram.

GOODWIN, Albert (1845-1932)

From Trinity Bridge — The Backs. *Signed and inscribed, watercolour, 10ins. x 14¾ins.*

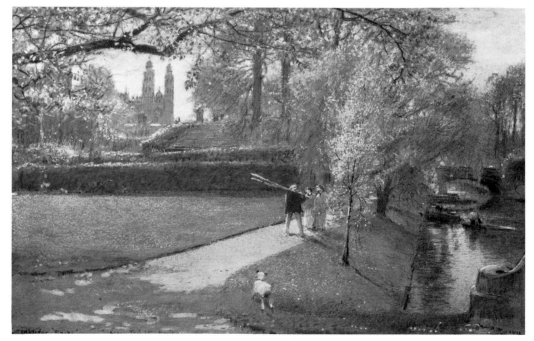

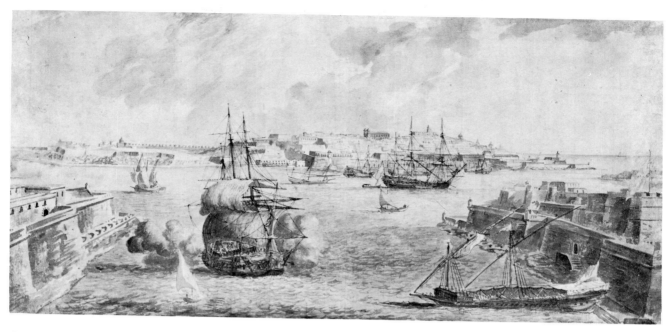

GORE, Charles (1729-1807) *(Martyn Gregory)*

A small two masted sailing vessel in the Grand Harbour, Valetta with a frigate and other shipping out to sea. *Pen and ink and watercolour, 6¼ins. x 8½ins.*

Right:

GOW, Mary L., Mrs. Hall (1851-1929)
The Catechism. *Signed and dated 1893, watercolour, 9¾ins. x 6¼ins.*

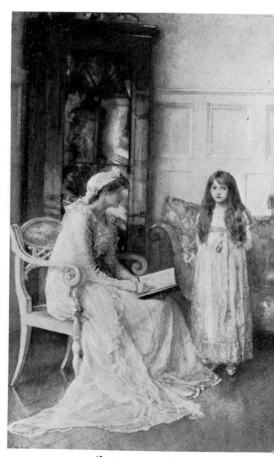

Above: *(Fitzwilliam Museum, Cambridge)*

GOW, Andrew Carrick (1848-1920)

Trinity College, C Staircase, Bishops Hostel. *Watercolour, 8⅜ins. x 5½ins.*

The subjects for which Gow was best known in his maturity are historical, military or genre. He also painted portraits. The present example illustrates his combination of a free style and accurate drawing.

(Lawrence of Crewkerne)

GRAHAM, Lord Montagu William (1807-1878)

Figures with Horse and Cart in a Landscape. *Pencil and watercolour, 6¾ins. x 10½ins.*

Although Graham's figure drawing is poor, he is of interest as a pupil of de Wint, working almost exactly in the manner of the master. There is an overall roughness which is absent from de Wint's own drawings.

(Martyn Gregory)

GRANT, 'Miss'

A Female Figure with Flowing Drapery. *Watercolour, 21ins. x 14ins.*

(National Galleries of Scotland)

(Sotheby's)

GREEN, Amos (1735-1807)

Conway Castle. *Pencil, pen and grey ink, and brown and grey washes, 9½ins. x 14¼ins.*

The woolly effect of much of Green's work is largely attributable to the carlessness of his pen work. Here this is best seen on and near the castle.

GREEN, Henry Towneley (1836-1899)
A Confidential Exchange. *Signed and dated 1880, watercolour, 9½ins. x 7½ins.*

(Sotheby's Belgravia)

GREEN, Nathaniel Everett (-1899)
Near Dorking. *Signed and inscribed, watercolour, 15ins. x 11½ins.*

Green's drawing, especially of trees, of which he was fond, tends to be rather flat and lacking in detail. Suitably enough a light acid green was a favourite colour.

(Sotheby's Belgravia)

GREEN, James (1771-1834)
Indian Jugglers. *Signed, watercolour, 33½ins. x 25ins.*

(Sotheby's)

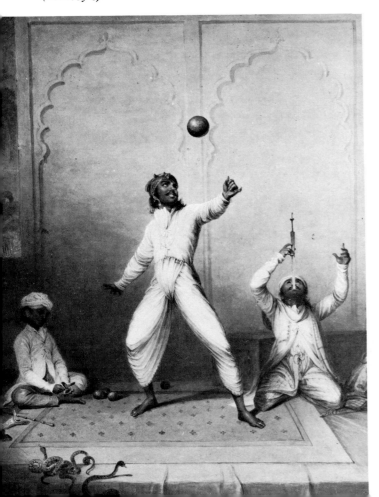

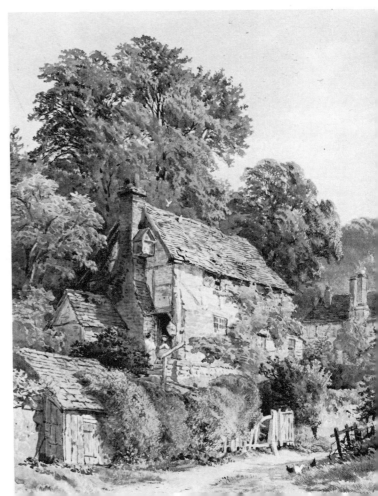

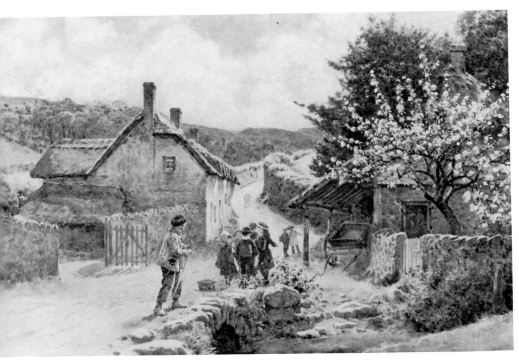

GREGORY, Charles (1849-1920)
Unwillingly to School, Branscombe, Devon. *Signed and dated '87, watercolour heightened with white, 12½ins. x 18½ins.*

(Sotheby's)

(Sotheby's Belgravia)

GREGORY, Edward John (1850-1909)
The Young Botanist. *Signed with initials and dated '95, watercolour heightened with white, 14¾ins. x 8¾ins.*

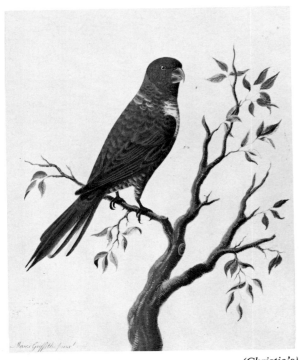

(Christie's)

GRIFFITH, Moses (1747-1819)
A Green Parrot on a Branch. *Signed and dated 1772, bodycolour on vellum, 12½ins. x 9⅞ins.*

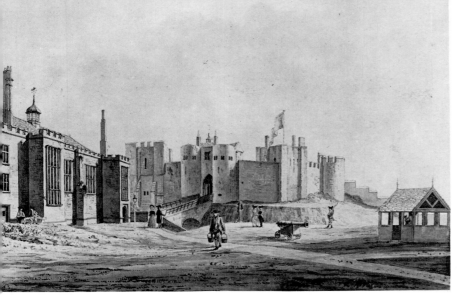

GRIFFITH, Moses (1747-1819)

Chester Castle. *Signed and dated 1781 on mount, pen and ink and watercolour, 9ins. x 12¾ins.*

The qualities which made Williams describe Griffith as 'a real primitive, a sort of rustic untaught Sandby' are evident in this example of his work. However, several other antiquarians and their employees such as Grose and Cocking, and Nixon could produce work which was very similar.

(Sotheby's)

GRIMM, Samuel Hieronymus (1733-1794)

The Queen's Head and Artichoke, Marylebone Turnpike. *Pen and grey ink and watercolour, 6¼ins. x 9¼ins.*

This is a comparatively modest and informal example of Grimm's work. His architectural work is characterised by neatness and gentlemanly restraint.

(Dudley Snelgrove Esq.)

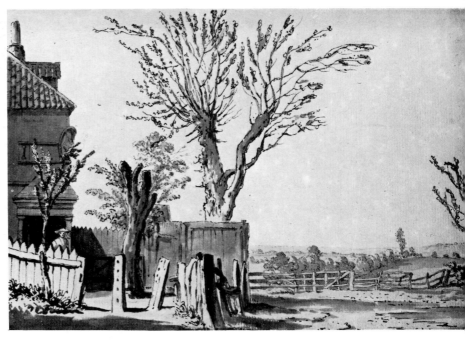

GRIMSHAW, John Atkinson (1836-1893)

Barden Tower, Yorkshire, with peasants in the foreground. *Signed and dated 1864, bodycolour, 15⅝ins. x 21¼ins.*

Grimshaw's rare work in water and bodycolour is quite unlike his oil paintings, and indeed, apart from precision of detail, his watercolours seem to have little in common with each other. As well as landscapes he produced dead birds and flowers in the manner of William Henry Hunt or William Cruickshank.

(Christie's)

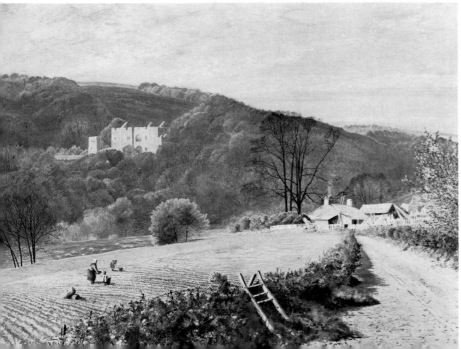

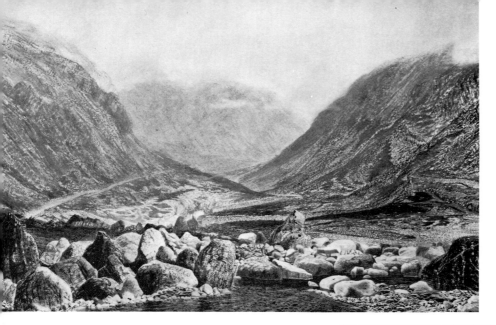

GRIMSHAW, John Atkinson (1836-1893)

Vale of Newlands, Cumberland. *Signed and dated 1868, pencil, pen and brown ink and watercolour heightened with white, 13⅞ins. x 20⅛ins.*

In this example the facility of Grimshaw's technique almost gives the impression of a painting over a photograph.

(Christie's)

GROSE, Daniel Charles (c.1760-1838)

Athluny Castle, Co. Neath, 1792. *Pen and grey ink and watercolour, 5ins. x 7ins.*

Daniel Grose's work shows a greater depth than that of his uncle, although it is still distinctly amateur. His figure drawing may owe something to that of his uncle's friend, John Nixon, at this period, which is weak in the same ways.

(Dudley Snelgrove Esq.)

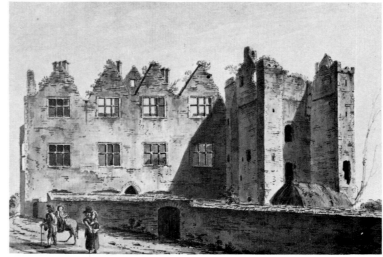

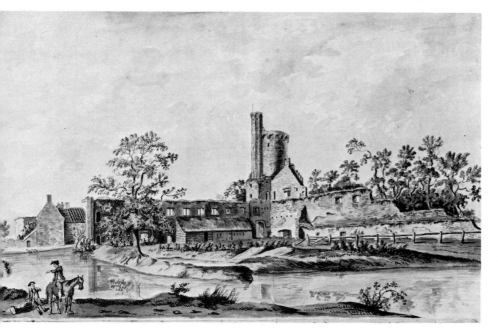

GROSE, Captain Francis (1731-1791)

A South East View of the Inside of the Ruins of Caister Hall, Norfolk, 1775. *Signed, inscribed and dated 1775, pen and black ink and watercolour, 12⅜ins. x 20¼ins.*

Although Grose's drawing is poor his topography is doubtless accurate. His work has some of the primitive appeal of that of Moses Griffith and is probably impossible to distinguish, except where clearly signed, from that of his servant and draughtsman Thomas Cocking.

(Christie's)

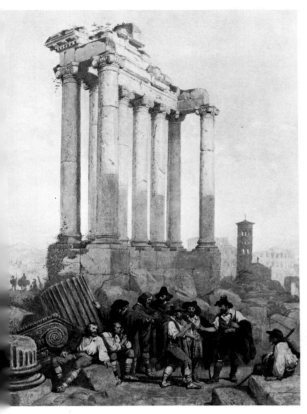

HAAG, Carl (1820-1915)

Remains of the Temple of Fortune, Rome. *Signed and dated 1850, watercolour, 29½ins. x 21¾ins.*

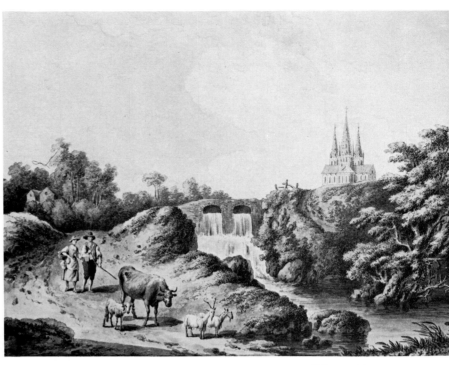

HACKERT, Johann Gottlieb (1744-1793)

View from Stow near Lichfield. *Signed and dated 1779, pen and ink, pencil and watercolour, 8¼ins. x 10½ins.*

Like Grimm, Hackert was an immigrant from the Continent and his style with its thin careful outlines and flatness of effect is based on Continental rather than English practice. The careful hatching on grass and foliage is typical.

HAGHE, Louis (1806-1885)

Grenoble. *Signed and inscribed, pencil and watercolour heightened with white, 10⅞ins. x 15¾ins.*

Haghe's watercolour work is best, as here, when he frees himself from the pedantic approach of the lithographer. Although it is not particularly obvious in this illustration he painted with his left hand.

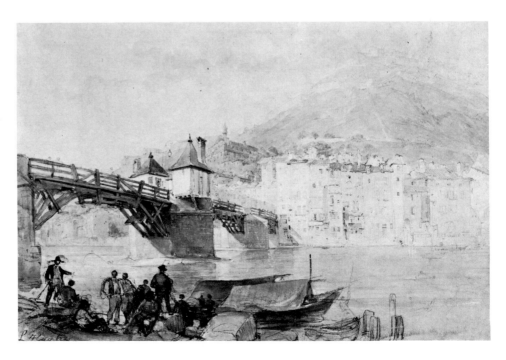

HAGHE, Louis (1806-1885)
An extensive view of the Bay of Naples with the Town and Vesuvius beyond. *Signed and dated 1870, pencil, water and bodycolour, 9ins. x 13ins.*

(Martyn Gregory)

HALE, William Matthew (1837-1929)
Loch Maree. *Signed and dated 1878, watercolour, 27ins. x 34ins.*

(Beryl Kendall)

HAMERTON, Robert Jacob
Kidwelly Castle, South Wales. *Signed and dated 1855, pencil and watercolour heightened with white, 13½ins. x 19½ins.*
Hamerton was primarily an illustrator and lithographer. He painted many portraits and figure subjects.

(Agnew)

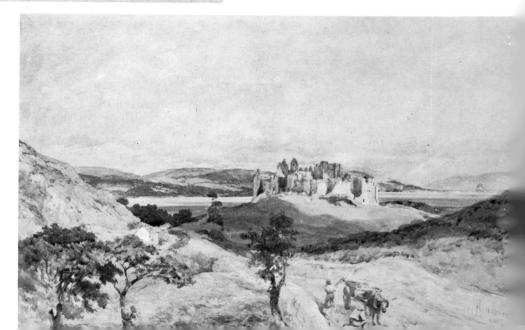

HAMILTON, William (1751-1801)

Mythological Scene: Woman Comforting an Eagle. *Pen and grey ink and watercolour, 9¼ins. x 6¾ins.*

(Dudley Snelgrove)

HARDING, George Perfect (-1853)

Portrait of Sir Edward Dering. *Signed with initials and dated 1793, pencil and grey wash, 3½ins. x 3ins. oval.*

The only difficulty with Harding's wash miniature copies of historical portraits and old masters is to distinguish them from those of his father Sylvester.

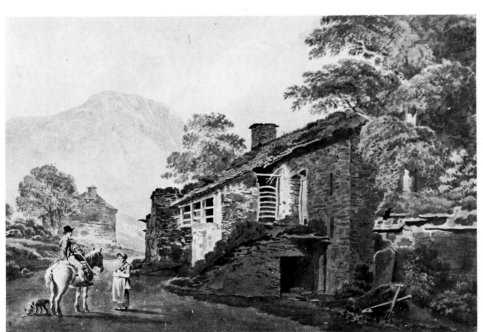

HARDEN, John (1772-1847)

Lakeland Farm. *Pen and ink and watercolour, 14ins. x 20ins.*

Harden was one of the best amateur watercolourists of his period and was also a skilful draughtsman. His figures are usually good and he had a feeling for brick and stone work. He sometimes used white heightening and buff or grey paper, and his colouring could be strong.

(Abbot Hall Art Gallery, Kendall)

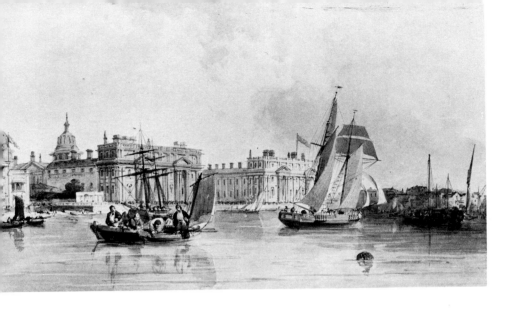

HARDING, James Duffield (1797-1863)
Greenwich Hospital. *Watercolour, 8ins. x 13ins.*

(Private Collection)

HARDWICK, John Jessop (1831-1917)
Still Life of Fruit and Leaves. *Signed and dated 1865, watercolour, 10ins. x 14ins.*
As well as Hunt-like still-lifes, Hardwick painted landscapes.

(Martyn Gregory)

HARDY, Dudley (1867-1922)
'Peace'. *Watercolour, 7½ins. x 11ins.*
Hardy was an illustrator, cartoonist, fashion, theatre and poster draughtsman as well as a painter of landscapes, seascapes, North African, Far Eastern, biblical and genre subjects in a variety of styles.

(Beryl Kendall)

HARDY, James, Yr. (1832-1889)
A Scottish Highland Scene with a Huntsman. *Signed and dated 1873, watercolour, 16½ins. x 12ins.*

HARE, Augustus John Cuthbert (1834-1903)
Neuchatel-en-Braye. *Watercolour, 12ins. x 10ins.* A good example of the effectiveness of Hare's free and wet technique.

HARDY, Thomas Bush (1842-1897)

On the Medway. *Signed and inscribed, water-colour, 9ins. x 13ins.*

(Private Collection)

HARGITT, Edward (1835-1895)

A Drover in the Borders. *Signed and dated 1875, watercolour, heightened with white, 9¼ins. x 13⅝ins.*

As a painter in the Cox tradition Hargitt could be very effective, although his foregrounds are sometimes too busy. His well drawn figures and cattle are generally subordinated to the landscape.

HARRADEN, Richard Bankes (1778-1862)

Lincoln Cathedral, seen from the South East. *Signed and dated 1838, watercolour, 14ins. x 23ins.*

(Sotheby's)

(Martyn Gregory)

HARLEY, George (1791-1871)

A Village Church in a Landscape. *Signed and dated 1828, watercolour, 5¾ins. x 8ins.*

Harley tended to use strong greens and ochres.

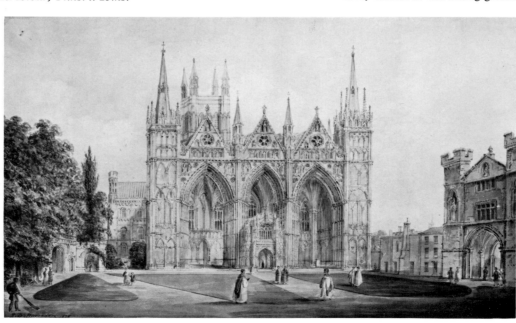

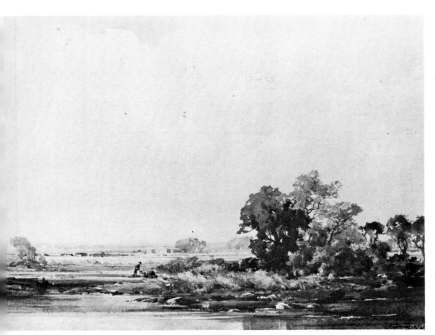

HARRINGTON, Charles (1865-1943)

Near Warrens End, Mortimer. *Signed and dated '24, watercolour, 10⅜ins. x 14¼ins.*

This is a late work in the Cox and de Wint tradition.

HARRIS, Daniel

Corpus Christi College from the Canterbury Gate of Christ Church. *Pen and grey ink and watercolour (1792 Almanac), 11¾ins. x 17¾ins.*

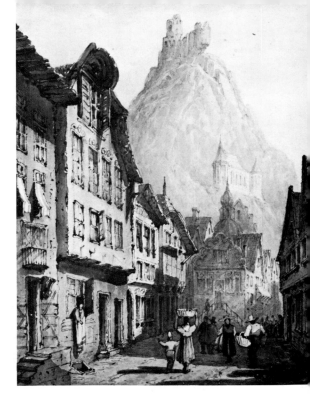

HARRIOTT, William Henry (-1839)

Oberstein near Treves, 1836. *Pen and brown ink and watercolour heightened with white, 9ins. x 6¾ins.*

Harriott could be one of the closest imitators of Prout with whom he probably visited the Continent. He also worked in a number of other styles including those of Devis, Francia and Cotman.

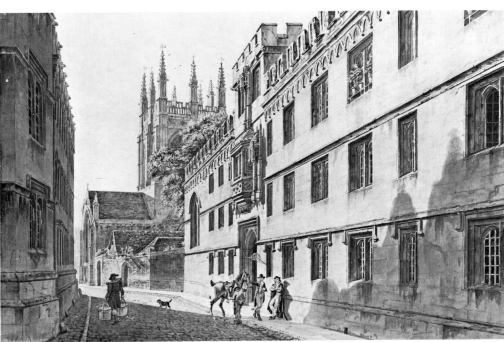

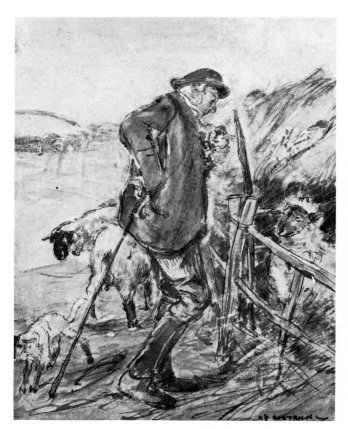

(Dudley Snelgrove Esq.)

**HARTRICK, Archibald Standish
(1865-1950)**

A Shepherd holding a Lamb. *Signed, watercolour, pen and black ink, 11½ins. x 8¾ins.*

HASSAM, Alfred

Portrait of a Young Man. *Signed with initials and dated 8/62, watercolour heightened with white, 8⅞ins. x 7ins.*

As well as watercolours for their own sake Hassam produced stained glass designs.

(Sotheby's Belgravia)

HASELER, Henry

View of the Rooms at Dawlish. *Inscribed on old backing, pencil and watercolour, 9¼ins. x 15ins.*

An unambitious and pretty example of Haseler's work. He often employed a rounder and less detailed technique which is reminiscent of that of Girtin. The emphasis of lighting in his work is also reminiscent of that of Girtin followers such as Manskirch.

(Martyn Gregory)

HASSELL, John (1767-1825)
An extensive view of Tarbert, Co. Kerry. *Signed and dated 1795, watercolour, 12¾ins. x 21ins.*

(Sotheby's)

HATHERELL, William (1855-1928)
Derby Day. *Signed, watercolour, 15ins. x 23ins.*
As well as contemporary scenes Hatherell was particularly known for his biblical subjects.

(Bourne Gallery)

HAVELL, William (1782-1857)
A View near Reading. *Signed, watercolour, 6⅞ins. x 12⅜ins.*
Havell developed from a follower of Girtin into an excellent landscape painter in the manner of de Wint. As well as landscapes in the Thames Valley he painted Italian peasant subjects.

(Private Collection)

HAYES, Claude
(1852-1922)

Farnham. *Signed, watercolour, 9¼ins. x 13¾ins.*

An artistic descendant of Cox and Collier, Hayes often worked in a very loose and sketchy manner. The sky is always very important to his compositions.

(Private Collection)

(Sotheby's Belgravia)

HAYES, Edwin (1820-1904)

Making for Shore in Dangerous Seas. *Signed, watercolour heightened with white, 10¾ins. x 14¾ins.*

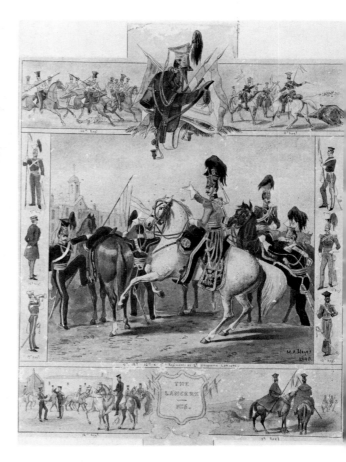

HAYES, Michael Angelo (1820-1877)

The Lancers — No. 6. *Signed, inscribed and dated 1840, watercolour, 17ins. x 12½ins.*

(Sotheby's)

(Anthony Reed)

(Anthony Reed)

HAYWARD, John Samuel (1778-1822)

Near Enniskerry. *Signed with monogram, inscribed and dated 1805, also on reverse, watercolour, 7½ins. x 11¼ins.*

Hayward was a close friend of Joshua Cristall and his style, both for landscapes and portraits, is clearly derived from Cristall's looser manner. At the very beginning of his artistic career he worked in an old fashioned Grimm-like style, and he was also influenced by Cotman. His chartacteristic monogram and inscription can be seen in this drawing.

HAYWARD, John Samuel (1778-1822)

A Young Woman Looking Down. *Pencil and watercolour, 4ins. x 3¾ins.*

HEARNE, Thomas (1744-1817)

A House in the Jacobean Style. *Pencil and watercolour, 11⅛ins. x 14¾ins.*

(Christie's)

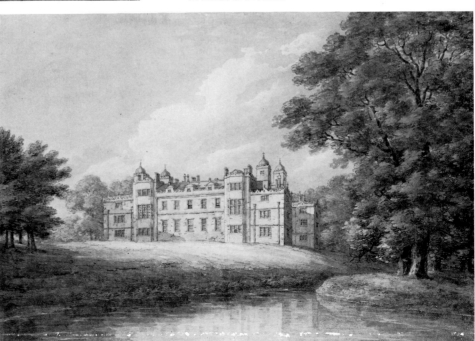

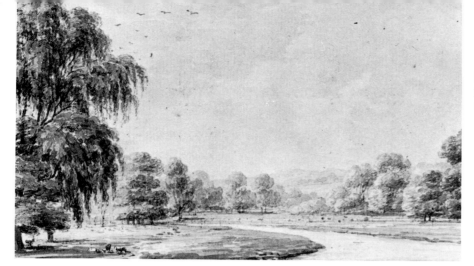

HEARNE, Thomas (1744-1817)
From Hitchin Priory. *Pencil and watercolour, 4½ins. x 7ins.*

(Private Collection)

(Martyn Gregory)

HEATH, William (1795-1840)
Napoleon meeting Captain Maitland aboard the Bellerophon. *Signed and dated 1816, watercolour, 8ins. x 11½ins.*

HENDERSON, Charles Cooper (1803-1877)

The Exeter — London Coach. *Signed with monogram, pen and brown ink and watercolour, 8¾ins. x 10½ins.*

Henderson made a name for himself as a coaching painter. He generally used light brown ink outlines and light colour washes.

(Sotheby's)

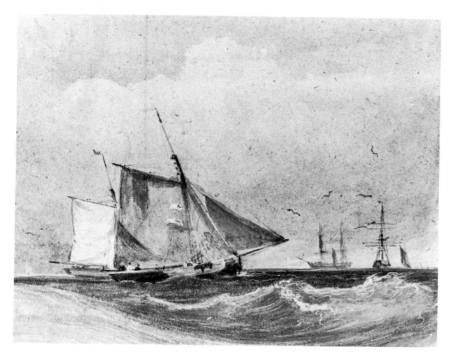

HENDERSON, John (1764-1843)
Cutter and Shipping in a Swell. *Water and bodycolour lightly varnished, 5½ins. x 7ins.*

As well as painting in full watercolour, Henderson produced drawings in the manner of the school of his friend and neighbour Doctor Monro. He also copied watercolours by Hearne, Cozens and Turner owned by Monro.

(Martyn Gregory)

HENSHAW, Frederick Henry (1807-1891)
The Forum. *Signed, watercolour, 8ins. x 11½ins.*
There is often a fuzziness about Henshaw's work which is the result of much rubbing and stopping out.

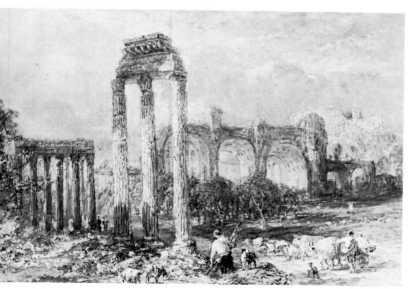

(Dr. C.R. Beetles)

HERALD, James Watterson (1859-1914)
Arbroath Harbour. *Watercolour, 19½ins. x 16¼ins.*
Herald was an eccentric and a recluse. The two main influences on his style appear to have been Arthur Melville and Charles Condor.

(Glasgow Art Gallery)

411

HERBERT, Alfred (c.1820-1861) *(Bourne Gallery)*

Off the Dutch Coast. *Signed, watercolour, 12ins. x 30ins.*

(Williamson Art Gallery, Wirral)

HERDMAN, William Gawin (1805-1882)

Monks Ferry 1866. *Watercolour, 13ins. x 6ins.*

This illustrates Herdman's naïvety of compostion and drawing, linked to accurate topography.

HERING, George Edwards (1805-1879)

A Scene in the Italian Lakes. *Watercolour, 18ins. x 26ins.*

(Sotheby's)

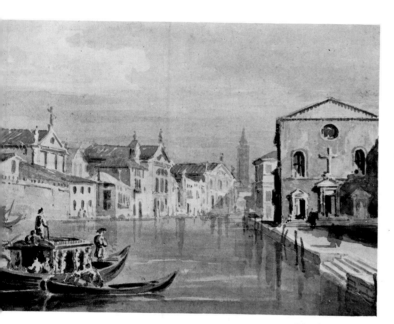

HERIOT, George (1766-1844)

A Lake in Canada. *Pen and ink and watercolour, 8¼ins. x 12⅜ins.*

A drawing in Heriot's Sandby manner with careful pen and ink outlines and light colour washes.

(Private Collection)

(Andrew Wyld)

HERIOT, George (1766-1844)

Venice: The Grand Canal, Facing Santa Croce, after Canaletto. *Watercolour, 6⅛ins. x 8½ins.*

HERKOMER, Sir Hubert von (1849-1914)

'And Culture stills his Harmonies to Heed, The Inspiration of the Uncaught Reed.' *Signed with initials and dated 1903, watercolour, 19ins. x 14ins.*

A subject near to Herkomer's heart since he was also an operatic composer.

(Bonham's)

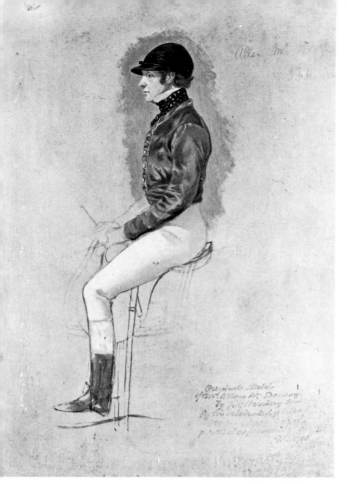

HERRING, John Frederick (1795-1865)
Portrait Sketch of the Jockey Allan McDonough. *Signed with initials, inscribed and dated 1846, watercolour, 17½ins. x 12¼ins.*

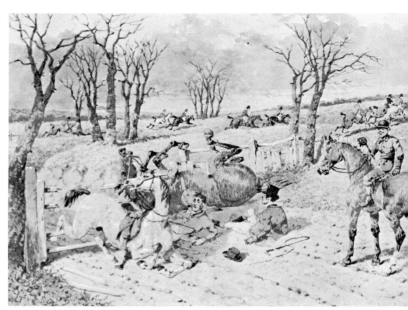

HERRING, John Frederick, Yr. (1815-1907)
'Yah! What a Jolly Smash!...' *Signed and inscribed, watercolour heightened with white, 8½ins. x 12¼ins.*

Both in farmyard and hunting scenes Herring employed a more nobbly style than that of his father. This is largely due to the overall hatching in brown ink and to small blobs of body-colour. The basic colour is generally a varient of ochre.

HICKIN, George Arthur
Hen and Chicks. *Signed, watercolour and bodycolour, 9ins. x 13ins.*

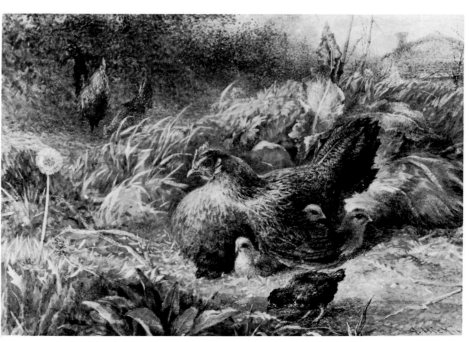

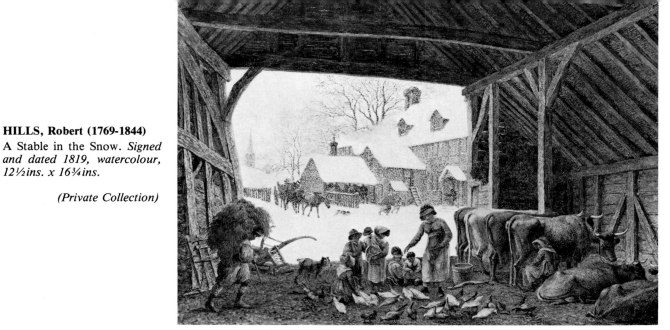

HILLS, Robert (1769-1844)
A Stable in the Snow. *Signed
and dated 1819, watercolour,
12½ins. x 16¾ins.*

(Private Collection)

HILLS, Robert (1769-1844)
Interior of Barn with Herds-
men, Children and Cows.
*Signed and dated 1822, pencil
and watercolour, 19⅛ins. x
27⅛ins.*

From about 1810 Hills
employed a pointillist
technique which sometimes
became rather muzzy. How-
ever, it was particularly
suitable for showing the
textures of brick and wood.
Before that date his water-
colours are rather eighteenth
century in feeling with a
limited range of low colour
washes and careful outlines.
He also made excellent small
and free sketches throughout
his career.

(Phillips)

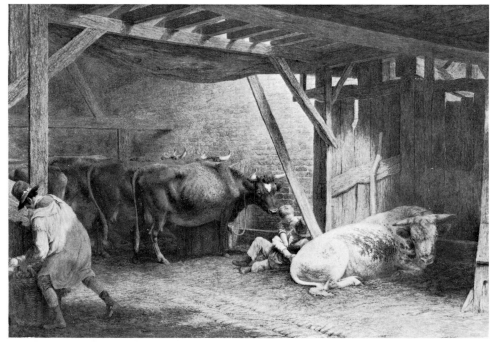

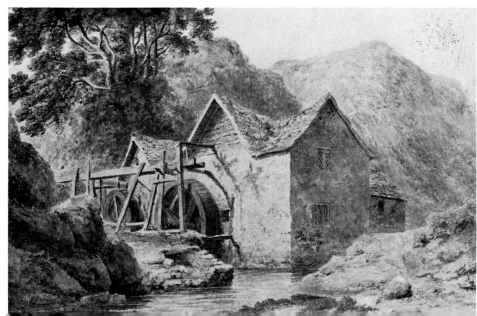

HILLS, Robert (1769-1844)
Aberfoyle, Perthshire. *Water-
colour, 7ins. x 10⅛ins.*

(Private Collection)

415

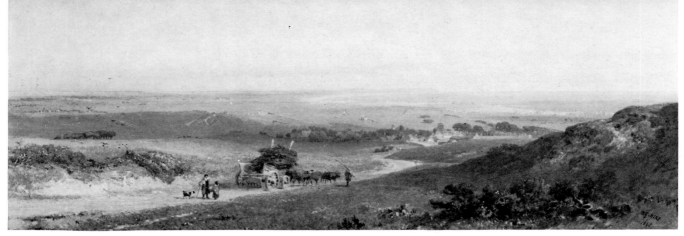

HINE, Henry George (1811-1895)

A View of Pevensey Bay. *Signed and dated 1868, watercolour, 11¼ins. x 28½ins.*

The Sussex Downs and coast were particular favourites for Hine and he was good at showing the hazy atmosphere which is characteristic of the area. His style was influenced by those of Fielding and Collier.

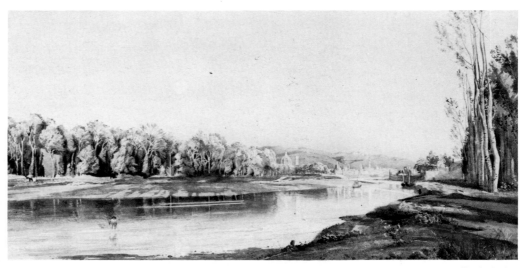

HINE, Henry George (1811-1895)

Florence — 'The Moon Is Up Yet T'is Not Night'. *Signed with initials and dated 1874, watercolour heightened with white, 11½ins. x 22ins.*

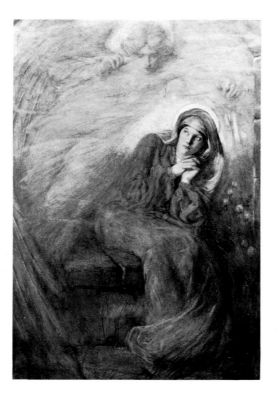

HOBSON, Cecil James (1874-1915)

The Angel of the Annunciation. *Signed, watercolour, 13½ins. x 20¾ins.*

HODGSON, David (1798-1864)
An Overgrown River Bank.
Watercolour, 6⅝ins. x 11ins.
The members of the Norwich school
were particularly fond of sketching
plants and trees on riverbanks.
Hodgson also painted fine Norwich
street scenes and old houses.

(Martyn Gregory)

**HOLL, Francis Montague
'Frank' (1845-1888)**
Bad News. *Signed with initials,
watercolour, 7¾ins. x 11⅜ins.*

(National Galleries of Scotland)

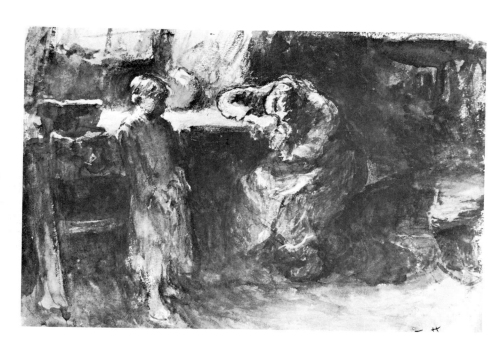

HOLLAND, James (1800-1870)
By the Church of San Simeone Piccolo,
Venice. *Signed with initials, pencil and
watercolour heightened with white,
13⅞ins. x 18½ins.*
Much of Holland's earlier work shows
the strong influence of Bonington's
Paris circle, particularly in the careful
and linear drawing of buildings con-
trasting with areas of more impression-
istic handling. Holland's signings and
initiallings are often very informal and
it can be a moot point as to whether a
scribble is in fact a monogram or part
of the composition.

(Christie's)

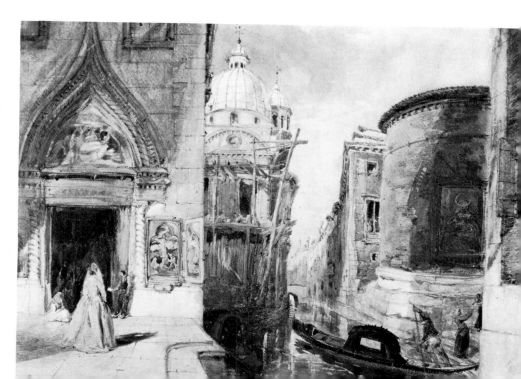

HOLLAND, James (1800-1870)
Bathing Machines at Eastbourne. *Signed with monogram, dated 9 Sept. '61 and inscribed, pencil and watercolour heightened with white, 3⅞ins. x 6ins.*

Holland's informal sketches, often on the Kent and Sussex coasts, with their freedom and their notes as to the state of the tide, prevailing wind or time of day are amongst the most immediately appealing of his works.

(Private Collection)

(Andrew Wyld)

HOLWORTHY, James (1781-1841)
Conway Castle by Moonlight. *Inscribed in the sky, pen and ink and watercolour, 10ins. x 14½ins.*

Holworthy was one of Glover's most faithful disciples and all the master's mannerisms can be seen in his work. On the whole he worked in monochrome with only slight touches of colour. He was fond of ruined castles and dramatic bursts of light.

HOOD, John
The Northumberland in Three Positions. *Signed, pen and ink and grey wash, 30ins. x 40ins.*

(Martyn Gregory)

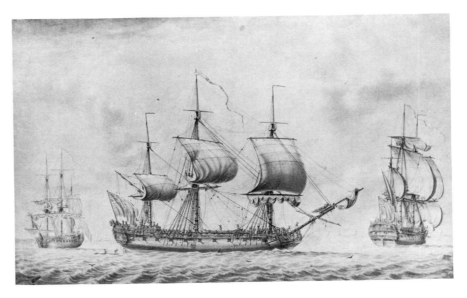

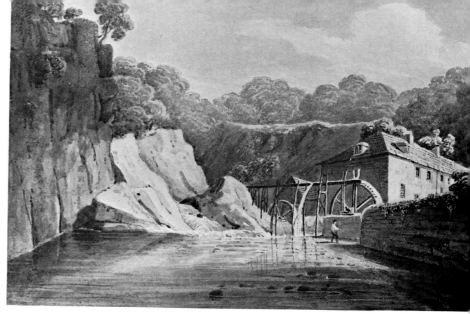

HORNER, Thomas

Aberdulais Mill. *Watercolour, 8ins. x 11½ins.*

Horner was working in South Wales between 1816 and 1820. As well as landscape and topographical watercolours of this sort he painted Grimm-like Swiss views, perhaps copied from prints.

(National Museum of Wales)

(Dudley Snelgrove Esq.)

HORNER, Thomas

Family Picnic at the Vale of Neath. *Pen and grey ink and watercolour, 11½ins. x 19ins.*

The drawing of the hillsides in the distance of this watercolour seems to indicate a familiarity with the work of the Town School.

HOUGH, William B.

Plums in a Basket. *Signed, watercolour heightened with white, 10¾ins. x 14¾ins.*

Hough was for the most part a close imitator of 'Birdsnest' Hunt, but he was also a competent landscape painter.

(Sotheby's)

HOWITT, Samuel (1756-1822)
Rabbits Outside a Warren. *Signed, watercolour, 5¾ins. x 8¼ins.*
Somehow Howitt's animals are always very lifelike without being pedantically realistic. They are also particularly his own. There is something about the formalised hatching on the pelts and the luminosity of the eyes (even when drawn in pencil) which may be derived from the style of earlier men such as Charles Collins, but which is unmistakeable.

(Phillips)

HOWITT, Samuel (1756-1822)
Sportsmen and their Dogs beside a Waterfall. *Signed and dated 1791, watercolour, 10ins. x 14ins.*
A good example of Howitt's landscape-with-sportsmen manner, which is based on the style of his brother-in-law Rowlandson. This illustration also shows his typical fretted foliage.

(Sotheby's)

HOWSE, George (-1860)
Fisherfolk Embarking at the Edge of a Lake. *Signed, watercolour, 9¾ins. x 26½ins.*

(Sotheby's)

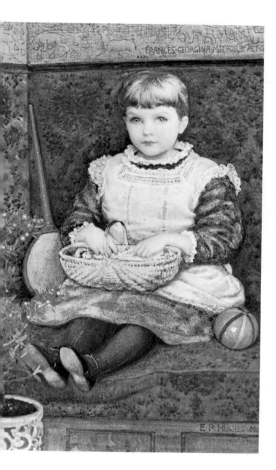

(Beryl Kendall)

HULL, William (1820-1880)

A Fisherman on a River. *Signed, watercolour, 8½ins. x 13¾ins.*

Hull rarely worked in full colour in his landscape drawings, and, indeed, in his earlier career the colour, when used, is weak. He was best known for fruit and flower pieces in the manner of William Henry Hunt and for book illustrations.

HUGHES, Edward Robert (1851-1914)

Portrait of Frances Georgina Mitford. *Signed, inscribed and dated 1880, watercolour heightened with bodycolour, 12¼ins. x 8ins.*

(Sotheby's Belgravia)

HULL, Edward

Distant View of Ely Cathedral. *Signed and dated 1864, watercolour, 10¼ins. x 16⅛ins.*

A charming example of the work of the second Edward Hull who painted landscapes in a clear and bright manner and also produced genre subjects and illustrations.

(Christie's)

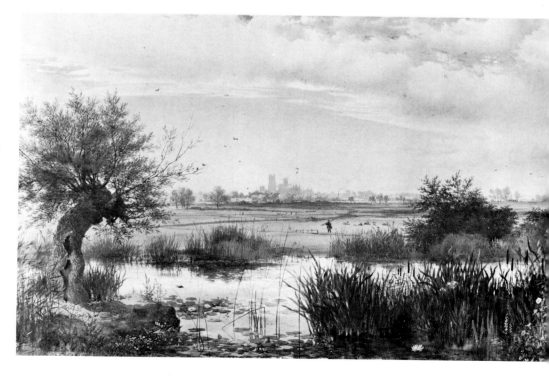

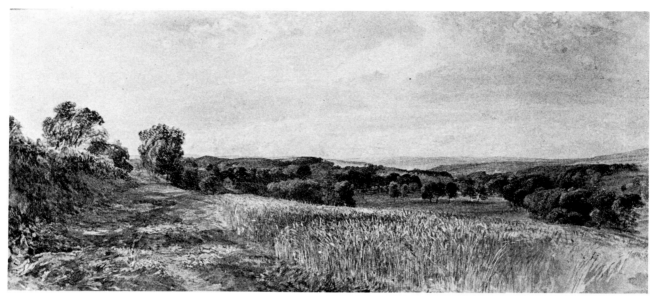

HUNT, Alfred William (1830-1896)
Cornfield near Rokeby. *Watercolour, 7ins. x 16ins.*

(Martyn Gregory)

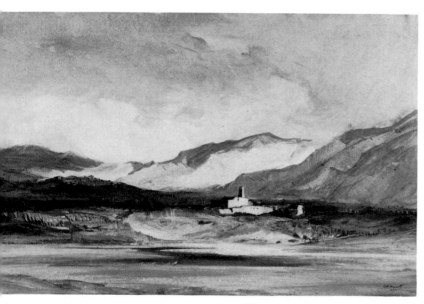

(Fitzwilliam Museum, Cambridge)

HUNT, Cecil Arthur (1873-1965)
The Castle by the Ford. *Signed, watercolour, 14⅛ins. x 20¾ins.*
Hunt's colours are often very bright and he was fond of using the scratching technique seen here.

(The Fine Art Society)

HUNT, William Henry (1790-1864)
The Boy and The Wasp. *Signed, watercolour, 16½ins. x 12¼ins.*

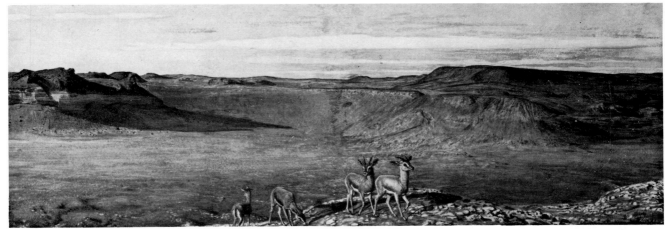

(Julian Hartnoll)

**HUNT, William Holman
(1827-1910)**
The Wilderness of Gizeh. *Signed
with monogram and dated 1854,
watercolour heightened with
white, 9¾ins. x 27¾ins.*

**HUNT, William Howes
(1806-1879)**
Boats in an Estuary, Braden
Quay. *Pen and brown ink and
watercolour heightened with
white, 11ins. x 17½ins.*

(Dudley Snelgrove Esq.)

**IBBETSON, Julius Caesar
(1759-1817)**
A Long-Fin Albacore. *Signed and
inscribed 'An Albacore caught Janu
28. 1788. By Skinner a Mulatto sea-
man in Lat 2.N. about 18 inches in
length — on opening him a number
of small fish were found together
with a white substance Resembling
a Heart from whence he probably
takes his name, Julius Ibbetson del
ad Nat. Vestal.' Blue and grey
washes, 9ins. x 14½ins.*

This dates from Ibbetson's time as
draughtsman to Cathcart's Chinese
embassy.

(Christie's)

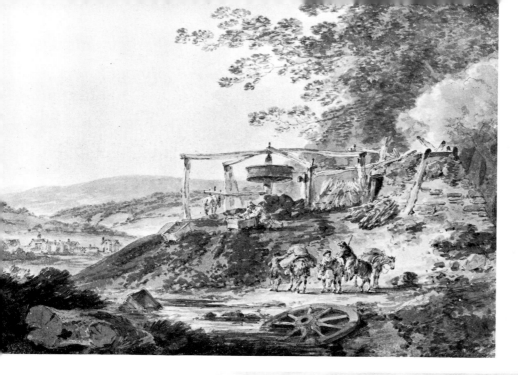

IBBETSON, Julius Caesar (1759-1817)
Lime Kiln, Forest of Dean. *Watercolour, 8⅝ins. x 11½ins.*

(Private Collection)

IBBETSON, Julius Caesar (1759-1817)

Skaters on the Serpentine near the Old Cheesecake House, Hyde Park. *Signed, pen and grey ink and watercolour, 13⅞ins. x 23ins.*

(Christie's)

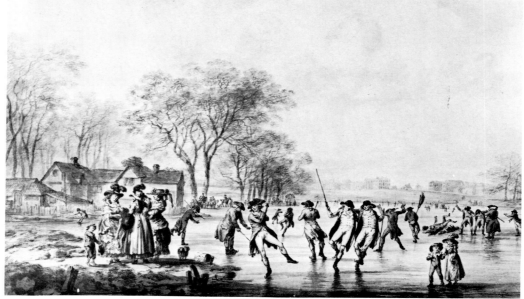

INCE, Joseph Murray (1806-1859)

The White Horse Inn. *Signed and dated 1840, watercolour, 6¾ins. x 9¾ins.*

The signature with its flattened J is characteristic. The stippled effect which is here used for trees and foliage can on other occasions provide an excellent rendering of brick and stone.

(Sotheby's)

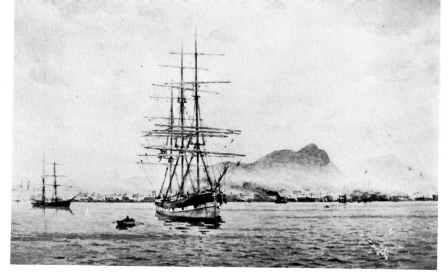

INGRAM, William Ayerst (1855-1913)

The Port of Leith. *Signed, watercolour, 16ins. x 24ins.*

Ingram's watercolour work provides a link between the Glasgow and Newlyn schools.

(Bourne Gallery)

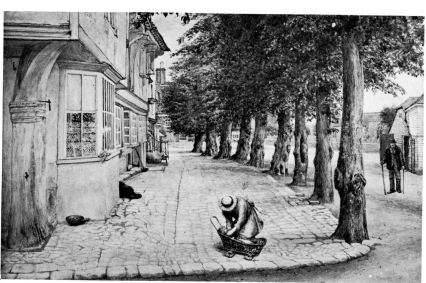

(Bourne Gallery)

JACKSON, Frederick Hamilton (1848-1923)

A Village Street. *Signed, watercolour, 17ins. x 25ins.*

As well as this type of very detailed work Jackson produced broad and atmospheric marine and landscape sketches in both oil and watercolour.

JACKSON, Samuel (1794-1869)

Rainbow over the River Avon. *Watercolour, 11⅜ins. x 17⅝ins.*

A fine example of Jackson's sophisticated technique, showing much scratching, sponging and stopping out, as well as his predeliction for rather harsh lighting.

(Bristol City Art Gallery)

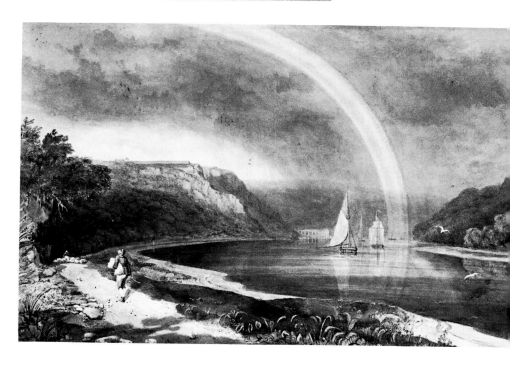

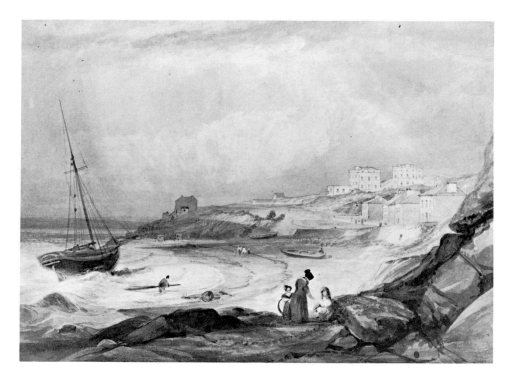

JACKSON, Samuel (1794-1869)
The Beach at Clevedon. *Pencil and watercolour, 8¾ins. x 11½ins.*

(Martyn Gregory)

JOHNSON, Edward Killingworth (1825-1896)
Teasing Kitty. *Watercolour heightened with white, 18¾ins. x 10ins.*
A worker in the sweetly flowered field of Goodwin Kilburne, Johnson was at his best when at his most detailed.

(Sotheby's Belgravia)

JACKSON, Samuel Phillips (1830-1904)
A Ship standing off from a Burning Vessel. *Signed, watercolour, 5½ins. x 8¼ins.*
This example shows Jackson's talent for hazy atmospherics, but not his weakness of over-using bodycolour.

(Martyn Gregory)

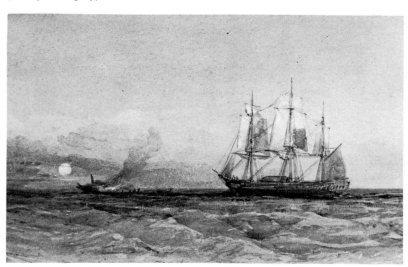

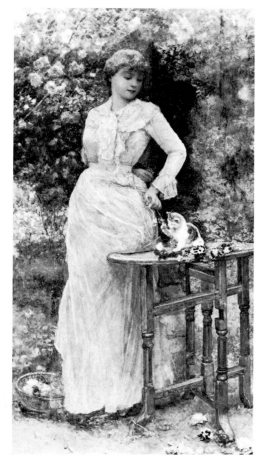

(Stone Gallery, Newcastle upon Tyne)

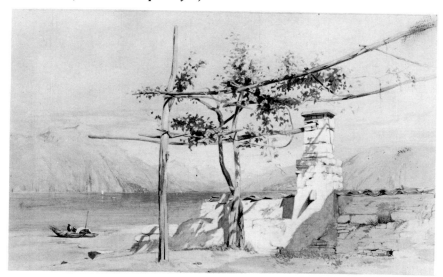

(Sotheby's)

JOHNSTON, Rev. George Liddell (1817-1902)

A Skeleton Riding a Strange Animal Watched by a Dinosaur with a Ballet Dancer on It's *(sic)* Tail. *Pencil and watercolour, 6ins. x 18ins.*

JOHNSON, Harry John (1826-1884)

A Mediterranean Coastal Scene. *Watercolour heightened with white, size unknown.*

Johnson's style varies from an approximation of that of his master Muller, with its impressionistic freedom, to a more characteristic concern with clean draughtsmanship as here. In this he shows a kinship with the lithographic draughtsmen of his time.

JOHNSON, Robert (1770-1796)

An Angler near a Ruined Abbey. *Watercolour, 9¾ins. x 14ins.*

Johnson's work is naturally not particularly original, especially in the busy foliage drawing. It can be more detailed than the present example would suggest.

(Dudley Snelgrove Esq.)

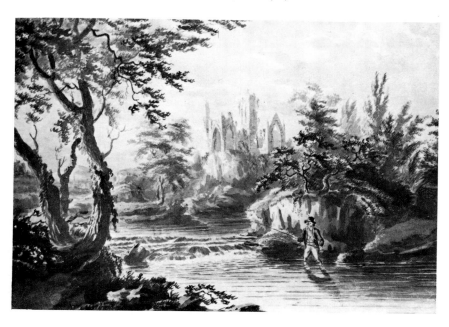

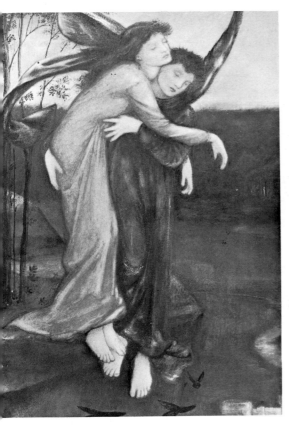

(Spink and Son Ltd.)

JONES, George (1786-1869)
View of Dublin. *Pen and ink and watercolour on blue paper, 7⅛ins. x 10⅜ins.*

(Christie's)

JONES, Sir Edward Coley BURNE- (1833-1898)
Zephyr and Psyche. *Signed and dated 1865 on the reverse, watercolour and bodycolour, on canvas, 14½ins. x 10ins.*

JONES, George (1786-1869)

Cottages on a Welsh Hillside. *Watercolour, 8⅞ins. x 13⅜ins.*

Jones's preference was for monochrome wash drawings often on blue paper. His handling is usually loose and atmospheric.

(Martyn Gregory)

JONES, Reginald T. (1857-)
A Ship at Mooring. *Signed, watercolour, 7ins. x 5ins.*

(Private Collection)

JUTSUM, Henry (1816-1869)
Oxford. *Watercolour, 14½ins. x 11⅛ins.*

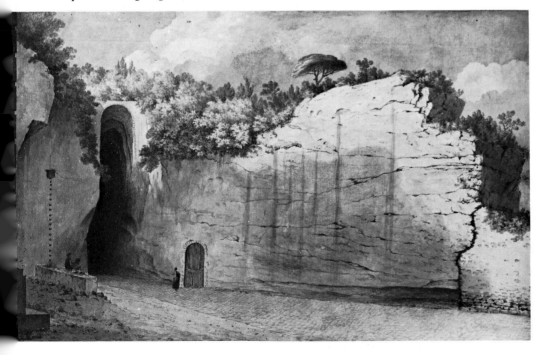

JONES, Thomas (1742-1803)
The Grotto of the Posilippo, Naples. *Inscribed, watercolour, 9½ins. x 15½ins.*

Much of Jones's work owes its inspiration to his master Wilson. However, during his years in Italy from 1776-1783 he was also much influenced by his acquaintances Towne and Warwick Smith.

(Dudley Snelgrove Esq.)

429

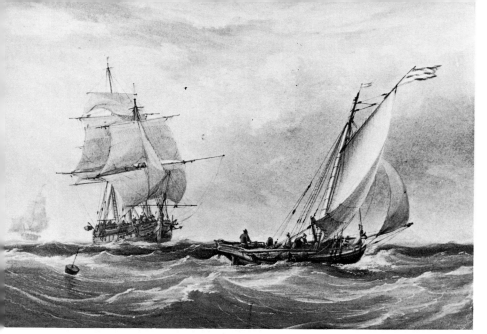

(Martyn Gregory)

JOY, William (1803-1867)

Fishing Boat with Merchantman. *Water-colour, 8¾ins. x 11¾ins.*

It is not often possible to say which of the Joy brothers was responsible for a particular drawing, or whether they were working in collaboration, although John seems to have preferred inshore subjects. The seas, especially William's, are often painted in rather sickly light greens or blues.

KEENE, Charles Samuel (1823-1891)

The Meet. *Pencil and watercolour, 7½ins. x 10¾ins.*

Keene's rare watercolours are unexpectedly free when compared to his beautifully precise pen and ink drawings. His colours are light, often greys, browns and pinks.

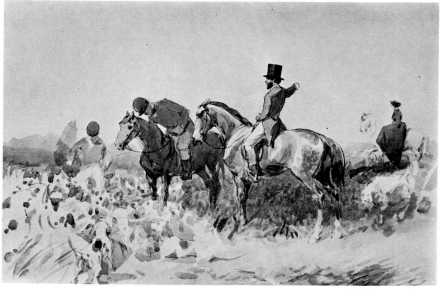

(Anthony Reed)

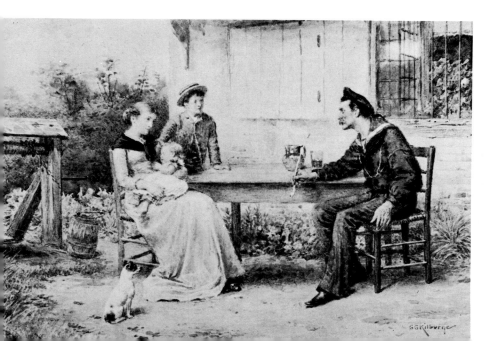

KILBURNE, George Goodwin (1839-1924)

Tales of the Sea. *Signed, watercolour, 8ins. x 11ins.*

Kilburne's contemporary subjects often show a greater strength than his eighteenth century costume pieces. Very occasionally he approaches the force and clarity of a Tissot.

(Bourne Gallery)

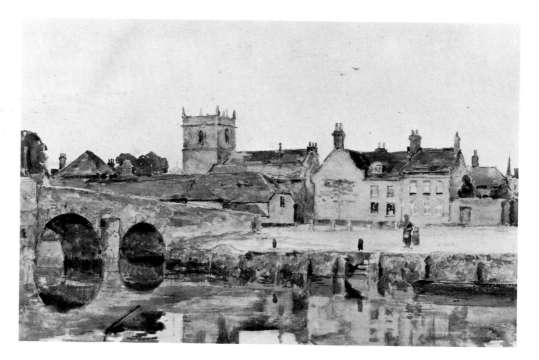

KING, Henry John Yeend (1855-1924)
Evening at Wareham. *Signed, watercolour, 9½ins. x 13¾ins.*

(Sotheby's Belgravia)

KIRKPATRICK, Joseph
Potato Gatherers. *Signed, watercolour, 9½ins. x 6½ins.*

(Beryl Kendall)

KNIGHT, John Baverstock (1788-1859)
A View in the Lake District. *Watercolour, 10ins. x 16ins.*
This is rather a free drawing for Knight, who usually worked more within the disciplines of the Towne school.

(Martyn Gregory)

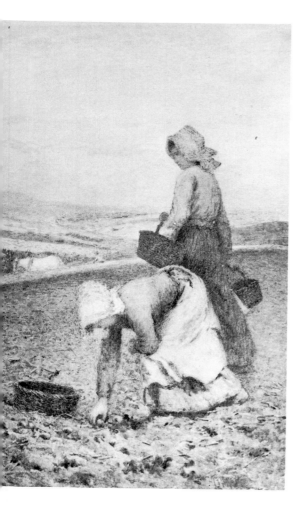

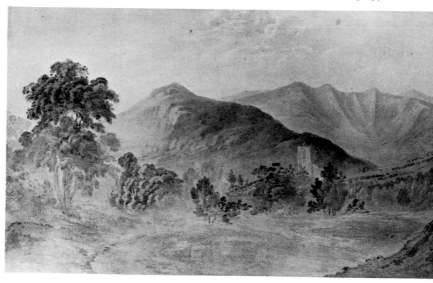

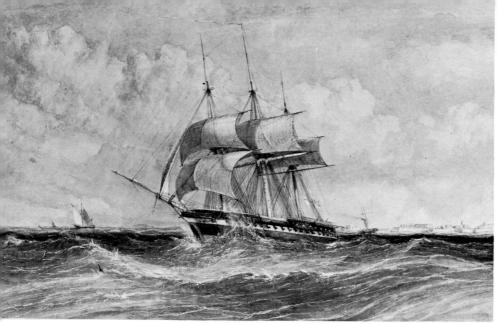

KNELL, William Adolphus (c.1805-1875)
Vernon Frigate, Malta. *Watercolour, 9¼ins. x 13¼ins.*

Knell's style was derived from that of Bonington and Bentley with much scratching to indicate the waves, using a distinctive dark green and a band of still darker water along the horizon or in the middle-distance.

(National Galleries of Scotland)

KNOX, George James (1810-1897)
Cottages under the Snow. *Watercolour heightened with white, 8ins. x 20ins.*

Knox was partial to rather garish pinks and to ochres.

(Dr. C.R. Beetles)

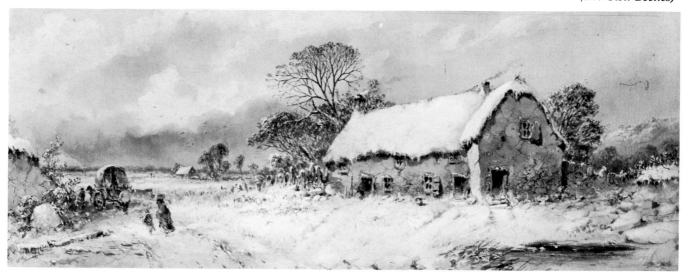

LA CAVE, Peter
Feeding Horses. *Signed and dated 1807, watercolour, 7½ins. x 10ins.*

La Cave's work is pretty, conventional and rather weak. His pencil drawings tend to be much stronger. He seems to have used both the forms La and Le Cave. There is further confusion since some of his pupils appear to have been in the habit of signing his work themselves.

(Private Collection)

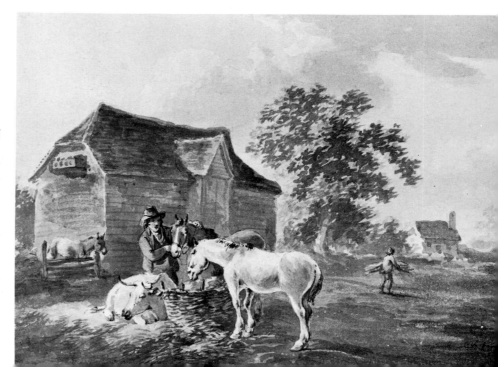

432

(Martyn Gregory)

LADBROOKE, John Berney (1803-1879)

A Wooded Lane with a Stile, and a House seen through the Trees in the Background. *Signed with monogram, watercolour, 8¼ins. x 10ins.*

(Bourne Gallery)

LAMPLOUGH, Augustus Osborne (1877-1930)

Desert Scene with Boats in the Distance. *Signed, watercolour, 9ins. x 24ins.*

Lamplough was very much of an Impressionist and the sandy effects of his desert paintings were generally achieved by leaving large areas of bare paper

(Christie's South Kensington)

LANCASTER, Percy (1878-1951)

The Flower Market. *Signed, watercolour, 13ins. x 9ins.*

Lancaster is at his best as a landscape painter in the tradition of Cox and Collier. His figure work is good, if conventional.

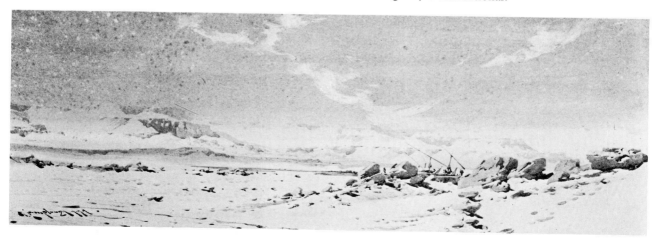

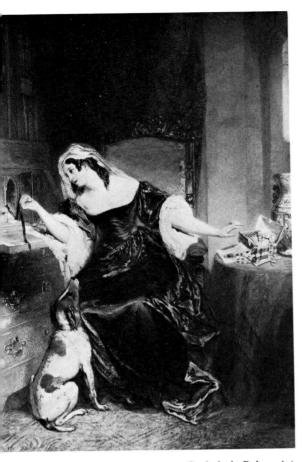

LANDSEER, Charles (1799-1878)

Sad Memories. *Signed with monogram and dated '48, watercolour, 22¼ins. x 16ins.*

From 1828 Landseer was best known for his conventional literary and costume subjects. However, he had previously visited Portugal and Brazil which inspired him to rather more spirited sketches. Inevitably, he also produced sporting pictures.

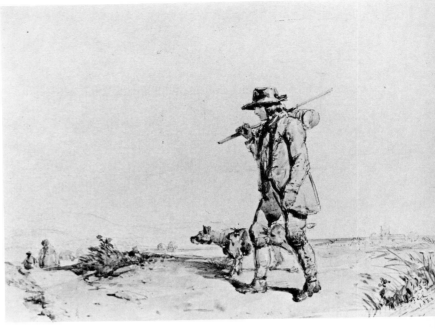

LANDSEER, Sir Edwin Henry (1802-1873)

A. Man and Dog in a Landscape. *Signed with initials and dated 1822, watercolour and bodycolour, 5¾ins. x 7¾ins.*

Landseer's watercolours are rare and for the most part date from the earlier part of his career. He was, however, a fine draughtsman working in pencil or chalk, and he also produced brown wash studies and caricatures. His monogram could possibly be mistaken for that of Edward Lear.

LANE, Rev. Charlton George (c.1840-c.1892)

A View of Venice. *Watercolour, 1¾ins. x 4⅞ins.*

Lane's colours are similar to those used by T.B. Hardy in his Venetian subjects, but his style seems to owe more to W. Callow.

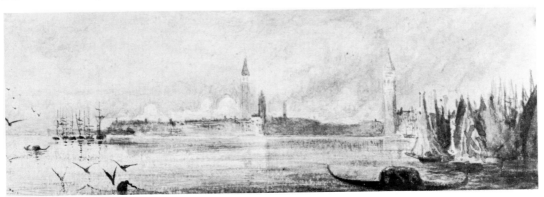

LANGLEY, Walter (1852-1922)

Tales of High Adventure. *Signed, watercolour, 21½ ins. x 25¾ ins.*

This is an ambitious composition for Langley, who more often confined himself to repetitive head and shoulder profile portraits. However, these two can show great technical accomplishment.

(Bonham's)

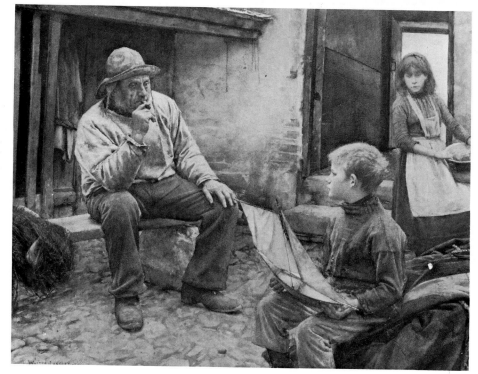

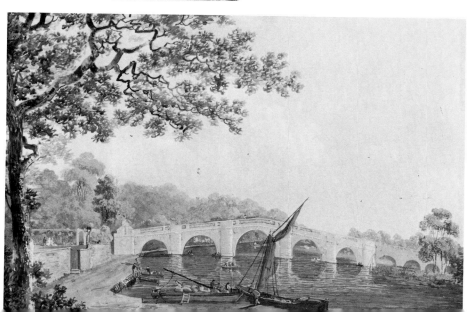

LANSDOWN, Henry Venn (1806-1860)

Ralph Allen's Town House, Bath. *Pen and grey ink and watercolour, 9½ ins. x 13¾ ins.*

(Dudley Snelgrove Esq.)

LAPORTE, John (1761-1839)

Richmond Bridge. *Signed, body-colour, 15¼ ins. x 20ins.*

The zig-zag branches and the busy hooked and fretted foliage are entirely typical of Laporte.

(Sotheby's)

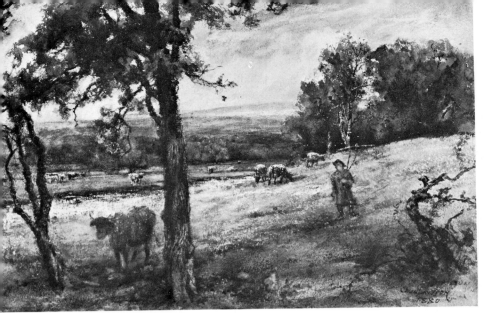

LAWSON, Cecil Gordon (1851-1882)
Riverside Pastoral. *Signed and dated 1880, watercolour, 11¾ins. x 17½ins.*
In his watercolours Lawson was an impressionist before his time.

(National Galleries of Scotland)

LEAR, Edward (1812-1888)

Perivolia, Crete. *Inscribed and dated 18 April 1864, pen and brown ink and watercolour, 6¼ins. x 9¼ins.*

(Bonham's)

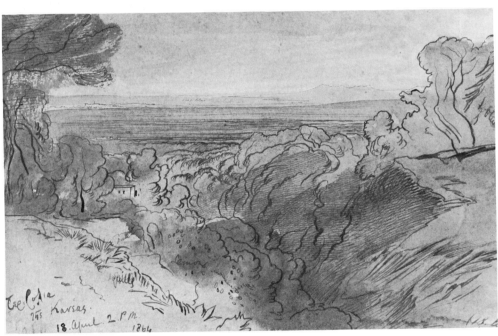

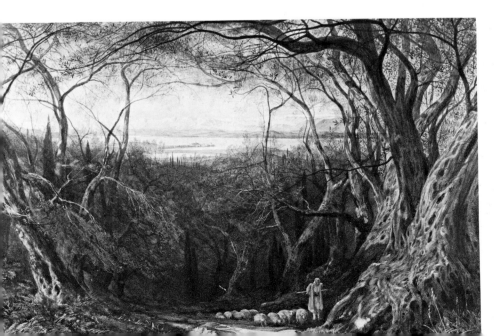

LEAR, Edward (1812-1888)
Corfu, 1871. *Watercolour, 15ins. x 22ins.*

(Christie's)

LEAVER, Noel Harry (1889-1951)

Branbach on the Rhine. *Signed, watercolour, 12ins. x 18ins.*

Leaver's most typical works are upright North African street scenes with vivid blue skies. However, he also painted in Britain and on the Continent. He often employed a basis of ochre.

(Dr. C.R. Beetles)

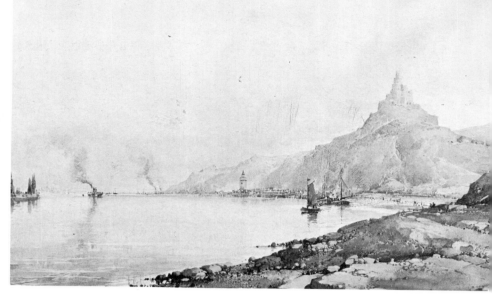

LEECH, John (1817-1864)

Bathing Woman: "Teach you to swim? Lor bless yer my love, why of course I can!" *Inscribed, pen, brown ink and watercolour, 5ins. x 6⅛ins.*

The tyro should beware of the many excellent chromolithographs after Leech's large hunting subjects.

(Fitzwilliam Museum, Cambridge)

LEGGE, Charlotte Anne, Hon. Mrs. Perceval

Deal Beach. *Signed with monogram and inscribed, pencil, pen and brown ink and watercolour, 4¼ins. x 11¼ins.*

When making finished watercolours, C.A. Legge sometimes used a linear technique which has led to her work being mistaken for that of Lear.

(Beryl Kendall)

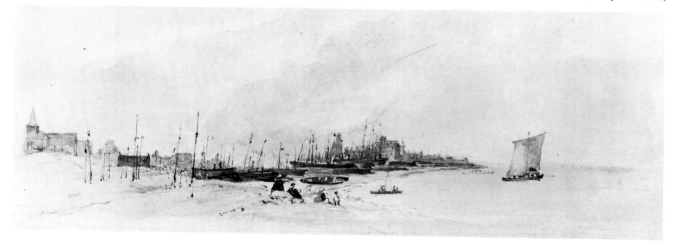

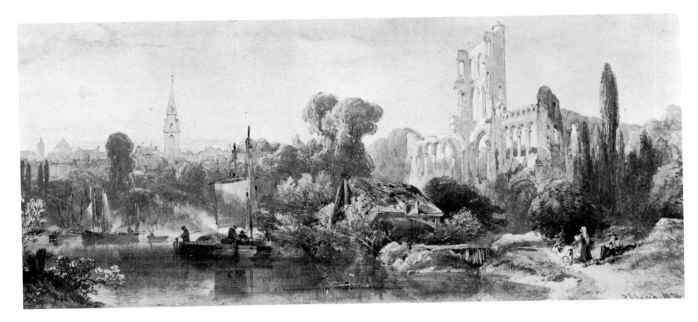

(Dr. C.R. Beetles)

LEITCH, Richard Principal

A Continental Town with a Ruined Abbey. *Signed and dated 1874, pen and brown ink and watercolour heightened with white, 9½ins. x 21ins.*

The work of R.P. Leitch is less varied than that of his brother and generally more crude in execution. He used much ochre and light green and his architecture is painstakingly outlined. He also used a characteristic grey for shadows.

LEITCH, William Leighton (1804-1883)

The Bridge at Pau. *Signed and dated 1839, watercolour, 8ins. x 12ins.*

Leitch's earlier work tends to be the more interesting.

(Christie's South Kensington)

LEITCH, William Leighton (1804-1883)

Mr. Muir's House on the Gareloch. *Watercolour, 24ins. x 40¼ins.*

(Sotheby's)

LEITCH, William Leighton (1804-1883)

Landscape with Castle. *Signed with initials and dated 1850, watercolour, 11ins. x 17½ins.*

By the date of this watercolour Leitch had developed his romantic formula of trees-lake-mountain, which has much in common with the late work of Varley and tends to be over-idyllic. His distant hills are usually a misty purple.

(Private Collection)

LENS, Bernard, III (1682-1740)

Spring Head, Wookey Hole. *Inscribed, pen, grey ink and grey wash, 9¾ins. x 14ins.*

(Dudley Snelgrove Esq.)

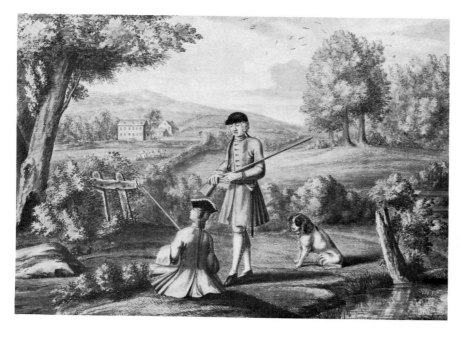

LENS, Bernard, III (1682-1740)

Two Sportsmen and a Distant Country House. *Pen and grey ink and grey wash, 9¾ins. x 13ins.*

(Dudley Snelgrove Esq.)

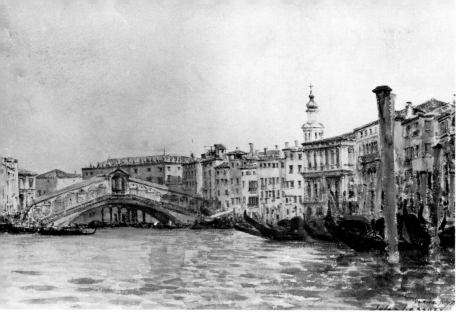

LESSORE, Jules (1849-1892)
Venice July '78. *Inscribed, signed and dated July '78, water and bodycolour, 13½ins. x 19½ins.*

(Martyn Gregory)

LEWIS, John Frederick (1805-1876)

Highland Hospitality. *Watercolour heightened with white, 21⅝ins. x 29½ins.*

This work dates from a tour of the Highlands in 1830 with George Cattermole and Evans of Eton, who are shown on the right. It contains many of the elements of Lewis's mature style. His handling of watercolour can have the fluidity of an oil sketch.

(Christie's)

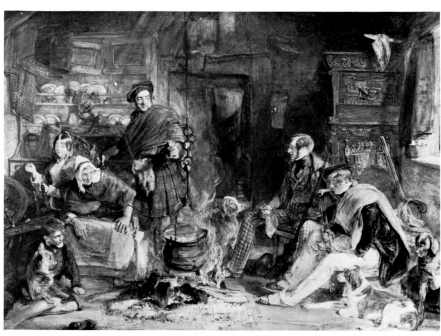

LEWIS, John Frederick (1805-1876)
A Desert Caravan. *Pen and brown ink and watercolour heightened with white, 13ins. x 31½ins.*

(Phillips)

LEYDE, Otto Theodore (1835-1897)

Drying Nets. *Signed, watercolour, 12ins. x 28ins.*
Leyde's work provides a link between the German and Dutch schools and the Scottish painters amongst whom he lived.

(Bourne Gallery)

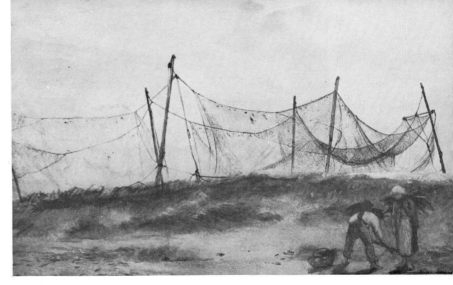

LINES, Henry Harris (1800-1889)

Guard Room, Haddon Hall. *Signed and dated 1832, watercolour, size unknown.*
Although his figure drawing is very weak, Lines had a feeling for the textures of wood and stone and was a competent landscape painter. He shared a taste for Haddon Hall and other picturesque buildings with his brother S.R. Lines.

(Maidstone Museum)

LINNELL, John (1792-1882)

Rooks Hill, Kent. *Signed and dated 1828 and inscribed, pencil, pen and brown ink and watercolour, size unknown.*
Linnell was a consumate sketcher. He often used thin washes of light green.

(Martyn Gregory)

LINNELL, John (1792-1882)

Mowers in the Field in Porchester Terrace, Bayswater. *Signed with initials, inscribed and dated June 9th 1830, and also signed in full, pencil and watercolour, 5¾ins. x 7⅜ins.*

(Christie's)

LITTLE, Robert W. (1854-1944)

(Bourne Gallery)

Near Genoa. *Signed, watercolour, 6ins. x 8ins.*

LLOYD, Thomas James (1849-1910)

'Pippins'. *Signed and dated 1895, watercolour, 6ins. x 9ins.*

(Bourne Gallery)

LLOYD, Walter Stuart
Clovelly. *Signed, watercolour, 20½ins. x 37ins.*

LLOYD, Walter Stuart
Gloucester. *Signed and inscribed, watercolour heightened with white, 29½ins. x 19ins.*

LOCKER, Edward Hawke (1777-1849)
Figure by an Oast House. *Pencil and watercolour, 3⅜ins. x 7⅞ins.*
Locker also worked in a more precise topographical manner.

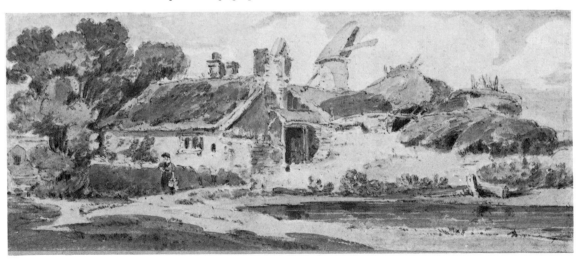

LOCKHART, William Ewart (1846-1900)

'Where the boats come in'. *Signed, pencil and watercolour, 4ins. x 7ins.*

(Martyn Gregory)

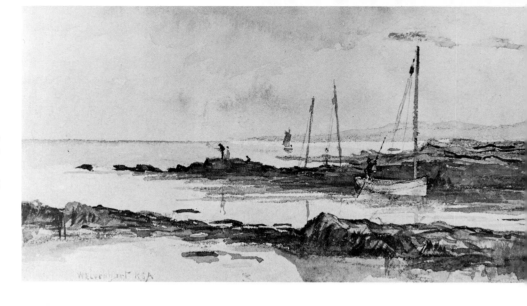

LOUND, Thomas (1802-1861)

A Norfolk Mill. *Watercolour, 12⅞ins. x 8¼ins.*

Lound is one of the best of the amateur Norwich painters with a strong sense of colour and a dashing, sketchy style. However, the work of the Rev. J. Bulwer, a fellow Cotman pupil can be close to his. He may also have been influenced by Holland and the Bonington school, as in the linear treatment of planks and roofs here.

(Private Collection)

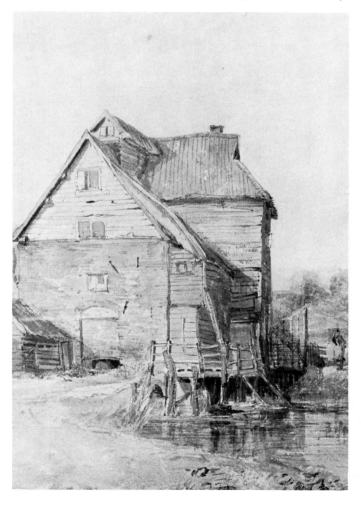

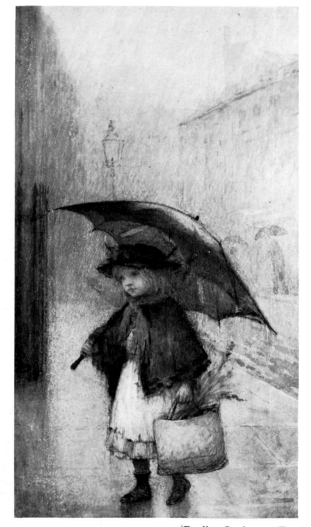

(Dudley Snelgrove Esq.)

LUDOVICI, Albert, Yr. (1852-1932)

Small Girl under a Large Umbrella. *Watercolour, 13ins. x 7¼ins.*

LUNDGREN, Egron Sellif (1815-1875)
A Young Scandinavian Girl. *Signed with initials, watercolour, 14¼ins. x 9¾ins.*

MACBETH, Robert Walker (1848-1910)
The Foster Mother. *Signed and dated 1896, watercolour, 11ins. x 19ins.*

McCLOY, Samuel (1831-1904)

A Book of Verse. *Signed, watercolour, 9ins. x 12ins.*

McCloy's genre subjects are often overworked but his portraits can be very effective. He sometimes dropped the 'Loy' of his signature to form a monogram.

McCULLOCH, Horatio (1805-1867)

Near Glencoe. *Signed, watercolour, size unknown.*

McCulloch had a considerable influence on succeeding Scottish painters but his technique and use of colour tend to be rather untidy.

(National Galleries of Scotland)

McKEWAN, David Hall (1817-1873)

Harlech Castle. *Signed and dated 1843, watercolour, 20ins. x 30ins.*

In his landscapes McKewan is a slightly pedestrian follower of Cox, but he also painted dashing and pleasing studies of trees and woods often in brown wash. He worked in the Near East as well as in Britain.

(Bourne Gallery)

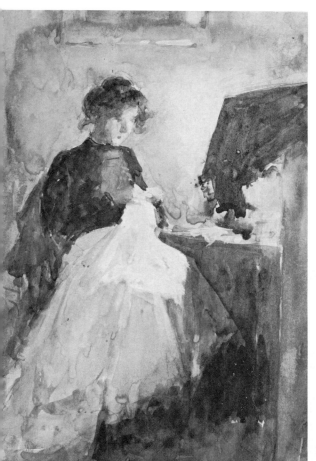

(Beryl Kendall)

McEVOY, Arthur Ambrose (1878-1927)

Woman Sewing. *Pencil and watercolour heightened with white, 9ins. x 6⅛ins.*

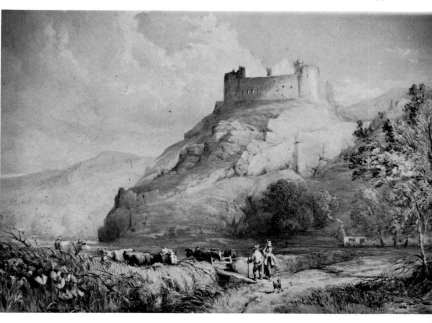

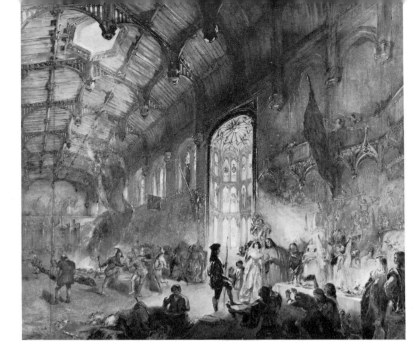

MACLISE, Daniel (1806-1870)
A Medieval Banquet. *Signed, watercolour heightened with white, 23⅜ins. x 25¼ins.*

(Christie's)

McTAGGART, William (1835-1910)
Dawn at Sea — Homewards. *Signed, watercolour, 11¼ins. x 15⅜ins.*
McTaggart was the first of the Scottish Impressionists and has been described as the greatest painter of the sea in motion. He often used small sheets of rough, damp paper. In his early work he often uses white heightening. Later he preferred to leave untouched areas of paper.

(National Galleries of Scotland)

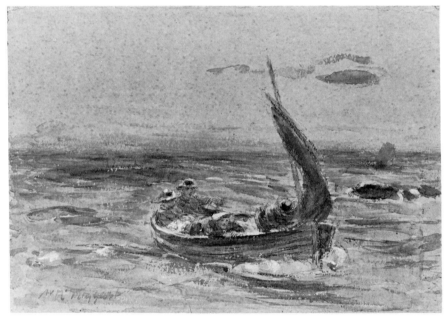

MacWHIRTER, John (1839-1911)
View in the Trossachs. *Signed with initials, watercolour heightened with bodycolour, 12¼ins. x 18¼ins.*
Unless one is feeling very strong the work of John MacWhirter, with its repeated compositions of silver birch and purple heather can be a little nauseating. When he is working to less of a formula however he can be quite pleasantly Whistler-like and impressionistic. The 'MacW' signature is typical.

(Sotheby's Belgravia)

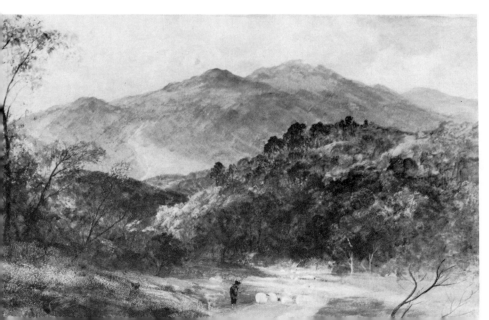

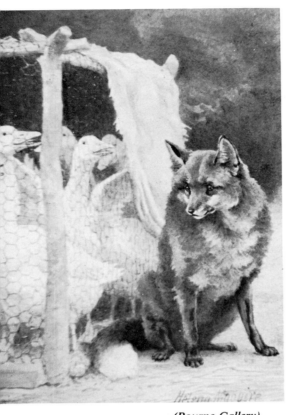

(Ashmolean Museum)

MALCHAIR, John Baptiste (1731-1812)
View from the Warden's Lodgings, New College. *Extensively inscribed on reverse and dated 20 Nov. 1786, 'This drawing served as a lesson in the art of perspective to the lady of Doctor Oglander the present warden', pencil and watercolour, 11¾ins. x 17⅜ins.*

(Bourne Gallery)

MAGUIRE, Helena J. (1860-1909)
Foxed. *Signed, watercolour, 9ins. x 7ins.*

MALTON, Thomas, Yr. (1748-1804)
Covent Garden. *Watercolour, size unknown.*

(Spink & Son Ltd.)

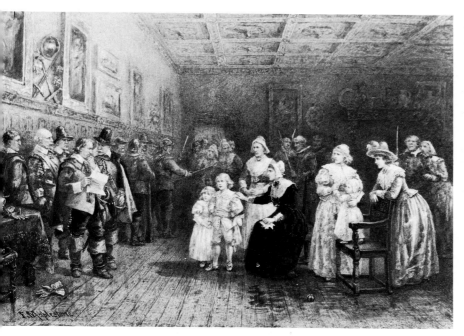

(Christie's South Kensington)

MAPLESTONE, Florence E.
'When Did You Last See Your Father?' *Signed, watercolour, 13ins. x 18½ins.*
See under Maplestone, Henry, in Volume One.

(Dudley Snelgrove Esq.)

MANBY, Thomas (-1695)
A Lane with a Bank of Trees. *Signed and dated '56, grey wash, 15½ins. x 10⅛ins.*

MARKES, Albert Ernest (1865-1901)
Beach at Scheveningen with Beached Boats. *Signed and inscribed, watercolour heightened with white, 18⅞ins. x 28ins.*

A particularly fine variation on Markes's usual theme.

(Phillips)

449

(Beryl Kendall)

MARKS, Henry Stacy (1829-1898)

A Parakeet. *Pencil and watercolour heightened with white, 12¼ins. x 9¼ins.*

Marks is at his best with dashing and lively studies of birds, often parrots. He also produced more elaborate and ambitious compositions on literary subjects and landscapes, often near the Suffolk coast. He made good use of bodycolour.

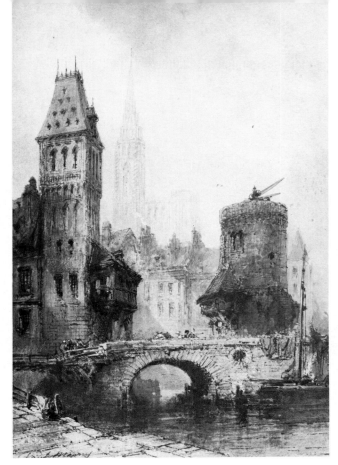

(Sotheby's)

MARNY, Paul (1829-1914)

Strasbourg. *Signed, watercolour heightened with bodycolour, 17¾ins. x 12ins.*

MARLOW, William (1740-1813)

Castel 'Elmo, Posillipo. *Pencil, pen and grey ink and watercolour, 15¼ins. x 25⅜ins.*

An example of Marlow's more precise and sober style.

(Christie's)

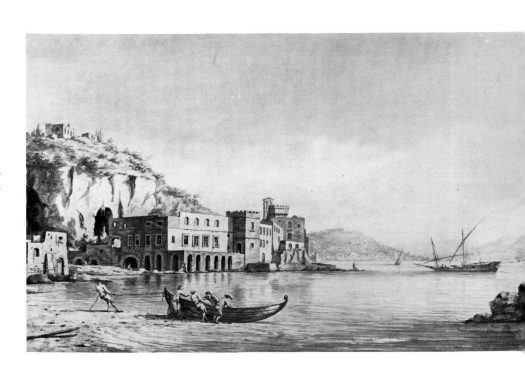

MARRIS, Robert (1750-1827)
View of Foremark 1795 with Swarkestone Bridge in the Distance. *Pen and ink and watercolour, size unknown.*

Marris provides a link between A. Devis and F. Towne and his style combines elements of theirs. Here the handling of the foliage owes much to the former and the geometrical planes of the composition perhaps derive from the latter. His work is often signed and inscribed on the reverse, and the signature has been misinterpreted as Morris.

(Derby Museum and Art Gallery)

MARSH, Arthur Hardwick (1842-1909)
The Hesperus. *Signed and dated 1868, watercolour, 29½ins. x 21ins.*

(Stephen Furniss)

MARSHALL, Charles (1806-1890)
View of St. Pauls and Waterloo Bridge, Somerset House to the left. Taken from the Gallery of the Shot Tower. *Watercolour, 6ins. x 4½ins.*

(Martyn Gregory)

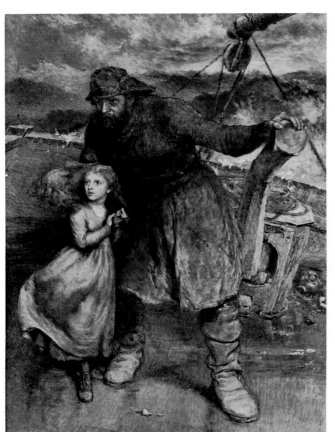

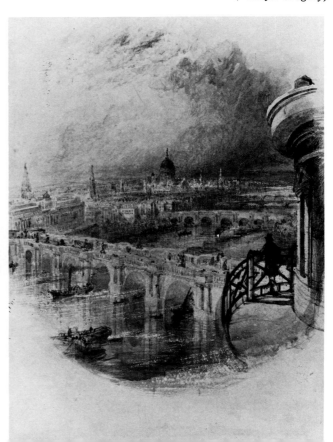

(Private Collection)

MARSHALL, Herbert Menzies (1841-1913)

St. Pauls from the Thames. *Signed and dated 1880, watercolour heightened with white, 6½ins. x 9¾ins.*

A typical subject for Marshall who also painted French Cathedrals and rivers. His work is generally on a small scale and in a free style with much use of blues and russets.

(Dudley Snelgrove Esq.)

MARTIN, Elias (1739-1818)

A Milliner, Miss Laverock. *Watercolour, 10ins. x 6¼ins.*

MARTIN, John (1789-1854)

(Christie's)

A Distant View of Eastbourne, showing a line of Martello Towers. *Watercolour heightened with white, 8½ins. x 21½ins.*

Martin's watercolours are usually composed on a horizontal plane and this example shows his use of stippling and dragging in the foreground.

MARTINEAU, Edith (1842-1909)

Cutting Gorse, Cockshot Hill. *Signed and dated 1890, watercolour, 9ins. x 11ins.*

(Bourne Gallery)

MASON, Frank Henry (1876-1965)

Katwyk Beach. *Signed with initials and inscribed, watercolour, 6¼ins. x 8½ins.*

This drawing shows kinship with the handling of studies of exactly similar subjects by T.B. Hardy.

(Martyn Gregory)

MAY, Captain Walter William (1831-1896)

A Fishing Boat at Low Tide. *Signed and dated '55, watercolour heightened with white, 8ins. x 13ins.*

A worker in the traditions of E.W. Cooke and C. Stanfield. May's naval experience ensured his accuracy in the depiction of shipping.

(Bourne Gallery)

MEDLYCOTT, Rev. Sir Hubert James (1841-1920)
Venice, Sunset over San Giorgio. *Signed and dated Oct 24 1891, watercolour, 8ins. x 14ins.*

(Bourne Gallery)

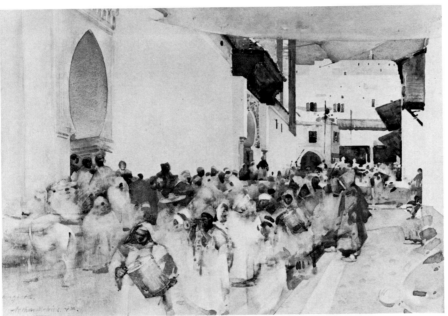

MELVILLE, Arthur (1858-1904)
A Moorish Procession. *Inscribed 'Tangiers' and signed and dated '73, watercolour, 23¾ins. x 31¾ins.*

(National Galleries of Scotland)

MENDS, Captain George Pechell (-?1872)
H.M.S. Bellerophon, 78 Guns, Captain Lord George Paulet, Malta, May 1853. *Signed, inscribed and dated, watercolour, 18ins. x 25ins.*

(Sotheby's)

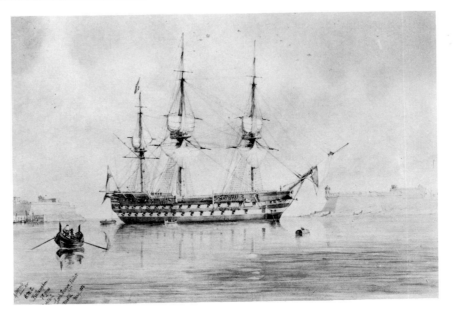

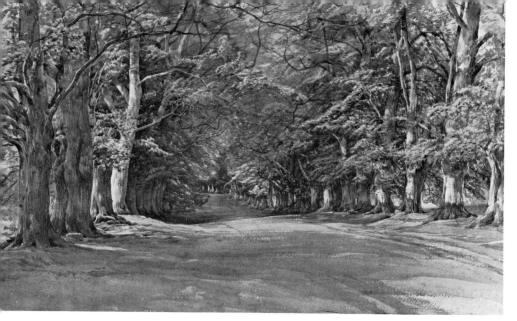

MIDDLETON, John (1827-1856)

An Avenue of Trees in Gunton Park. *Watercolour, 12¼ins. x 18¼ins.*

Middleton is one of the best of the later Norwich painters in watercolour. Like the rest of the school he is preoccupied with light and his studies of plants can be very effective.

(Christie's)

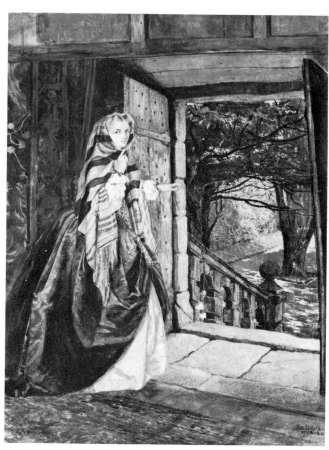

(Dudley Snelgrove Esq.)

MILLAIS, Judith Agnes Boothby

Dorothy Vernon at Haddon Hall. *Signed and dated 1861, watercolour, 16½ins. x 13ins.*

See under Millais, William Henry, in Volume One.

MILLAIS, William Henry (1828-1899)

The Trossachs. *Signed and inscribed, watercolour 17ins. x 24ins.*

One can see the stippling which is so typical of much of Millais's work here. His work is usually intensely rendered, but he was too unambitious in his choice of subject matter to exercise his talents fully.

(Bourne Gallery)

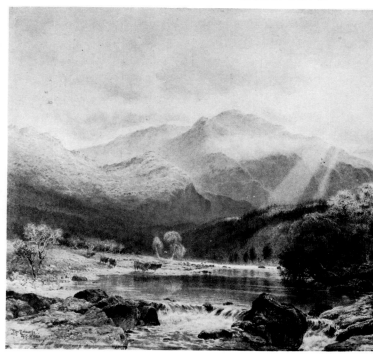

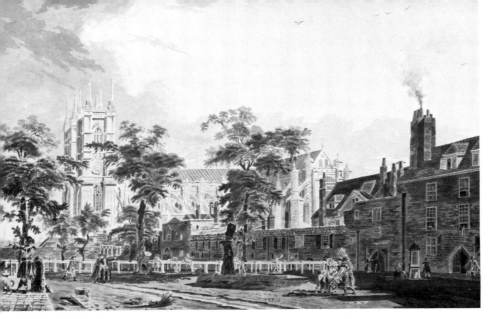

MILLER, James
Westminster Abbey from Dean's Yard.
*Pencil and watercolour, 16ins. x
24⅜ins.*
An attractive, if sometimes inaccurate
worker in the manner of Sandby. His
figures are sometimes out of scale.

(Christie's)

**MITCHELL, William Frederick
(c.1845-1914)**
H.M.S. Victoria. *Signed and dated
1891, and numbered 1539, water-
colour, 20ins. x 29ins.*
The number at the bottom left of this
watercolour should be noted since
Mitchell numbered all his works up
to at least 3,500.

(Sotheby's)

MOGFORD, John (1821-1885)
Tantallon Castle. *Signed and
inscribed 'Langham Sketching
Club March 1865', watercolour,
8ins. x 14ins.*

(Bourne Gallery)

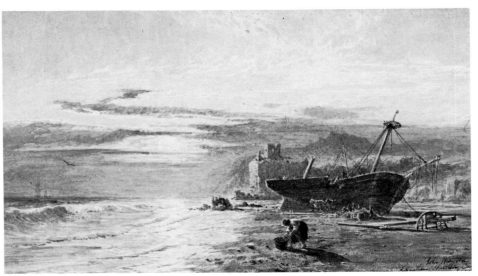

MOLE, John Henry (1814-1886)

Watermill near Chagford, Devon, with Children making Daisy-chains. *Signed and dated 1870, watercolour heightened with white, 11½ins. x 17⅜ins.*

Like Birket Foster with similar subjects Mole used a precise stippled technique. His children are usually more weakly drawn than the landscape settings.

(Christie's)

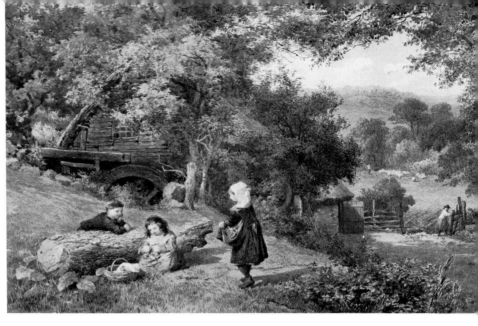

MONRO, Alexander (1802-1844)

Old Houses perhaps near Bushey. From a Sketchbook. *Watercolour, 10½ins. x 8¼ins.*

(Sotheby's)

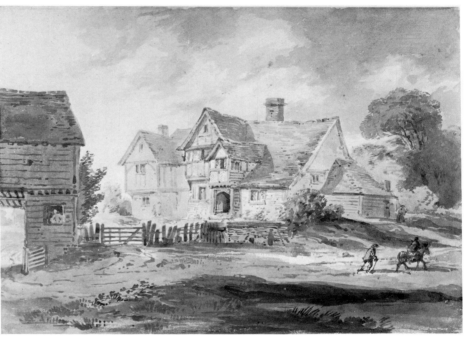

MONRO, Dr. Thomas (1759-1833)

Landscape with Horseman. *Charcoal and brown wash heightened with white on blue paper, 10½ins. x 14¾ins.*

This drawing shows the influence that the style of Gainsborough had on Monro's. The Doctor is, however, usually a little more specific as to detail than his master. He was an excellent, if traditional, draughtsman.

(Ashmolean Museum)

457

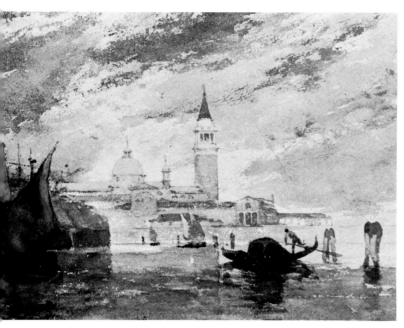

MONTALBA, Clara (1842-1929)

San Giorgio, Venice. *Signed and dated 1881, watercolour, 8ins. x 11ins.*

Some of Montalba's Venetian subjects are very much more highly finished, and less interesting, than the present example.

MOORE, George Belton (1806-1875) *(Sotheby's)*

A View down Fish Street Hill, London, showing the Monument and St. Magnus-the-Martyr. *Signed and dated 1830, watercolour, 21ins. x 14½ins.*

Moore was a pupil of A. Pugin whose careful architectural drawing he imitated and whose weakness in figure drawing he shared. As well as London buildings he painted Italian subjects.

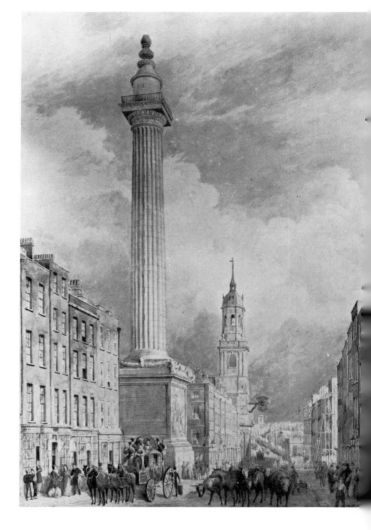

MOORE, Henry (1831-1895)

Whitby Sands at Low Water, from the Cliffs near Mulgrave. *Signed, inscribed and dated 1864, watercolour, 13¼ins. x 20¾ins.*

A late example of Moore's Pre-Raphaelite manner. He is best known for his impressionistic marine paintings in which the role of shipping is subordinated to that of the sea. His impressionism is based upon very careful study.

(Christie's)

458

MORE, Jacob (1740-1793)

View of Inveresk. *Signed, black chalk and brown wash, size unknown.*

An example of More's Scottish style, before he had adopted the Claudian formula of his Roman period.

(National Galleries of Scotland)

MORE, Jacob (1740-1793)

A View of Vico Varo, Italy. *Pen and grey ink and watercolour, size unknown.*

More is best known for his Italian watercolours which are often, as here, romantic river valleys. In this mood he is a disciple of Claude. His pen outlines are careful, if stylised, and his colours are predominantly muted greys and greens.

(National Galleries of Scotland)

MORTIMER, John Hamilton (1741-1779)

A Captive Maiden brought before a Barbarian Chief in a Cave. *Pen and grey ink and watercolour, 7½ins. x 11ins.*

The careful hatching in this drawing is entirely typical of Mortimer. In his unwashed pen drawings he goes further with dotting and hatching which imitate stipple engraving.

(Christie's)

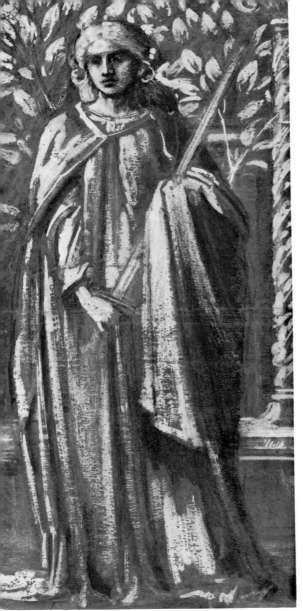

MOTTRAM, Charles Sim

Between Sea and Sky. *Signed and dated 1889, watercolour, 19ins. x 32ins.*

As well as coastal and landscape paintings Mottram produced figure and genre subjects.

MORRIS, William (1834-1896)

Justice. *Black chalk and bodycolour on brown paper, 17ins. x 9ins.*

A number of employees of Morris and Co., including Fairfax Murray, produced very similar designs.

MUIRHEAD, John (1863-1927)

A Farm Track. *Signed and dated 1922, watercolour, 7ins. x 9⅞ins.*

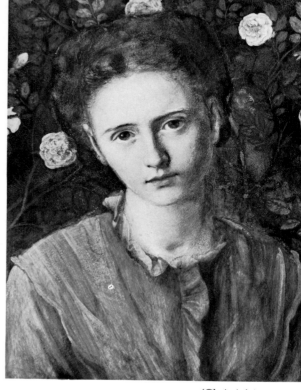

MULLER, William James (1812-1845)

Glen Ledder. *Signed with initials and inscribed, watercolour, 12¾ins. x 20¼ins.*

An example of Muller's work in pure watercolour which illustrates his dashing technique at its most effective. He was ambidextrous and the backward sloping inscription and reversed initials are typical. At times he made use of bodycolour and tinted paper. He also built up his tints with layers of colour rather in the manner of de Wint.

MURRAY, Charles Fairfax (1849-1919)

Portrait of Clara Sentance, Wearing a Red Dress against a Background of Roses. *Signed, inscribed and dated 1870 on the reverse, watercolour and bodycolour, 11¾ins. x 9¼ins.*

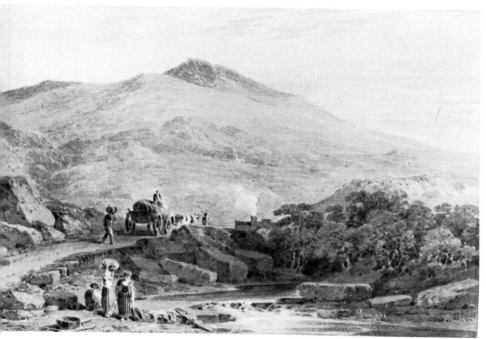

MUNN, Paul Sandby (1773-1845)

Moel Siabod from the Bangor Road. *Signed and indistinctly dated, watercolour, 6⅛ins. x 9⅛ins.*

Munn also worked in elegant, if unambitious, grey wash.

NAFTEL, Isobel, Mrs.

Portrait of Young Boy and Girl. *Signed and dated June 28th 1859, watercolour, 19½ins. x 16ins. oval.*

As well as for portraits Mrs. Naftel was well-known for views in the Channel Islands and on the south coast, and for flower pieces and genre subjects.

(Stephen Furniss)

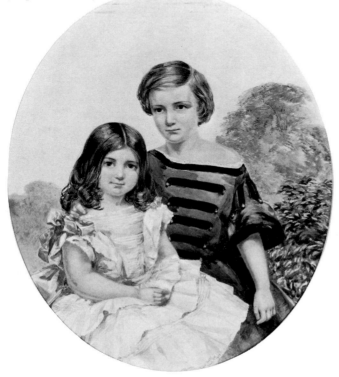

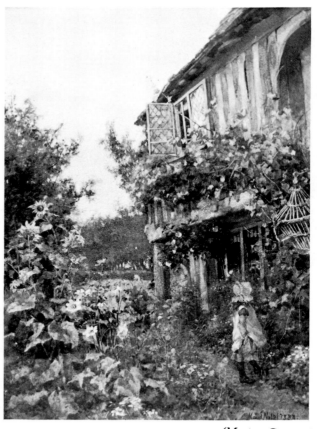

(Martyn Gregory)

NAFTEL, Maud (1856-1890)

A Cottage Garden. *Signed and dated 1888, watercolour heightened with white, 12ins. x 10ins.*

When working as a pure landscape painter rather than, as here, in the manner of Helen Allingham, Maud Naftel was perhaps the most accomplished of her family.

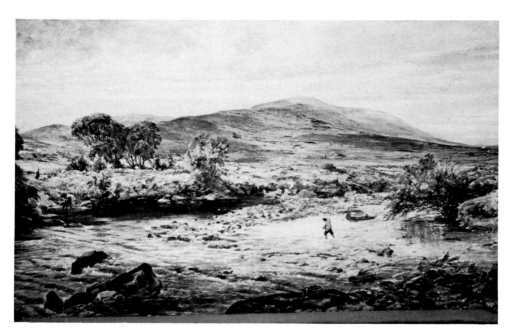

NAFTEL, Paul Jacob (1817-1891)

Blackwater Bridge, Kenmare, Ireland. *Signed and dated 1861, watercolour, 35ins. x 17ins.*

(Bourne Gallery)

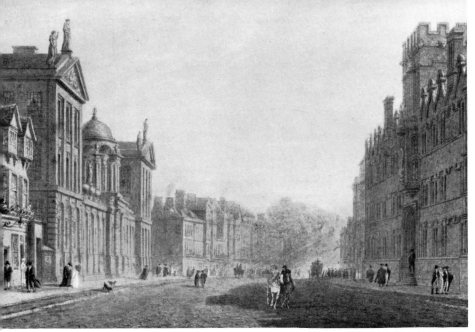

NASH, Frederick (1782-1856)
The Queen's College and the High. *Pencil and watercolour heightened with white, 8ins. x 10⅜ins.*
The aquatint from this watercolour was published in 1814.

(Christie's)

NASH, Joseph (1809-1878)
Cooper's College Hall. *Signed, heightened with white, 12¼ins. x 16ins.*

Although apparently no relation Nash shared the subject matter and some of the failings of his older contemporary and namesake Frederick. In particular both tended to overuse bodycolour. Joseph's work is characterised by a neatness and precision of detail which is to be expected from a lithographic draughtsman.

(Sotheby's)

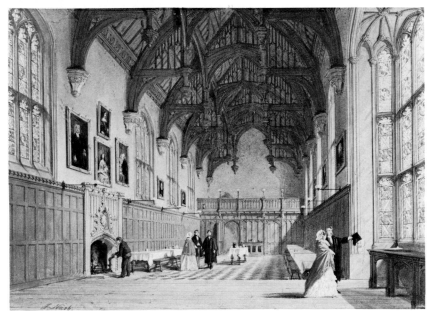

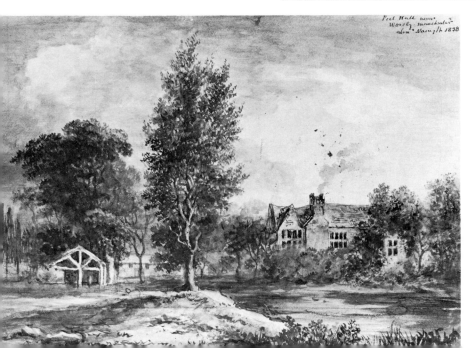

NASMYTH, Alexander (1758-1840)
Peel Hall near Manchester. *Signed, inscribed and dated 1838, watercolour heightened with white over pencil, size unknown.*

(National Galleries of Scotland)

463

NASMYTH, Alexander (1758-1840)

(Agnew)

Edinburgh from the East. *Pen and grey ink and watercolour, 13¾ins. x 17½ins.*

NAYLOR, Thomas (fl.1778-1800)

Shipping in a Calm. *Signed and dated 1794, pen and ink and watercolour, 8½ins. x 11ins.*

(Martyn Gregory)

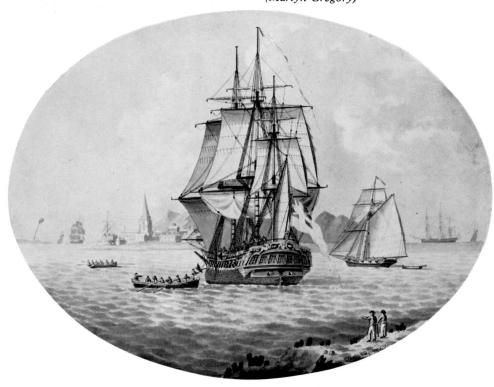

464

NEALE, John Preston (1780-1847)
Tottenham Church. *Signed and dated 1815 and inscribed on reverse, watercolour, 5¾ins. x 8ins.*

(Martyn Gregory)

NEALE, John Preston (1780-1847)
St. Paul's Cathedral from the River. *Signed and dated 1835, watercolour, 5½ins. x 8½ins.*

This is a fairly typical example of Neale's London work, except that he often used a careful pen outline. His favourite colour is green and his lighting can be a little lurid.

(Sotheby's)

NESFIELD, William Andrews (1793-1881)
The Falls of Tummel. *Watercolour heightened with white, 27ins. x 38ins.*

Nesfield's period as a professional painter lasted from 1816-1852, although, of course, he drew at other times. His work can provide excellent examples of the style fostered by the 'Annuals' in the 1820s and 1830s.

(Christie's)

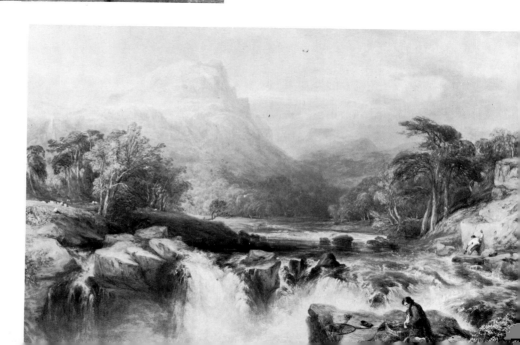

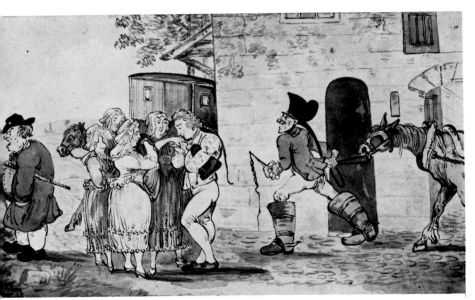

NEWTON, Richard (1777-1798)
The Inn at Montreuil, with the Valet la Fleur taking leave of the Wenches — an illustration for L. Sterne, *'A Sentimental Journey'. Watercolour, 5¼ins. x 8¼ins.*

Newton was a very weak draughtsman and his colouring is harsh. The faces of the group in the centre with their features drawn as in a medieval manuscript may be a hallmark.

(Sotheby's)

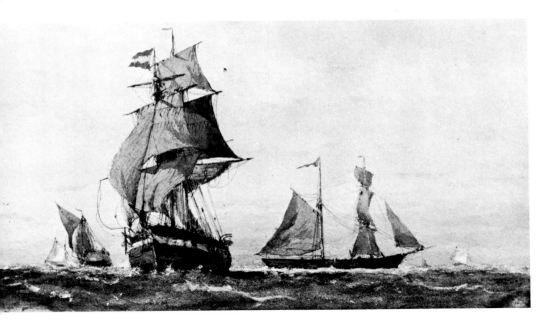

NIBBS, Richard Henry (1816-1893)
A Merchantman Going About. *Signed, watercolour, 12ins. x 22ins.*

(Bourne Gallery)

NICHOLL, Andrew (1804-1886)
Landscape with Town through a Bank of Flowers. *Signed, watercolour, size unknown.*

Nicholl's career began with charming, if naïve, views on the Antrim coast, before moving to antiquarian subjects for lithography and his well-known series of Irish ports seen through a fringe of wild flowers. In these the predomininant colour is a dark green. Later in Ceylon he often worked in pencil with white heightening on buff paper and in the 1860s his favourite subjects were storms, again on the Antrim coast.

(National Gallery of Ireland)

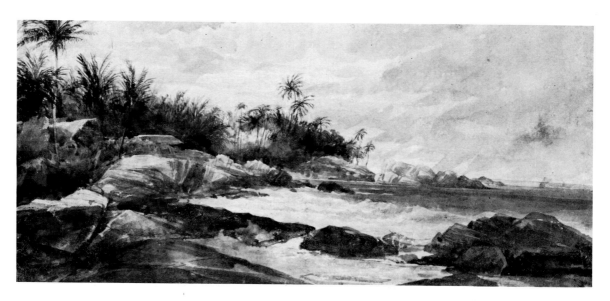

NICHOLL, Andrew (1804-1886)
Mutwell, Colombo, 1846. *Signed, water-colour, 7ins. x 14ins.*

(Martyn Gregory)

NICHOLSON, Francis (1753-1844)
Salzburg in an extensive Landscape with Farm and Figures in the Foreground. *Watercolour, 12ins. x 18ins.*

As with all Nicholson's foreign views this watercolour is based on a sketch by a travelling amateur. His rather woolly drawing of foliage can be seen in the middle ground. In many of his works there is a rather Payne-like barbed wire effect of grasses in the foreground.

NIEMANN, Edmund John (1813-1876)
Knole. *Signed, inscribed and dated '50, watercolour heightened with white, size unknown.*

At times Niemann also worked in a free style which is reminiscent of that of Muller.

(Christie's)

467

NISBET, Robert Buchan (1857-1942)

Cattle by a Pond on the Moors. *Signed, water-colour, 6½ins. x 11ins.*

NIXON, John (c.1750-1818)

Francis Grose on Howth Head with a view of Ireland's Eye and Lambay. *Inscribed, water-colour, 7⅜ins. x 10¼ins.*

This watercolour dates from 1791.

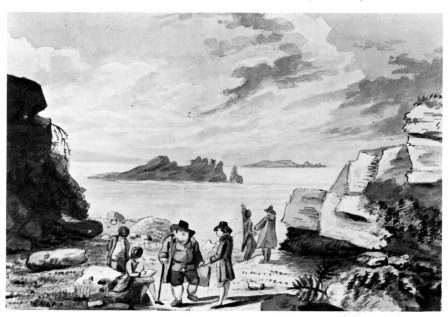

NIXON, John (c.1750-1818)

Greenwich Fair. *Signed with initials, inscribed and dated 1802, pencil and water-colour, 4¼ins. x 6¾ins.*

Nixon's anatomical drawing can often be faulted although his caricature portraits were said to be extremely like. He was an inveterate sketcher and his technical accomplishment grew throughout his career. Although he is best known for his caricatures he also painted pure landscapes and shipping subjects. In the present example the trees on the left show the influence of his friend Rowlandson.

NIXON, John (c.1750-1818)
Eagle Owls at Arundel Castle. *Signed with initials, dated 1807 and inscribed 'Drawn Vivam', watercolour, 4⅞ins. x 7¾ins.*

(Christie's)

NIXON, Rev. Robert (1759-1837)
Magdalen College and the High. *Signed and dated 1795, pencil and watercolour, 11¾ins. x 14¾ins.*
Nixon was an early friend and patron of Turner and the influence of Dayes may have been transmitted to him by his protegé. It is also possible that he produced some unclerical caricatures under the influence of his brother John, although on the evidence of his etchings his anatomical drawing was more accurate and less exaggerated.

(Ashmolean Museum)

NOBLE, R.P.
Extensive Rural Landscape with Anglers on a Bridge. *Signed, watercolour, 18¼ins. x 25ins.*
Noble's themes and style are generally based on those of Cox.

(Bonham's)

NORIE, Orlando (1832-1901)
The 86th Regiment Embarking from a Port. *Signed, watercolour, heightened with white, 13¼ins. x 20½ins.*

(King & Chasemore)

NORTH, John William (1842-1924)
The Garden at Halsway Manor, Somerset. *Inscribed on reverse 'Built by Cardinal Beaufort', watercolour heightened with white, 7¾ins. x 8⅞ins.*

(Christie's)

NUTTER, Matthew Ellis (1795-1862)
Wetheral Viaduct c.1835. *Watercolour, 5⅜ins. x 8½ins.*

(Carlisle Art Gallery)

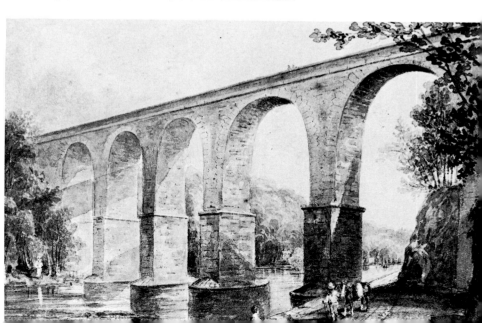

NUTTER, William Henry (1821-1872)
Carlisle. *Signed and dated 1859, watercolour, 7ins. x 11½ins.*

(Lawrence of Crewkerne)

OAKLEY, Octavius (1800-1867)
Portrait of Miss Isobel Oakley. *Watercolour, 20½ins. x 14¼ins.*
The sitter in this portrait was the daughter of the artist and the second wife of P.S. Naftel, as well as being a painter in her own right. Oakley normally specialised in gypsies and similar characters.

(Sotheby's)

(Martyn Gregory)

OLIVER, Emma Sophia, Mrs., neé Eburne (1819-1885)
In the Lake District. *Signed, watercolour, 14ins. x 19ins.*
After the death of her husband William in 1853 and her subsequent remarriage, she continued to use the name Oliver for professional purposes.

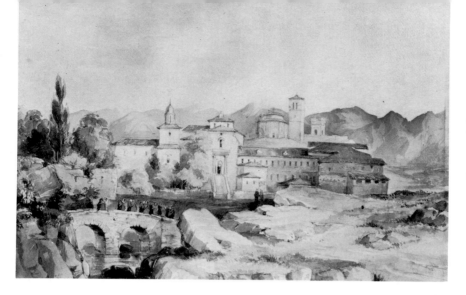

OLIVER, William (c.1804-1853)
The Convent of the Angels, Malaga.
Watercolour, 9½ins. x 14½ins.

(Sotheby's)

O'NEILL, Hugh (1784-1824)
A Church and Old Buildings (Bristol).
*Pen and grey ink and watercolour,
7½ins. x 12ins.*
O'Neill's known signatures include Neil,
Neill, O'Neil and O'Neill.

(Dudley Snelgrove Esq.)

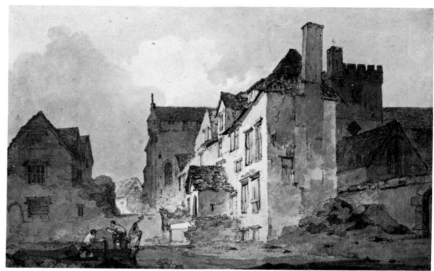

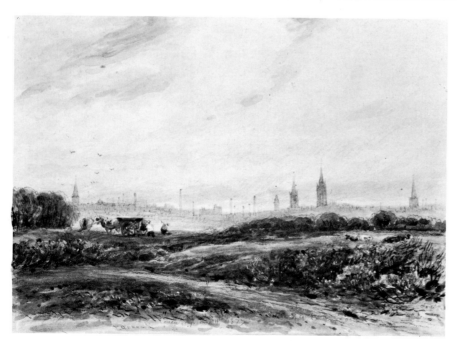

ORROCK, James (1829-1919)
A View of Coventry. *Signed, inscribed
and dated June 11 1877, pencil and
watercolour, 9ins. x 12ins.*

(Dr. C.R. Beetles)

472

OWEN, Samuel (1768-1857)

Shipping off the English Coast. *Signed and dated 1795. Pen and ink and watercolour, 7½ins. x 10ins.*

The linear use of grey in the water is typical of Owen's manner.

(Martyn Gregory)

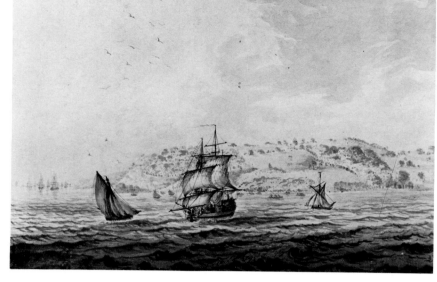

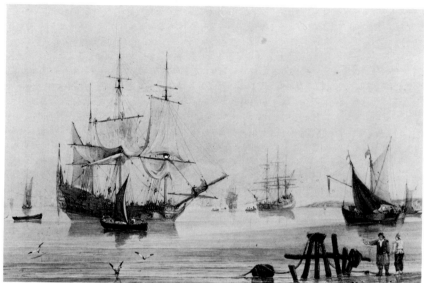

OWEN, Samuel (1768-1857)

Men-O-War and other Vessels at Anchor in a Bay. *Signed and dated 1822, watercolour, 8ins. x 11½ins.*

(Sotheby's)

PAGE, William (1794-1872)

Budletts, Uckfield. *Watercolour, 9¾ins. x 12½ins.*

Page was a competent and pleasing, if not great artist. He specialised in architectural and landscape subjects and sometimes made effective use of rich, dark greens.

(Beryl Kendall)

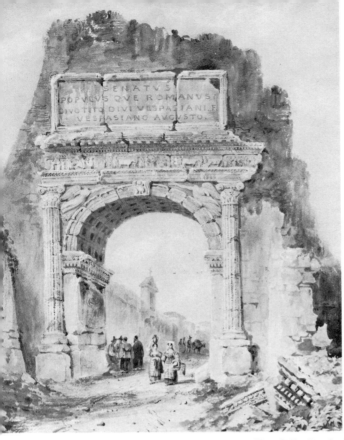

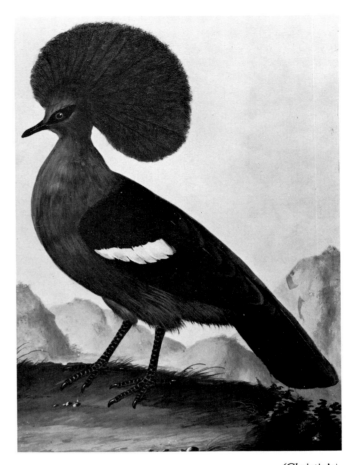

(Dr. C.R. Beetles)

PAGE, William (1794-1872)

The Arch of Titus. *Watercolour, 22ins. x 16ins.*

The mixture of rough linear drawing with the brush on the columns, trailing tendrils to the left and freely indicated stone work around the arch is very typical of Page.

(Christie's)

PAILLOU, Peter

Crowned Pigeon. *Bodycolour, 19½ins. x 13½ins.*

PALMER, Harry Sutton (1854-1933)

Reigate Heath. *Signed, watercolour, 10ins. x 14ins.*

(Bourne Gallery)

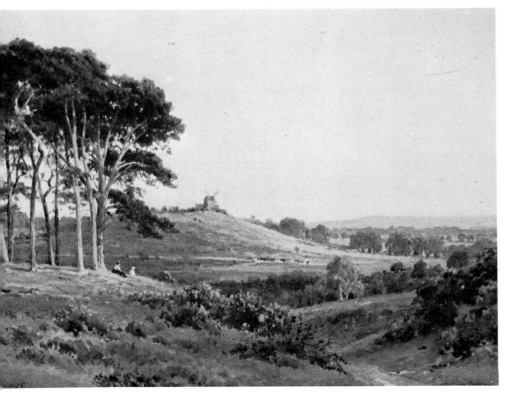

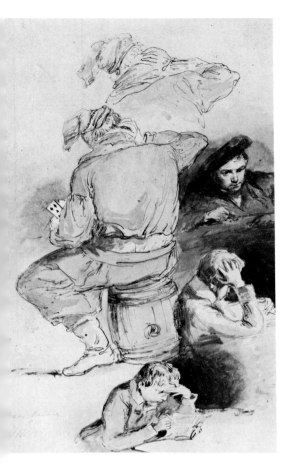

(Dr. C.R. Beetles)

PARKER, Henry Perlee, 'Smuggler' (1795-1873)

Studies of Smugglers and Others. *Signed with initials, inscribed and dated 1830, pen and grey ink and watercolour, 18¾ins. x 11¼ins.*

PARRIS, Edmund Thomas (1793-1873)

Temple of Olympian Zeus and the Acropolis. *Pencil and watercolour, 23ins. x 35⅝ins.*

The weakness of Parris's drawing and his failure to grasp the opportunities offered by a dramatic composition are well illustrated in this example of his work.

(Fine Art Society)

PALMER, Samuel (1805-1881)

The Street of Tombs, Pompei. *Signed with monogram and inscribed 'May I beg that you look at the study first in a very subdued light' on the reverse, pen and brown ink and watercolour heightened with white, 12¾ins. x 16¼ins.*

A watercolour made on the spot during Palmer's Italian honeymoon from 1837-1839. The inscription is possibly an indication that he sent it back to his father-in-law, John Linnell.

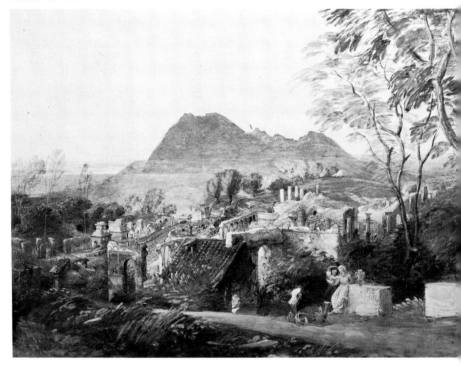

(Christie's)

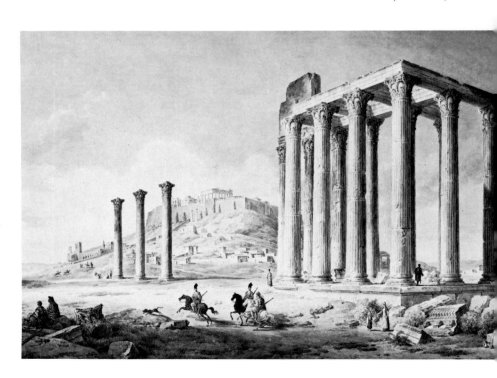

PARS, William (1742-1782)

The Falls at Powerscourt, County Wicklow. *Pen and grey ink and watercolour, 10¼ins. x 14¾ins.*

An example of Pars' later and looser style which is much less stylised than his early work in Greece and less exact than his last drawings in Rome. In this mood he represents a separate line of development to Sandby and in some ways is the precursor of the young Girtin and Turner.

(Christie's)

PARSONS, Arthur Wilde (1854-1931)

San Giorgio Maggiore: Venice. *Signed and dated 1903, watercolour, 14ins. x 22ins.*

This drawing is in a loose and damp style typical of the period, but after his further visit to Italy in 1911 Parsons adopted a Pre-Raphaelite clarity of colour and detail. Apart from Venice, his favourite sketching grounds were the Bristol area and Cornwall.

(Bourne Gallery)

PATON, Waller Hugh (1828-1895)

Kyle Akin, Skye. *Signed, inscribed and dated 12 July 1866, watercolour heightened with white, 9ins. x 14¼ins.*

Much of Paton's work was done in the open air and is thus rather dashing. However, in his earlier days he was influenced by the Pre-Raphaelites.

(Sotheby's)

476

PEARSON, Cornelius (1809-1891)

A Highland Loch. *Signed and dated 1856, watercolour, 23ins. x 37ins.*

Pearson's figure drawing was poor as can be seen here, which is why he often collaborated with such men as H. Tidey and T.F. Wainwright, the cattle painter.

(Bourne Gallery)

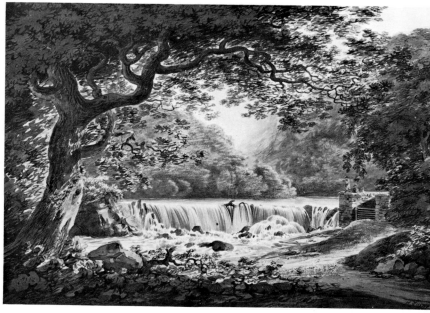

PAYNE, William (c.1760-1830)

Sir Francis Drake's Weir, on the River Tavy, Devon. *Signed and inscribed on old paper, watercolour, 11½ins. x 15¾ins.*

Payne was one of the drawing masters who owed their success to their easily copied mannerisms, many of which appear in this example. They included exaggeratedly curling branches, and a squiggly manner of foliage drawing, linear treatment of water and much dragging in the foreground. He often obtained depth by building up layers of grey, including his own pigment which is still known as Payne's Grey.

(Martyn Gregory)

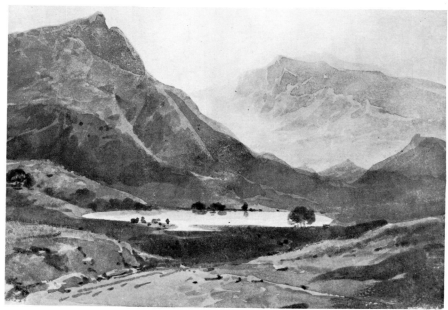

PEARSON, William

Llyn Nantlle Uchaf, Near Caernarvon. *Inscribed on reverse 'Ly. Nantle', watercolour, 3½ins. x 5⅛ins.*

This drawing illustrates Pearson's rather weak adaptation of the Girtin manner and his usual overstressing of a patch of light in the middle distance.

(Andrew Wyld)

477

PEARSON, William

A View Overlooking an Extensive Flat Landscape. *Watercolour, 8¼ins. x 14¼ins.*

(Martyn Gregory)

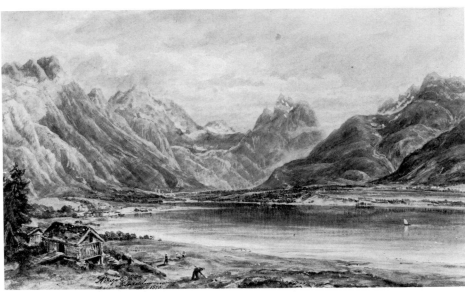

PERIGAL, Arthur, Yr. (1816-1884)

Romsdalen, Norway. *Signed, inscribed and dated 1870, water-colour heightened with white, 13ins. x 20½ins.*

(Sotheby's)

(Sotheby's)

PHIPSON, Edward Arthur 'Evacustes' (1854-1931)

Sadlergate Bridge, Derby, 1903. *Signed, inscribed and dated 1903, water-colour, 4¾ins. x 6¾ins.*

(Derby Museum and Art Gallery)

PICKEN, Thomas
View from Betchworth Park, Dorking.
Signed, watercolour.
See under Picken, Andrew, in Volume
One.

(Sotheby's)

PICKERING, George (1794-1857)
Lancaster Castle. *Watercolour,
7¼ins. x 10½ins.*
In some of his work Pickering
adopts the mannerisms of his
teacher Glover. However, this
drawing appears to be based on a
similar composition by Hearne.

(Sotheby's)

PIKE, William Henry (1846-1908)
Trebarwith Sands. *Signed, water-colour heightened with white, 17ins. x
27ins.*

(Bourne Gallery)

PINWELL, George John (1842-1875)

The Pied Piper of Hamlin. *Signed and dated '69, watercolour, 11¾ins. x 21ins.*

Pinwell's kinship with Fred Walker and his training as a wood engraver are evident in his watercolour illustrations, most notably in the uncomplicated compositions. His colouring can be very brilliant.

(Sotheby's)

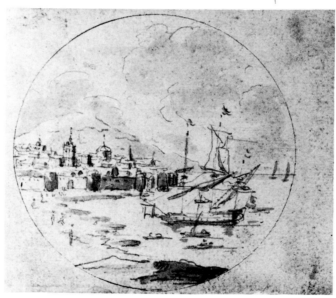

PLACE, Francis (1647-1728)

Italian Capriccio. *Pencil and grey wash, 3ins. diameter.*

(Martyn Gregory)

POCOCK, Nicholas (1740-1821)

Extensive Landscape with Cattle. *Watercolour, 8ins. x 10ins.*

An illustration of how competent but uninspired Pocock could be before he took Gainsborough's advice to combine landscape and marine painting in the same composition.

(Martyn Gregory)

POCOCK, William Innes (1783-1836)
Mapledurham House from the Thames.
Pencil and watercolour.

Pocock was a naval lieutenant and produced many drawings of far flung parts of the world. However, he also painted in England, most notably in the Southern counties and the Thames Valley where his brother inherited a property at Maidenhead in 1818. See entries for his brother and father under Pocock, Lexden Lewis, and Pocock, Nicholas, in Volume One.

(Martyn Gregory)

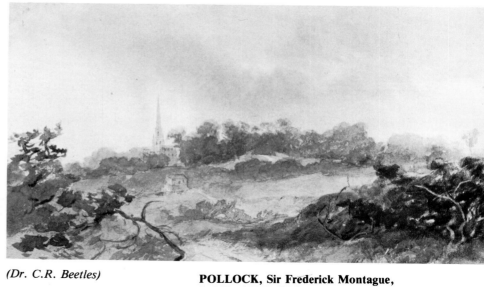

(Dr. C.R. Beetles)

POLLOCK, Sir Frederick Montague, 2nd Bt. (1815-1874)
Hampstead Heath and Christchurch.
Watercolour, 6½ins. x 12ins.

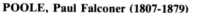

POOLE, Paul Falconer (1807-1879)
The Morning Milk. *Signed and dated 1841, watercolour, 18ins. x 13½ins.*

(Sotheby's Belgravia)

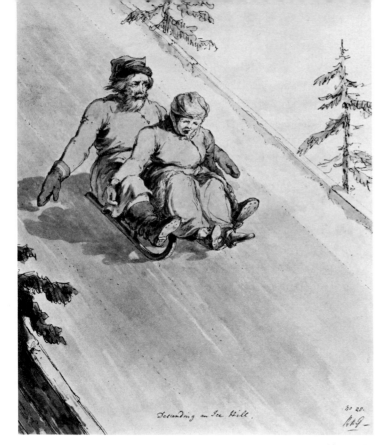

PORTER, Sir Robert Ker (1777-1842)

Going Down an Ice Hill — From an Album. *Signed with initials and inscribed and dated 1816, pen and grey ink and watercolour, 10ins. x 7½ins.*

As well as sketching on his travels Porter produced brown wash drawings as a member of Girtin's sketching club, panoramas and large battle subjects. His style varied widely.

POWELL, Joseph (1780-1834)

A Rustic Youth Leaning on a Fence. *Watercolour, 9⅜ins. x 5⅛ins.*

Powell filled many sketchbooks with small studies of figures and animals.

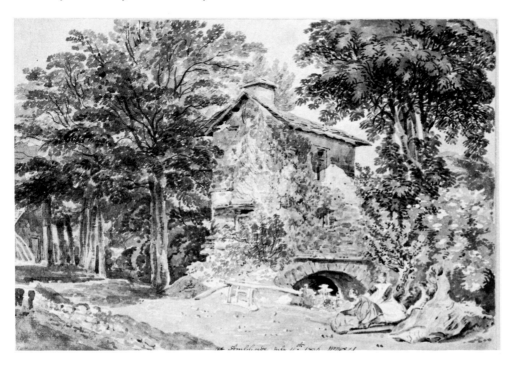

POWELL, Joseph (1780-1834)

At Ambleside. *Signed, inscribed and dated July 11th 1806, watercolour, 8ins. x 11ins.*

POYNTER, Ambrose (1796-1886)

Near Nouancourt. *Inscribed in pencil 'Near Nouancourt', watercolour, 6⅝ins. x 9⅛ins.*

In the architectural work for which he is best known Poynter's style is much more precise than in his landscapes. These show the influence of Boys, Bonington and their Paris set.

(Fitzwilliam Museum, Cambridge)

POYNTER, Sir Edward John (1836-1919)

A View at Wilden, Worcestershire. *Watercolour heightened with white, 9¾ins. x 13¾ins.*

The majority of Poynter's rare watercolours were done early in his career and they include both landscapes and literary subjects. This fine watercolour, however, dates from a later period and commemorates the visit to the house of a friend.

(Christie's)

PRICE, William Lake (1810-1891)

Byron's Room, Palazzo Mocengo, Venice. *Inscribed, pen and brown ink and watercolour heightened with white, 13½ins. x 19ins.*

This drawing shows both Price's lithographic technique and the influence of Bonington.

(Dudley Snelgrove Esq.)

PRITCHETT, Robert Taylor (1828-1907)

The Yacht Carina, a 40 Rater off Cowes. *Signed with monogram, inscribed 'Cowes' and dated 1894, watercolour.*

This is an unusually strong work for Pritchett, perhaps because it includes none of his rather poor figures.

(Sotheby's)

PROUT, John Skinner (1806-1876)

Battlefield. *Signed, watercolour, 9½ins. x 14⅛ins.*

An unusually adventurous subject for Prout, who often contented himself with imitating his uncle in subject matter and style. He also painted in Australia.

(Private Collection)

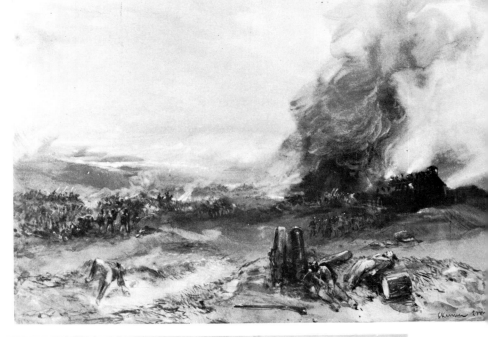

PROUT, John Skinner (1806-1876)

Mont Orgeuil, Gorey, Jersey. *Signed, pencil and watercolour heightened with white, 8⅛ins. x 20⅛ins.*

(Christie's)

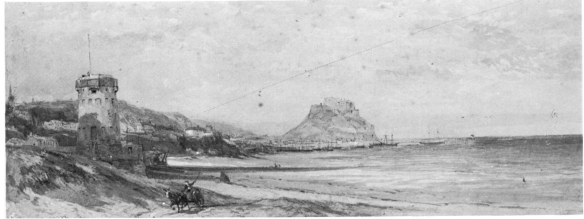

PROUT, Samuel (1783-1852)
Knaresborough. *Signed, water-colour, 8½ins. x 11¾ins.*

(Private Collection)

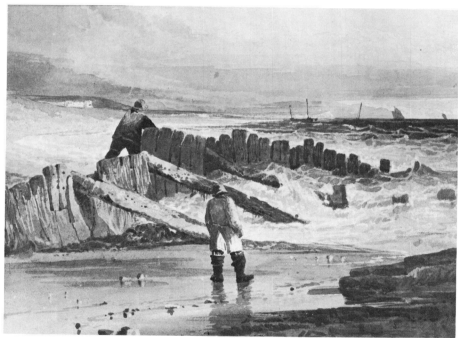

PROUT, Samuel (1783-1852)
Fishermen by a Breakwater. *Water-colour, 7½ins. x 10ins.*

(Christie's)

PROUT, Samuel (1783-1852)
Durham. *Watercolour, 17¼ins. x 23¼ins.*

(Lawrence of Crewkerne)

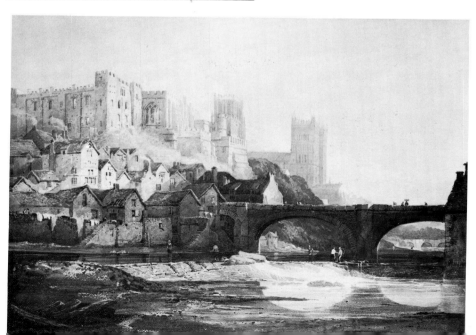

PUGIN, Augustus Charles de (1762-1832)
View of the High Street, Oxford, Looking West. *Pencil and watercolour heightened with white, 8¼ins. x 11ins.*

Pugin was above all an architectural draughtsman and when he drew his own figures they are often the weakest part of the composition. Thus he often collaborated with other artists such as Rowlandson and James Stephanoff. His architectural and topographical work is traditional and very competent.

(Christie's)

PYNE, George (1800-1884)
Harrow. *Signed, watercolour, 8⅛ins. x 11⅜ins.*

Pyne's forte was in painting old buildings, especially educational establishments, and his figures are easily recognised by their elongated tubular legs.

(Private Collection)

PYNE, James Baker (1800-1870)
A Boat under Construction. *Signed and indistinctly dated '35, watercolour, 14½ins. x 20ins.*

An exceptional work for Pyne who although influenced by Turner is generally less dramatic in style. He was above all a painter of lakes.

(Christie's)

PYNE, James Barker (1800-1870)

The Market Place, Baveno, Lago Maggiore. *Pencil and watercolour, 10¼ins. x 18½ins.*

Many of Pyne's watercolours look as if they were painted with lithography in mind.

(Christie's)

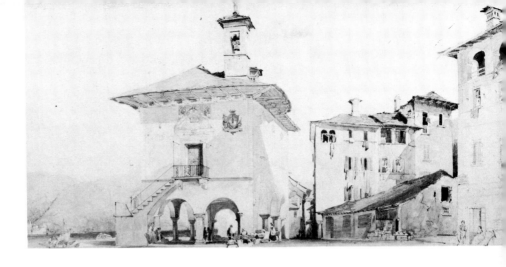

PYNE, Thomas (1843-1935)

Maldon, Essex. *Signed and dated 1908, watercolour, 17ins. x 25ins.*

(Bourne Gallery)

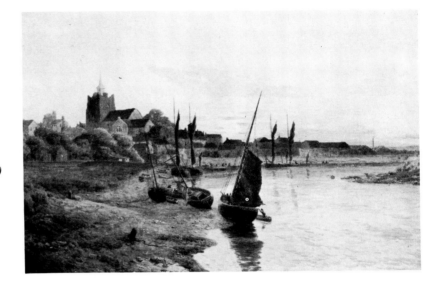

PYNE, William Henry (1769-1843)

Fishing Vessels by Fort Rouge, Calais. *Watercolour, 9ins. x 10ins.*

By far the largest part of Pyne's work consists of studies of figures and details which were intended for the use of other painters. His figures are well drawn and usually play a larger part in the composition of his finished watercolours, than they do in the present example.

(Martyn Gregory)

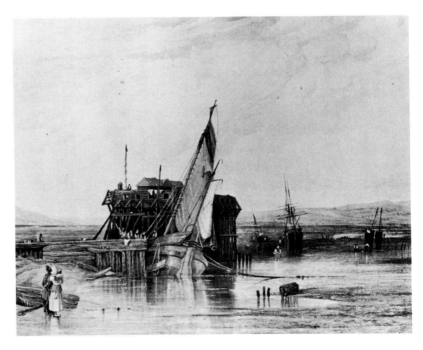

487

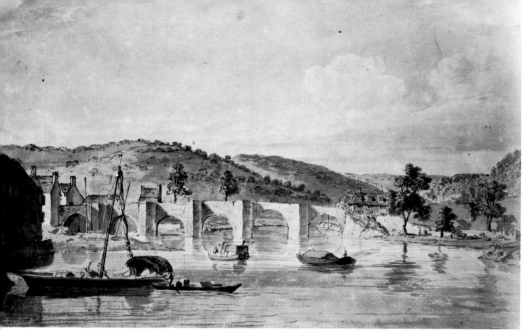

RACKETT, Thomas (1757-1841)
Wye Bridge, Monmouth. *Pen and brown ink and watercolour, 10¾ins. x 17ins.*

(Dudley Snelgrove Esq.)

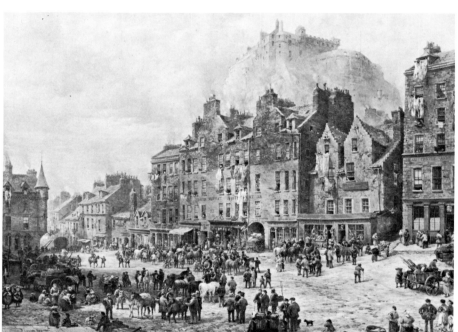

RAYNER, Louise J. (1832-1924)
View of The Grassmarket, Edinburgh. *Signed, pencil and watercolour heightened with white, 20⅞ins. x 28⅜ins.*

Louise's open air townscapes, for which she is best known, are less gloomy than the interiors which all the family produced.

(Phillips)

READ, Samuel (1815-1883)
The Village Church. *Signed and dated 1875, watercolour, 14¼ins. x 10¼ins.*

(Sotheby's)

RENTON, John (1774-c.1841)
Seated Girl, Hoxton. *Signed, pencil and watercolour, 10¼ins. x 7ins.*
An excellent example of Renton's slightly weak Cristall-like figures.

(Dudley Snelgrove Esq.)

REPTON, Humphrey (1752-1818)
The Pump Room, Bath. *Signed, inscribed and dated 1784, watercolour, 17½ins. x 23½ins.*

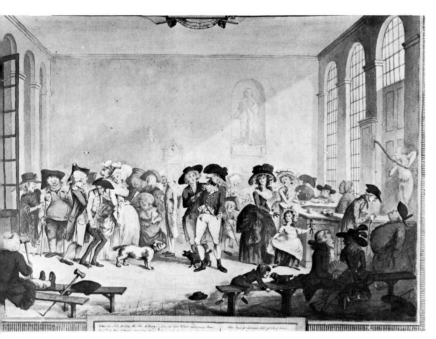

(Christie's)

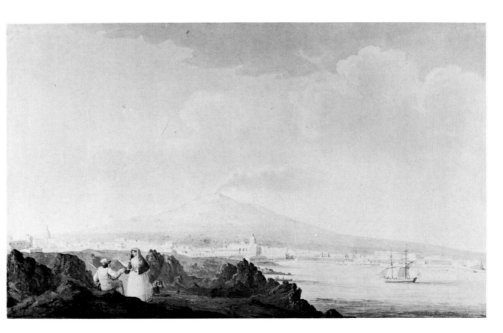

REVELEY, Willey (1760-1799)
Catania and Mount Etna. *Pen and grey ink and watercolour, 12½ins. x 19⅞ins.*

(Christie's)

RICH, Alfred William (1856-1921)
Stone Steps of a Mansion. *Signed, watercolour, 11ins. x 15¾ins.*

Rich often used a light buff or rough paper. He also sometimes — but not here — outlined his clouds with blue. This may have faded to pink.

(Dudley Snelgrove Esq.)

RICHARDS, John Inigo (c.1720-1810)

Thornbury Castle, Glos. *Signed and inscribed on reverse, watercolour, 8¼ins. x 12½ins.*

There are many landscapes in body-colour and the manner of J. Laporte which are traditionally attributed to J.I. Richards but may well be by another J. Richards.

(Spink & Son Ltd.)

RICHARDS, John Inigo (c.1720-1810)

Tunbridge Castle. *Inscribed, pen and brown ink and watercolour, 9½ins. x 13¾ins.*

(Dudley Snelgrove Esq.)

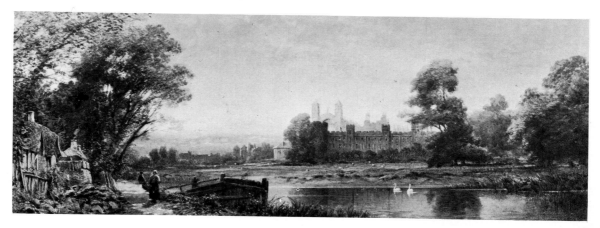

(Christie's)

RICHARDSON, Edward M. (1810-1874)
Eton College. *Signed, watercolour height-
ened with white, 7⅝ins. x 19½ins.*

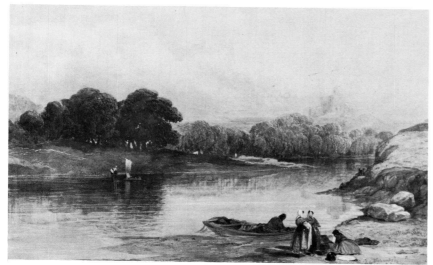

RICHARDSON, George (1808-1840)
Norham Castle. *Signed and indistinctly
dated, watercolour heightened with white,
11ins. x 16ins.*

(Bourne Gallery)

**RICHARDSON, Thomas Miles
(1784-1848)**

By the Falls. *Inscribed on reverse,
watercolour, 9½ins. x 13ins.*

For most of his career Richardson's
favourite sketching grounds were
the Borders and Northumbria and
he produced work in the traditions
of Cox whom he admired. How-
ever, towards the end of his life he
visited the Continent, perhaps with
his son, and this gave more light
and colour to his work.

(Sotheby's Belgravia)

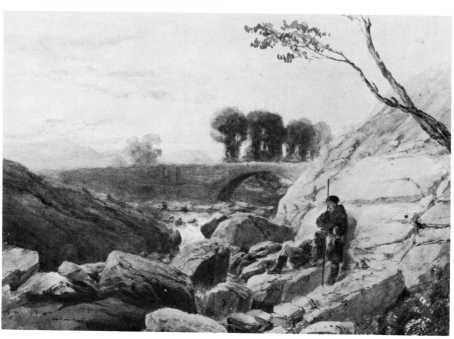

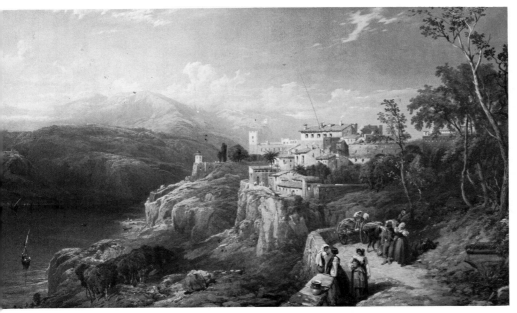

RICHARDSON, Thomas Miles, Yr. (1813-1890)

Monaco with Peasants and Carts on the Road. *Watercolour heightened with white, signed and dated 1866, 28¾ins. x 49ins.*

This is an example of Richardson at his very best in one of his highly finished exhibition watercolours. He often uses an intense blue in the sky. His compositions are generally good, if repetitive.

(Christie's)

RICHARDSON, Thomas Miles, Yr. (1813-1890)

Beached Fishing Vessel. *Watercolour, 9¼ins. x 6ins.*

This shows the effectiveness of Richardson as a sketcher.

(Martyn Gregory)

(Christie's)

RICHMOND, George (1809-1896)

Portrait of Charles Russell. *Pencil and watercolour heightened with white, 12½ins. x 9ins.*

As well as his masterly watercolour portraits Richmond was an excellent sketcher in pen and ink and produced occasional watercolour landscapes. In his later years he took life-sized head and shoulder portraits in chalk on buff paper.

RIGBY, Cuthbert (1850-1935)
A Snowbound Farm. *Signed and dated 1879, watercolour, 6⅜ins. x 9⅞ins.*

(Private Collection)

(Martyn Gregory)

RIVIERE, Briton (1840-1920)
A Sleeping Lion. *Watercolour, 15ins. x 21ins.*

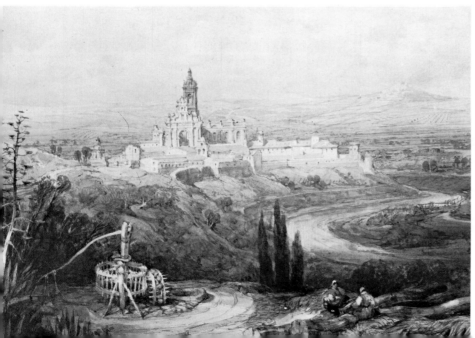

ROBERTS, David (1796-1864)
The Monastery of Cartuja, Xerez. *Signed and dated 1835, watercolour, 8¾ins. x 12⅜ins.*

(Christie's)

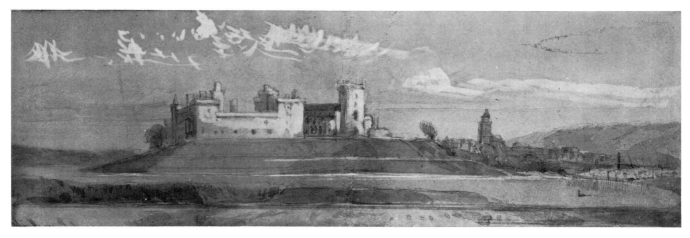

(Martyn Gregory)

ROBERTS, David (1796-1864)

Linlithgow Palace. *Inscribed, pencil and watercolour heightened with white on buff paper, 4½ins. x 13½ins.*

ROBERTS, David (1796-1864)

A Street in the Jews Town, Tetuan. *Signed, inscribed and dated April 1st 1833, pencil and watercolour heightened with white, 9¼ins. x 13½ins.*

(Sotheby's)

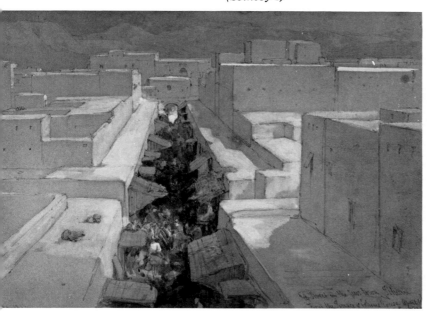

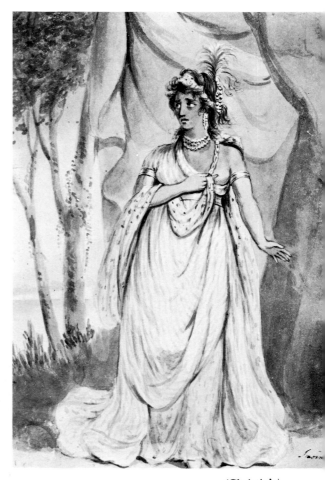

(Christie's)

ROBERTS, James (-c.1810)

Miss Younge as Imoinda in 'Oroonoko', Dec 16, 1779. *Inscribed and again on the reverse, watercolour, 8⅜ins. x 5¾ins.*

Although Roberts' style is ultimately derived from Sandby he preferred the brush to the pen for his outlines.

ROBERTSON, George (1748-1788)

An Attack Outside the Married Men's Arms. *Watercolour, 10ins. x 13½ins.*

Robertson often used massed strokes of the brush, seen clearly in this illustration, for his foliage drawing. His landscape work tends to be rather theatrical but he also painted straightforward topographical subjects and watercolour portraits in the manner of Downman.

(Sotheby's)

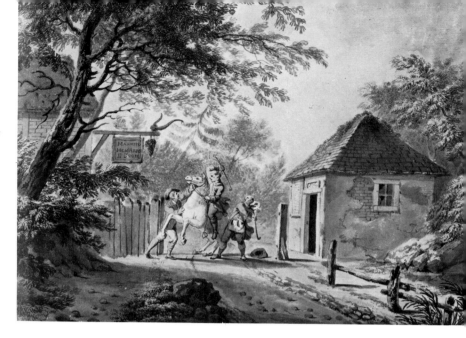

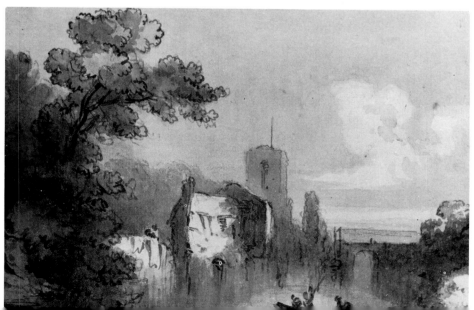

ROBERTSON, George (1748-1788)

Wanstead House, Essex, with Elegant Figures in the Foreground. *Pen and ink and grey washes, 13¾ins. x 20½ins.*

(Martyn Gregory)

ROBERTSON, James 'Drunken'
Ruins and Figures in a Boat. *Watercolour, 7ins. x 9¾ins.*

(Beryl Kendall)

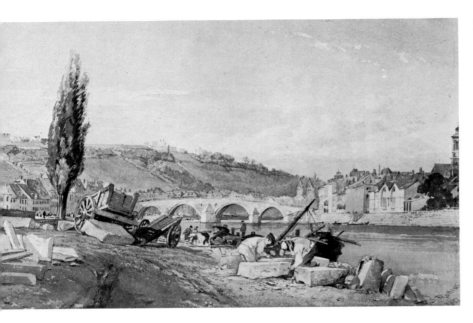

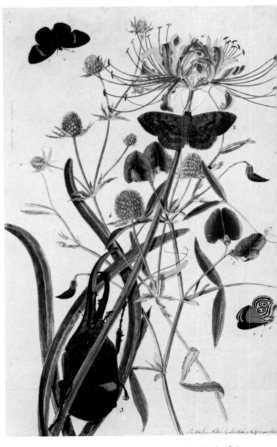

ROBINS, Thomas Sewell (1814-1880)
Liege from the River. *Signed, inscribed and dated '54, pencil and watercolour, 10¾ins. x 17⅞ins.*

Although best known as a coastal and marine painter Robins also produced a number of inland views particularly in France and Germany which show an unexpected informality of handling.

(Christie's)

ROBINS, Thomas Sewell (1814-1880)
Craft Running for Bergen-op-Zoom Harbour. *Signed and dated '58, watercolour, 17ins. x 24¼ins.*

(Sotheby's)

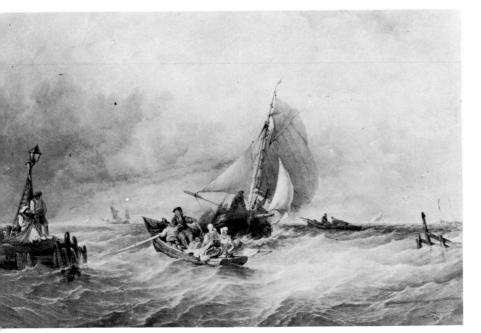

(Sotheby's)

ROBINS, Thomas, Yr. (1745-1806)
Amaryllis, Giliaris, Eryngium Amethystinium and Lathyrus. *Signed, inscribed and dated 1785, watercolour, 14ins. x 9½ins.*

Although a botanical painter Robins seems to have been as interested in insects as in flowers.

ROBINS, Thomas Sewell (1814-1880)
A Frigate Offshore. *Signed with initials and dated 1850, watercolour, 8ins. x 13ins.*

ROBINSON, Charles F.
Southwold. *Signed and inscribed, watercolour, 9½ins. x 13¼ins.*

(Bourne Gallery)

(Beryl Kendall)

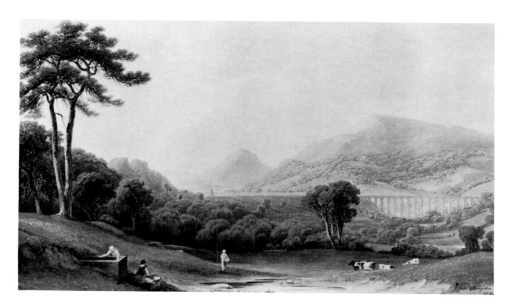

ROBSON, George Fennel (1788-1833)
The Vale of Llangollen. *Signed, dated and inscribed, watercolour, 12ins. x 19¾ins.*
Although his English and Welsh work is generally peaceful Robson had a great love of lightning and storms when painting Highland scenes.

(Lawrence of Crewkerne)

ROBSON, George Fennel (1788-1833)
South West View of the City of Hereford.
Watercolour, 8⅜ins. x 14⅞ins.

(Christie's)

**ROOKE, Thomas Matthew
(1842-1942)**

Oakley Street. *Inscribed and dated
1867, watercolour, 10ins. x 14ins.*

(Martyn Gregory)

**ROOKER, Michael 'Angelo'
(1743-1801)**

Caerphilly Castle. *Signed, water-
colour, size unknown.*

Rooker was one of the best of
Sandby's professional pupils and his
work is generally well controlled,
with delicate colours and excellent
drawing.

(Christie's)

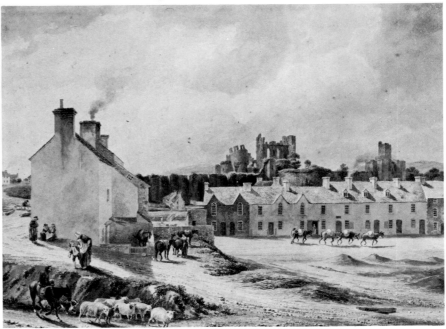

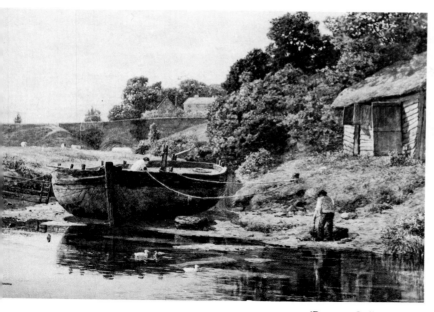

ROSCOE, S.G. Williams (1852-)
The River Barge. *Signed and dated '82, watercolour, 14ins. x 22ins.*

**ROSSETTI, Gabriel Charles Dante,
'Dante Gabriel' (1828-1882)**
Beatrice. *Inscribed, watercolour, 19ins. x 16ins.*

ROWBOTHAM, Charles
Lake Orta: Italy. *Signed, watercolour heightened with white, 15ins. x 26ins.*
Rowbotham is best known for his highly finished and over sweetened views on the Riviera and Italian Lakes with their vivid blues and great deal of white heightening. However, he was more varied in style than might appear and was an accomplished and pleasing sketcher.

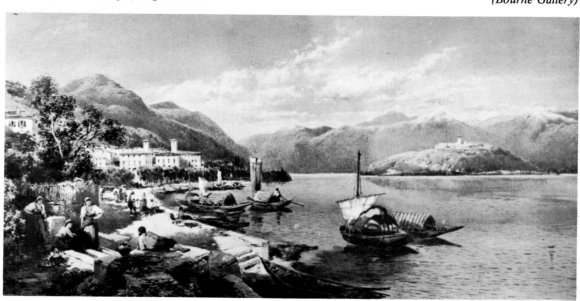

ROWBOTHAM, Charles
Thatched Farm Shed, Dover. *Signed and dated July 7 1874, watercolour, 8¾ins. x 13½ins.*

(Dudley Snelgrove Esq.)

ROWBOTHAM, Thomas Charles Leeson (1823-1875)
Riverside Village. *Signed and dated 1854, watercolour, 8ins. x 12½ins.*

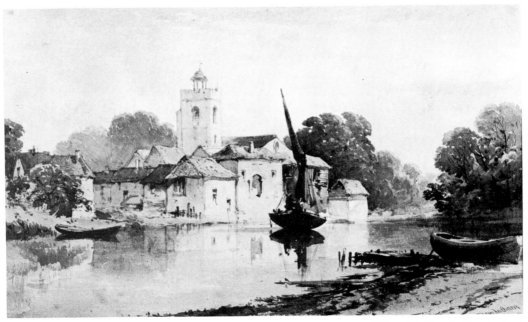

(Christie's South Kensington)

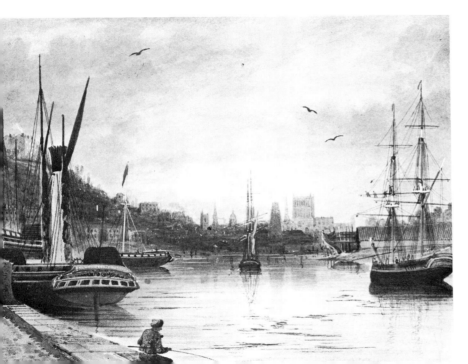

ROWBOTHAM, Thomas Leeson Scarse (1783-1853)
View up the River Avon from the Entrance to the Old Floating Dock, Bristol. *Watercolour heightened with white.*
In their generally low tones Rowbotham's watercolours are often akin to the early work of S. Prout, they are, however, generally less woolly in effect.

(City Art Gallery, Bristol)

RUSKIN, John (1819-1900)

Lanercost Priory, Cumberland. *Signed and inscribed verso, watercolour, 8½ins. x 7ins.*

Ruskin's style was in general based on that of Turner but it is best not to be dogmatic since he sometimes adopted the manner of the latest person to catch his eye.

(Martyn Gregory)

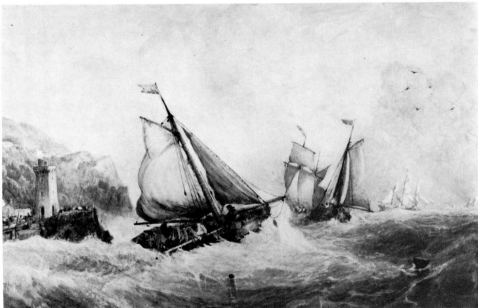

(Bourne Gallery)

SALMON, John Francis (c.1814-c.1875)

Lynmouth. *Signed, watercolour, 19ins. x 30ins.*

SAMUEL, George (-1823)

A Picnic Party. *Watercolour, 3ins. x 4½ins.*

Samuel's style is based on that of Sandby with touches of Dayes. His figures are poor.

(Andrew Wyld)

SANDBY, Paul (1725-1809)
Reading Abbey. *Pen and brown ink and watercolour, 5ins. x 7ins.*

(Private Collection)

SANDBY, Paul (1725-1809)
Women Preparing Food, Hyde Park 1780. *Grey ink and watercolour, 8⅛ins. x 12ins.*

(Christie's)

SANDBY, Paul (1725-1809)
A Ruined Castle in a Romantic Landscape. *Watercolour, 5ins. x 8ins.*

(Private Collection)

SANDYS, Anthony Frederick Augustus (1829-1904)
St Benet's Abbey. *Watercolour, 7⅝ins. x 13¾ins.*

Frederick Sandys is best known for his work as a follower of the Pre-Raphaelites and as an illustrator. However, early in his career he worked in pure watercolour and the crisp traditions of the later Norwich school.

SARJENT, Francis James (c.1780-1812)
Sketch of a Farmhouse and Outhouses. *Signed verso, pen and watercolour, 4½ins. x 4½ins.*

SARGENT, John Singer (1856-1925)
Santa Maria Della Salute. *Pencil and watercolour, 9⅞ins. x 26½ins.*

SASS(E), Richard (1774-1849)
Ruins at Askeaton, near Limerick, Ireland. *Signed, inscribed and dated 1816 on a label attached to reverse, watercolour, 18¼ins. x 26¼ins.*

Much of Sass's work has suffered badly from fading and the predominant colours which remain are often pink, ochre and green. His handling is often woolly.

(Christie's)

SCOTT, The Hon. Caroline Lucy, Lady (1784-1857)

River Scene. *Watercolour, 8⅛ins. x 13ins.*

An example of Lady Scott at her most Cotman-like using very bright highlights and concentrating on geometrical patterns. Even the bird flitting across the river is derived from Cotman.

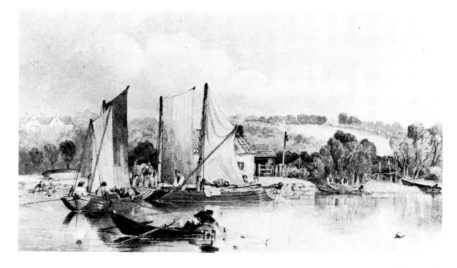

(Christie's)

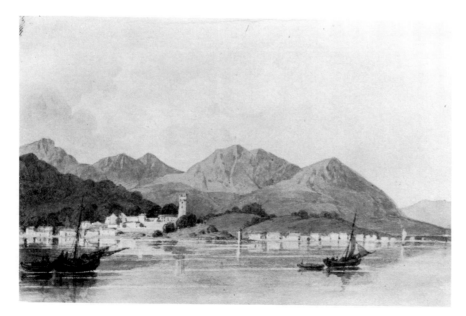

SCOTT, The Hon. Caroline Lucy, Lady (1784-1857)

Dunoon on the Firth of Clyde. *Signed C.L. Scott and dated 5 Oct 1836, watercolour, 6¼ins. x 8¾ins.*

In this drawing Lady Scott appears to have retreated from her Cotmanesque position and to have worked more in the manner of Girtin. She may also have been influenced by a print by W. Daniell.

(Glasgow Art Gallery and Museum)

504

SCOTT, William Bell (1811-1890)

The Spire of St Nicholas's Church (now Cathedral), Newcastle. *Watercolour, 36½ins. x 25¾ins.*

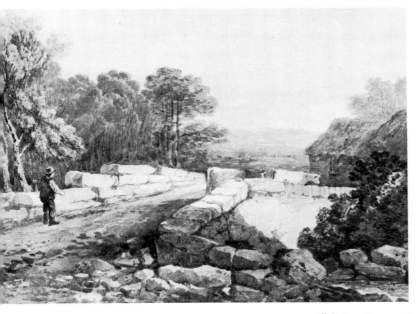

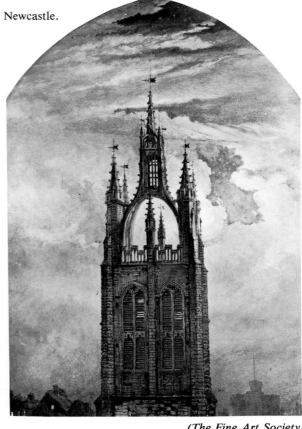

(Martyn Gregory)

(The Fine Art Society)

SCOTT, William Henry Stothard, of Brighton (1783-1850)

A Cowherd and his Cattle Returning Home. *Watercolour, 8½ins. x 12ins.*

A pleasing but rather woolly artist.

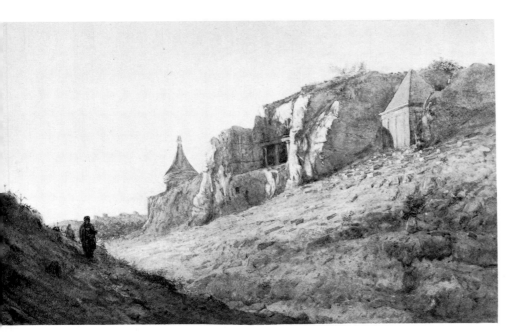

SEDDON, Thomas (1821-1856)

Sunset at a Hillside Temple — Tomb of Absolom and Jehoshaphat outside Jerusalem. *Signed and indistinctly dated, watercolour, 11½ins. x 19ins.*

The detail of Seddon's style probably derives from his friendship with Holman Hunt.

(Bonham's)

505

SERRES, Dominic (1722-1793)

Shipping off Helvoetsluys. *Signed with initials, inscribed and dated 1773, pen, ink and watercolour, 7¼ins. x 11¾ins.*

A drawing in Serres' van de Velde manner showing his use of heavy outlines.

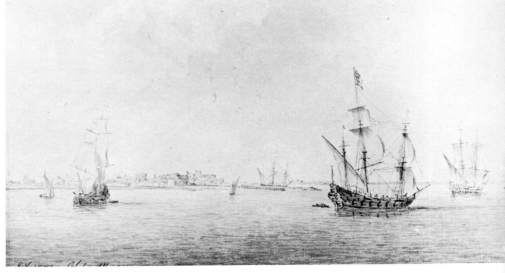

(Martyn Gregory)

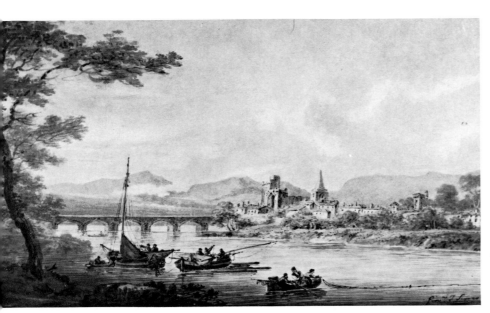

SERRES, John Thomas (1759-1825)

View of Pont St. Esprit, Provence. *Signed Gio*ⁿⁱ *T. Serres, pen and water-colour, 10ins. x 17ins.*

For some time after his return from Italy in 1791 Serres used the signature Giovanni. Both his landscapes and sea-scapes are largely in blues and greys with touches of yellow and pink. His pen work is neat and his compositions and drawing horizontal.

(Martyn Gregory)

SEVERN, Walter (1830-1904)

Highland Cattle in Loch Lomond. *Signed and dated 1891, water-colour heightened with body-colour, 23½ins. x 36ins.*

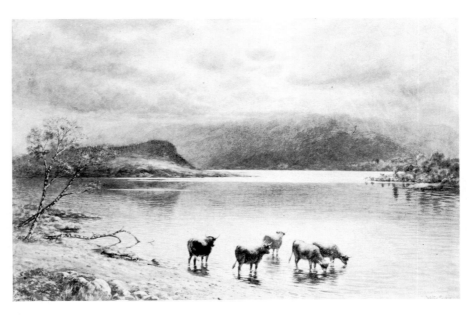

(Sotheby's Belgravia)

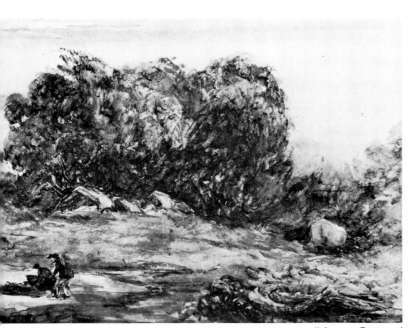

(Martyn Gregory)

SHALDERS, George (1826-1873)
Gypsy Encampment near Snowdon. *Signed and inscribed on old label 'No 9, Snowdon, sketched from nature', watercolour, 8ins. x 10½ins.*

(Stephen Furniss)

SHACKLETON, William (1872-1933)
The Lovers. *Signed and dated '09, mixed media, 16ins. x 11½ins.*

SHARPE, Louisa, Mrs. Seyffarth (1798-1843)
A Lady Fainting at a Reception. *Signed, watercolour heightened with white, 24⅛ins. x 31⅛ins.*

(Christie's)

507

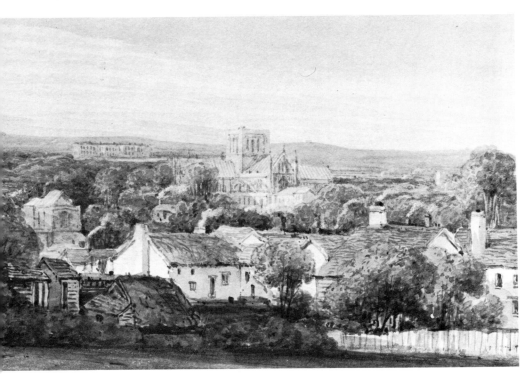

SHEPHERD, George
(c.1782-c.1830)
Winchester. *Signed and dated
1828, watercolour, 5¾ins. x
8½ins.*

(Agnews)

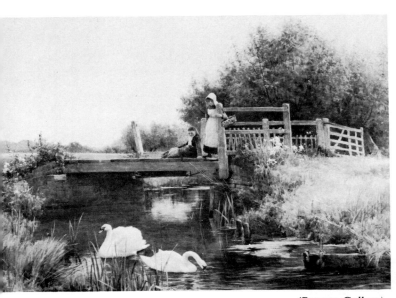

(Bourne Gallery)

SIGMUND, Benjamin D.
Near Cookham. *Signed and dated '83, watercolour, 19ins. x
28ins.*

SIMKIN, Richard (1840-1926)
Royal Horseguards, 2nd Lifeguards and Royal Horseguards.
Inscribed, watercolour, size unknown.

(Sotheby's Belgravia)

SIMPSON, Henry (1853-1921)
Venetian Scene. *Watercolour, 22ins. x 15ins.*
Simpson's work, especially later in his career, shows the strong influence of Turner and the Impressionists.

SKELTON, John (c.1735-1759)
The Edge of a Wood, with a Castellated Mansion by a River. *Pencil and watercolour, 5⅝ins. x 8½ins.*
A characteristic of Skelton's foliage drawing is sometimes a jagged pen outline which can best be seen in the top right hand corner of this illustration.

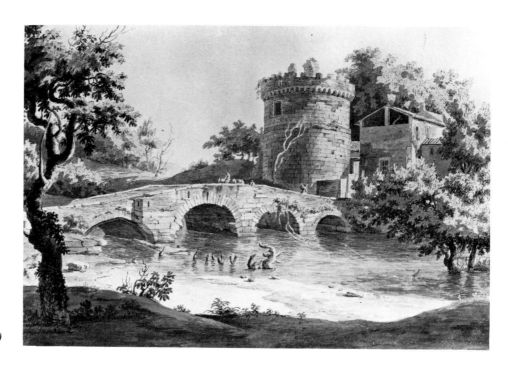

SKELTON, John (c.1735-1759)
Italian Landscape with River. *Watercolour, 10½ins. x 14¾ins.*

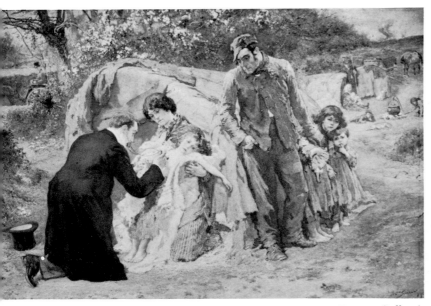

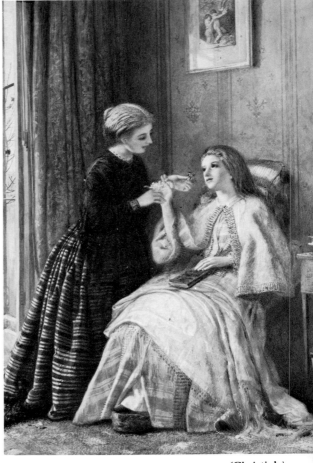

(Bourne Gallery)

SMALL, William (1843-1929)
The Good Samaritan. *Signed and dated 1901, watercolour, 20ins. x 30ins.*

SMALLFIELD, Frederick (1829-1915)
Flowers for the Convalescent. *Signed and dated 1860, watercolour, 25½ins. x 17⅞ins.*

(Christie's)

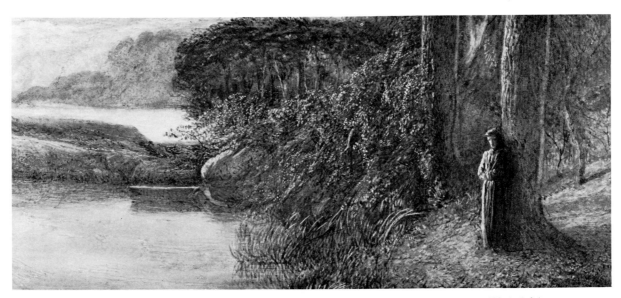

(Christie's)

SMETHAM, James (1821-1889)
Eventide. *Signed twice and dated 1865, watercolour heightened with white, 4ins. x 8⅛ins.*
Smetham's ability to produce a figure from a few broad lines is well illustrated here.

(Dr. C.R. Beetles)

SMITH, Arthur Reginald (1872-1934)
A Broadland Scene. *Signed with monogram, watercolour, 5¾ins. x 15ins.*

(Bourne Gallery)

SMITH, Carlton Alfred (1853-1946)
By the Fireside. *Signed and dated 1901, watercolour, 19ins. x 25ins.*

It seems likely that C.A. Smith used one model, or at least a series of very similar models, in much of his work.

SMITH, Lieutenant Colonel Charles Hamilton (1776-1859)
Hydrochaerus Cabisi. *Signed with initials and inscribed, pencil and watercolour, size unknown.*

Smith's initials which are clearly shown here are often misread.

(Christie's)

511

SMITH, James Burrell (1822-1897)

Derwentwater from below Keswick, Cumberland. *Signed and dated 1874, watercolour heightened with white, 16½ins. x 27¼ins.*

This is an unusual work for Smith in that it includes no waterfall either large or small. His style is generally based on that of the younger T.M. Richardson with much lush use of greens.

(Sotheby's Belgravia)

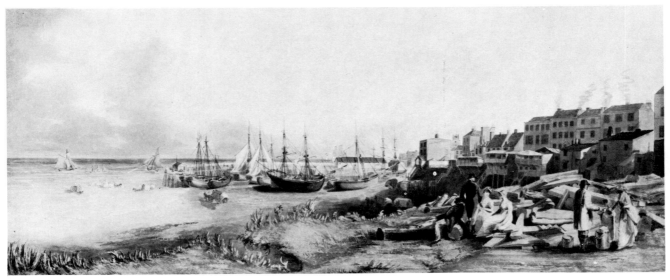

(Martyn Gregory)

SMITH, John Rubens (1775-1849)

Exterior View of Margate Harbour. *Signed and dated 1803, pen and ink and watercolour, 10¼ins. x 24ins.*
Smith also produced portraits in the manner of his father John Raphael Smith. See under Smith, John Raphael, in Volume One.

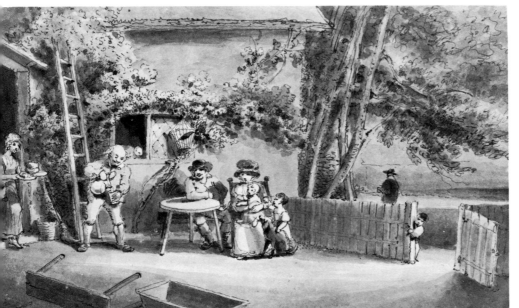

SMITH, John Thomas (1766-1833)

Outside an Ale-house. *Signed, pen and black ink and watercolour, 6⅛ins. x 9⅞ins.*

Smith's figure work lacks the sugar which is often an ingredient of the styles of Wheatley and Ibbetson when dealing with similar subjects. He also produced fine topographical drawings and portraits. The sharp twists and angles of his pen work are clearly evident in this watercolour.

(Fitzwilliam Museum, Cambridge)

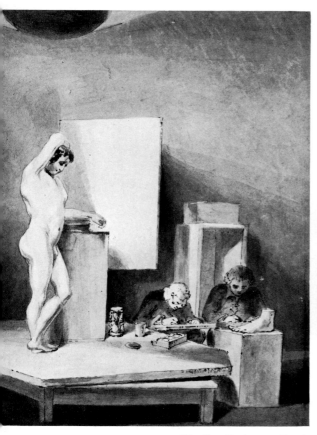

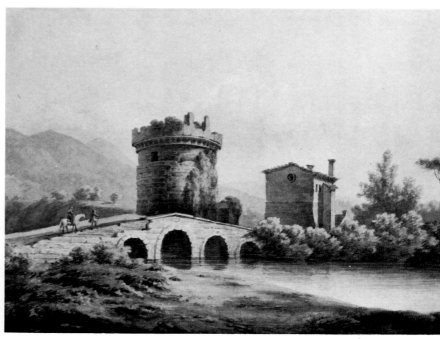

SMITH, John 'Warwick' (1749-1831)

A Fortified Bridge in Italy. *Watercolour, 7ins. x 9⅝ins.*

SMITH, John Thomas (1766-1833)

A Life Class. *Pen and grey ink and watercolour, 8ins. x 6ins.*

SMITH, John 'Warwick' (1749-1831)

A Natural Bridge over a Mountain Torrent. *Signed and dated 1785, watercolour, 12¼ins. x 17¼ins.*

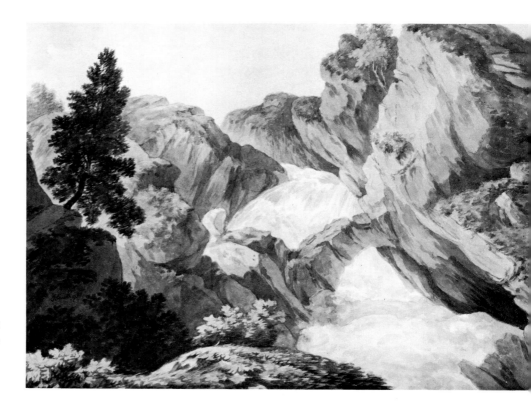

SMITH, Joseph Clarendon (1778-1810)

Near Bury. *Signed, inscribed and dated July 1808, watercolour, 8¾ins. x 12¾ins.*

Smith was trained as an engineer which shows in his technique with its careful drawing and hatching and monochrome or light colour washes.

(Private Collection)

(Sotheby's Belgravia)

(Bonham's)

SMITH, William Collingwood (1815-1887)

The Bay of Uri, Lake of Lucerne. *Signed, watercolour and bodycolour, 30ins. x 50ins.*

Smith's style derives from that of Callow, but in his large mountain lake subjects the treatment is very much akin to that of the younger T.M. Richardson.

SMYTHE, Lionel Percy (1839-1918)

A Peasant Girl. *Signed, watercolour, 13ins. x 10¼ins.*

514

SOUTHALL, Joseph Edward (1861-1944)
Ludford Bridge, Ludlow. *Signed with monogram and dated 1919, pencil and watercolour, 6½ins. x 9¼ins.*

STANFIELD, Clarkson (1793-1867)
Merchantman in an Estuary. *Signed, pencil and watercolour, 6ins. x 12½ins.*

Early in his painting career Stanfield produced marine drawings and coastal views in a cool style, with light colours. They show a kinship with the earlier work of Cox and S. Prout.

STANFIELD, Clarkson (1793-1867)
Lago Maggiore. *Water and body-colour on buff paper, 8¾ins. x 12½ins.*

515

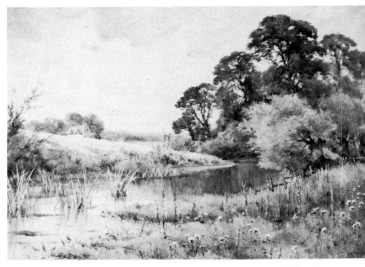

(Bourne Gallery)

STANNARD, Henry John Sylvester (1870-1951)

A Summer Stream. *Signed, watercolour, 13ins. x 19ins.*

This watercolour shows Stannard's most typical fluid and rather indistinct style. He was very fond of studding his foregrounds with loosestrife and similar plants by way of highlight.

(Private Collection)

STANFIELD, Clarkson (1793-1867)

Off Cadiz. *Watercolour, 6ins. x 8⅜ins.*

An example of the mature Stanfield, whose style was based on Turner and Callcott.

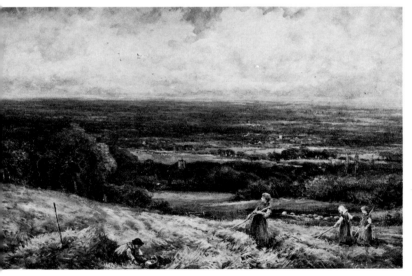

(Christie's South Kensington)

STANNARD, Henry John Sylvester (1870-1951)

Harvest Time. *Signed, watercolour, 25ins. x 29ins.*

An unusually controlled example of the artist's work which shows that he was capable of grander conceptions than would appear from the general run of his hedgerows and river banks.

STANNARD, Theresa Sylvester

A Cottage Garden. *Signed, watercolour, 13½ins. x 9½ins.*
See under Stannard, Henry John Sylvester in Volume One.

(Christopher Wood Ltd.)

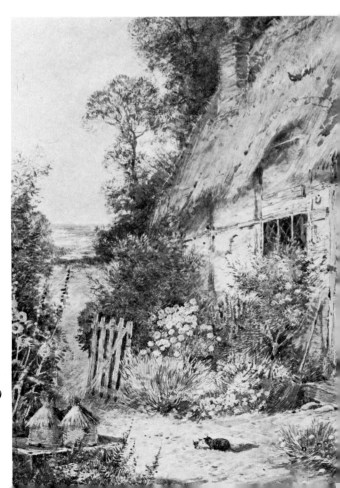

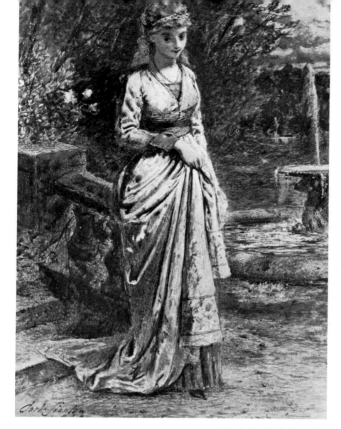

STANTON, G. Clark (1822-1894)
Evening Solitude. *Signed, watercolour heightened with white, 13ins. x 9ins.*

STARK, James (1794-1859)
Fir Trees at Knowle. *Watercolour on blue-grey paper, 21ins. x 14¾ins.*

STEEPLE, John (-1887)

Glencoe. *Signed and dated 1868, watercolour, size unknown.*

Steeple usually worked in the tradition of Cox as here but he sometimes showed affinities with the Glasgow School.

STEWART, James Lawson

Tudor Buildings, Compton, Staffs. *Signed with monogram, watercolour, 26ins. x 39ins.*

Stewart's work seems very accomplished at first sight but there is a naïvety of detail which can lessen the effect.

(Bonham's)

(Private Collection)

STEWART, Sir John James, 5th Bt. of Allanbank (1779-1849)

Huntsmen. *Pen and brown ink, blue and brown wash on light blue paper, 5⅜ins. x 7½ins.*

Stewart's figure drawings are firmly in the Italian tradition. However, his landscapes in England and the Scottish islands are freer and more colourful. Blue or grey paper is typical.

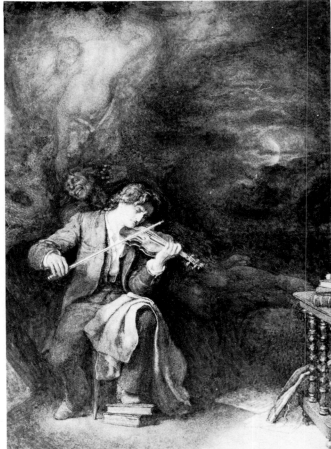

(Private Collection)

STOCK, Henry John (1853-1930)

Musician's Reverie. *Signed and dated 1888, watercolour, 20ins. x 13¾ins.*

518

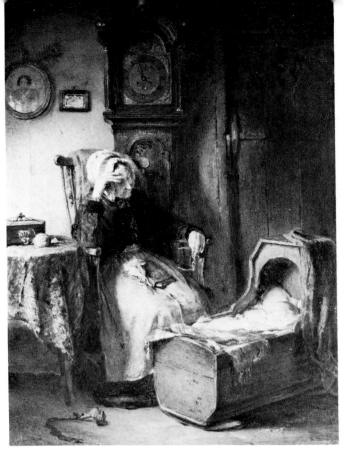

STOCKS, Arthur (1846-1889)

One Generation Fadeth Away; and Another Generation
Cometh. *Signed and dated 1883, watercolour, 15½ins. x
11ins.*

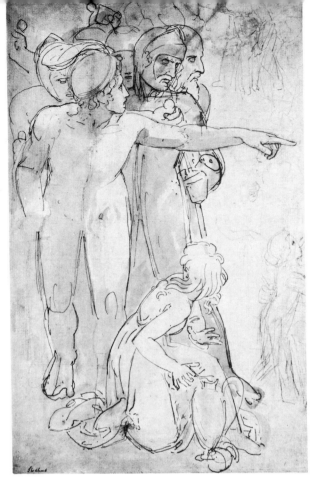

STOTHARD, Thomas (1755-1834)

A Classical Group of Figures. *Signed, pen, grey ink and
grey wash, 14½ins. x 8½ins.*

Stothard produced vast numbers of these figure sketches
in the manner associated with Blake. His finished illus-
trations are much more precise and charming. He drew
landscapes on a tour of the Lakes and Scotland in 1809.
For the fake signatures found on some of his drawings see
under Sunderland, Thomas.

**STRACHAN, Arthur Claude
(1865-)**

A Girl Feeding Birds. *Signed, water-
colour, 11½ins. x 18ins.*

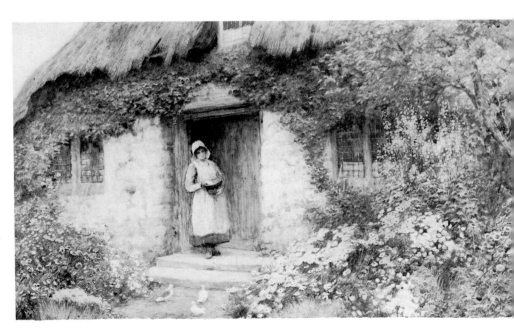

**SUKER, Arthur
(1857-)**
The Gouliot Passage, Sark,
Channel Islands. *Signed,
watercolour, 30ins. x 50ins.*

(Mr. and Mrs. M. Terry)

(Sotheby's)

SUNDERLAND, Thomas (1744-1828)
Mountainous River Landscape. *Pencil and blue and
grey wash, 7¼ins. x 11¼ins.*

Sunderland was an amateur pupil of J.R. Cozens and
possibly of J. Farington. Certainly his style, with its
classical pen outlines, and grey or blue washes is close
to that of the latter and perhaps ultimately based on
the Canaletto drawings at Windsor. Although a care-
ful recorder of the scene in front of him, whether in
the Lake District or in Europe, there is always an
artificial Italianate feeling to his work. For the
drawing of leaves he used a pen outline which is close
to Devis's bunches of bananas.

**SUNDERLAND, Thomas
(1744-1828)**
A detail from a watercolour by
Sunderland showing a fake Sandby
signature and date. This belongs to
the group discussed by Williams,
Early English Watercolours, page
16.

(Christie's)

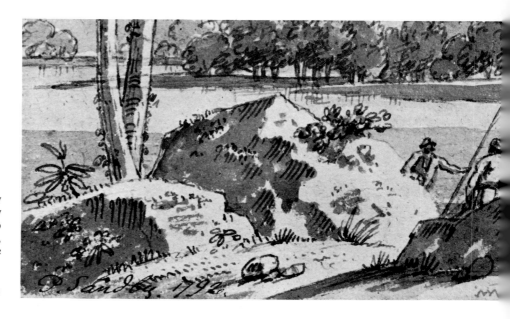

520

SWANWICK, Joseph Harold (1866-1929)
Cuckmere Valley. *Signed, watercolour, 8⅞ins. x 13⅛ins.*

(Private Collection)

(Fitzwilliam Museum, Cambridge)

SWARBRECK (or Schwarbreck), Samuel Dukinfield
Chester Rows. *Signed and dated 1843, watercolour, 9½ins. x 14¾ins.*

SWETE, Rev. John (c.1752-1821)
Teignmouth 1793. *Inscribed and dated 1793, watercolour, 9½ins. x 12¾ins.*

(Sotheby's)

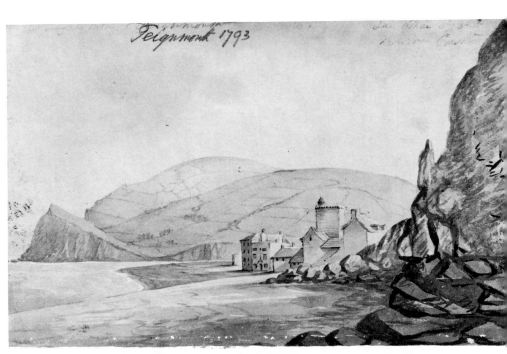

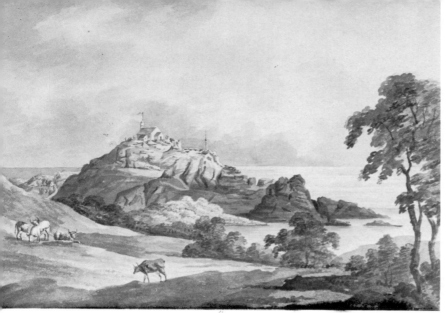

SWETE, Rev. John (c.1752-1821)

Ilfracombe Lighthouse from the Key Fields. *Inscribed on the mount, watercolour, 8ins. x 10½ins.*

A particularly good example.

TADEMA, Sir Lawrence ALMA- (1836-1912)

A Balneatrix. *Signed and inscribed 'OP CLXIX', watercolour, 15ins. x 13ins.*

Alma-Tadema placed his characteristic opus number in the extreme top left hand corner of this illustration (not visible here).

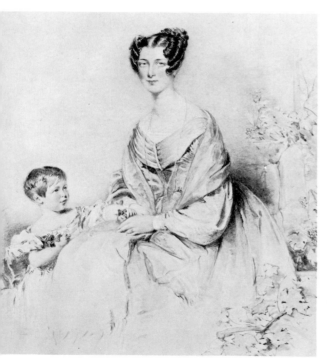

TATHAM, Frederick (1805-1878)

A Mother and Child. *Signed and dated 1839 under the mount, watercolour heightened with white, 17ins. x 17ins.*

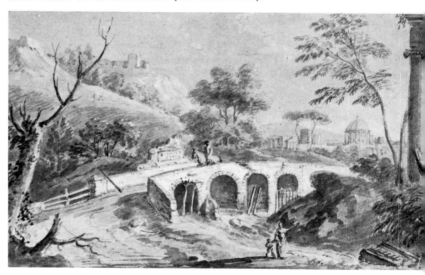

TAVERNER, William (1703-1772)

An Italian Landscape, with a Horseman on a Bridge near a Town. *Pencil and watercolour heightened with white on grey paper, 8¼ins. x 12½ins.*

The romantic and poetical work of Taverner stands at the head of one of the two traditions of eighteenth century watercolour painting. The other is exemplified by Sandby's careful topographical draughtsmanship. Taverner was much influenced by the Italians especially in his subject matter. His lighting is usually soft and he uses a dappled effect for foliage.

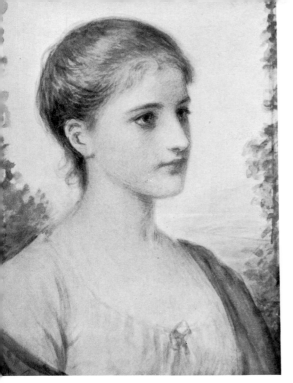

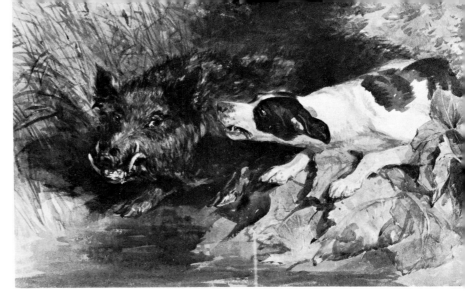

TAYLER, John Frederick (1802-1889)

Wild Boar at Bay. *Watercolour, 9¾ins. x 16ins.*

Tayler was a fine animal painter and he often produced hunting and hawking scenes in a light historical guise. His work is generally free and colourful and he often signed with the initials F.T.

TAYLER, Edward (1828-1906)

Portrait of a Girl. *Signed, watercolour, 12ins. x 9ins.*

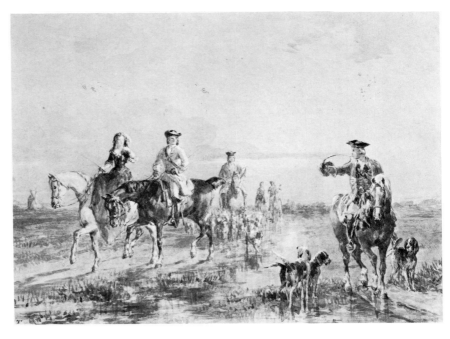

**TAYLER, John Frederick
(1802-1889)**

A Hunting Party. *Signed with initials and dated 1853, watercolour heightened with white, 9⅝ins. x 12¾ins.*

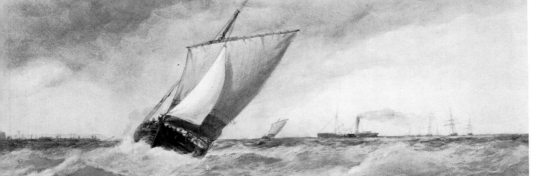

TAYLOR, Charles, Yr.

Sail and Steam on a Choppy Sea. *Signed, watercolour, 16ins. x 30ins.*

523

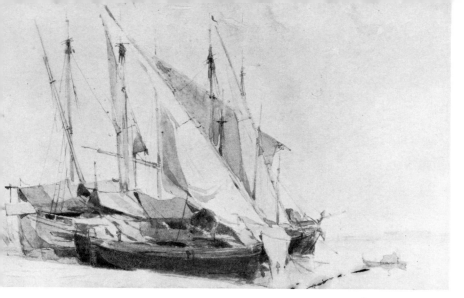

(Martyn Gregory)

TELBIN, William (1813-1873)

Fishing Vessels at Venice. *Watercolour, 4ins. x 6ins.*

Telbin's finished work is more formal than the present sketchy example. He was in fact a typical topographer and scene painter.

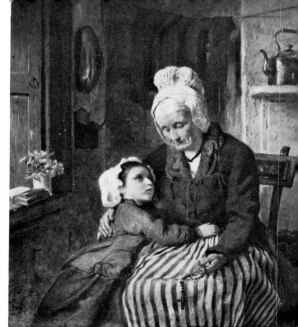

(Bourne Gallery)

THOMAS, William Luson (1830-1900)
Memories. *Watercolour, 13ins. x 10ins.*

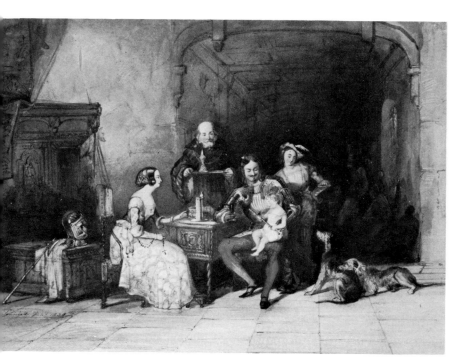

(Sotheby's)

TENNIEL, Sir John (1820-1914)

Charles I and his Family. *Signed and dated 1838, watercolour, 11ins. x 14¼ins.*

In his full watercolours Tenniel often used the monogram which is familiar from his drawings for Punch, rather than the full signature which is seen in this illustration.

(Private Collection)

THORBURN, Archibald (1860-1935)

Signed and dated 1923, watercolour, 10½ins. x 7⅛ins.

This is typical of Thorburn's work with its mixture of detail on the birds or animals and a sketched in background. Like much of his most pleasing work it is on a comparatively small scale.

THORNHILL, Sir James
(1675-1734)

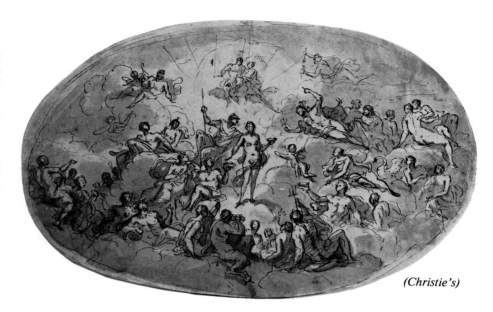

Hebe Among an Assembly of the Gods — Design for the Ceiling of a Dining Room. *Pen and brown ink and brown wash, 7¾ins. x 12½ins.*

Several of the faces in this drawing including that of Hebe, are indicated by Thornhill's characteristic shorthand of a cross in an oval. This must not, however, be taken as proof of Thornhill's authorship of a drawing since the mannerism was adopted by his follower Thomas Carwitham and probably by others.

(Christie's)

TILLEMANS, Peter (1684-1734)

(Sotheby's)

The Thames at Twickenham, with Pope's Villa to the Left. *Watercolour, 5¼ins. x 14¼ins.*

TOBIN, Rear-Admiral George (1768-1838)

View of the Naval Yard, Halifax, Nova Scotia, 1796. *Signed and dated 1796, and inscribed on the mount, watercolour, 7¾ins. x 10¾ins.*

Both Tobin's occasional clumsiness and his habit of using dots for facial features can be seen in this illustration. He was also a competent ship portraitist.

(Christie's)

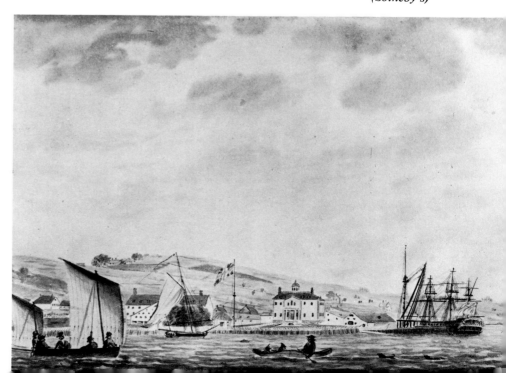

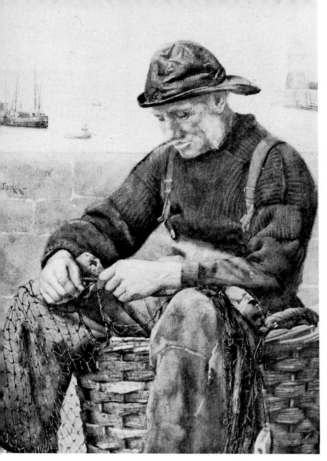

TOWERS, James (1853-)

A Woodland Clearing. *Watercolour heightened with white, 14½ins. x 17¼ins.*

Early in his career Towers specialised in still-lifes.

TODD, Ralph

Mending the Nets. *Signed, watercolour, 13ins. x 9ins.*

TOPHAM, Francis William (1808-1877)

Children Picking Hops. *Signed, inscribed 'Farningham' and dated 1870, watercolour, 13¼ins. x 19¼ins.*

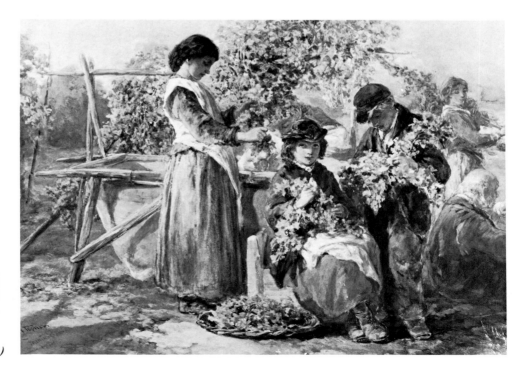

TOWNE, Francis (1740-1816)

Llyn Cwellyn near Snowdon. *Signed and dated 1777 and numbered 28, pen and grey ink and watercolour, 10¾ins. x 16¾ins.*

Towne is rarely concerned with detail, preferring a grand and stylised effect. This is obtained by the use of careful pen outlines and flat planes of low colours, in particular blues, greens and ochres. The pen work seems to become even more pronounced in his later work.

(Christie's)

TOWNE, Francis (1740-1816)

Foot of Mount Splugen near Chiavenna. *Inscribed on the reverse 'Early Morning Light from the Right', pen and black ink and watercolour, 14½ins. x 10¼ins.*

(Christie's)

TOWNE, Francis (1740-1816)

Houses at Ambleside. *Signed and dated 1786 and inscribed on the back of the mount, pen and brown ink and watercolour, 10⅜ins. x 15ins.*

(Christie's)

(Martyn Gregory)

TROWER, Walter John (-1877)
Bishop of Gibraltar

Halstadt, Austria, on the Shores of the Halstatter See. *Inscribed and dated 1846, reed pen and water-colour, 10½ins. x 17ins.*

Like many amateurs Trower painted in a style which was distinctly old fashioned. His concentration on heavy outlines drawn with the reed pen and thin washes of colour is more of the eighteenth century than the nineteenth, although it has an affinity with the style of Lear.

TUCKER, Edward
(c.1825-1909)

The Doge's Palace from the Lagoon. *Watercolour, 13ins. x 19ins.*

'Edward Arden' was not, as stated in Volume One, the elder E. Tucker but the younger (c.1847-1910).

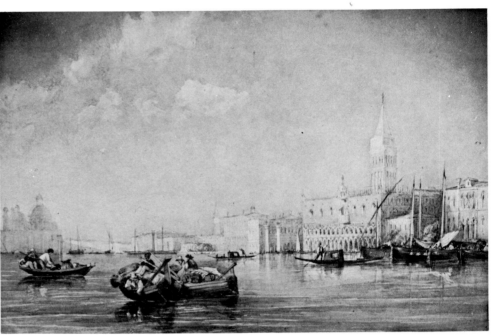

(Bourne Gallery)

TUKE, Henry Scott (1858-1929)

The Clipper Dvergo. *Signed and dated 1921, watercolour, 9ins. x 13ins.*

In his paintings of boats Tuke made great use of shimmering light and such incidentals as streaks of rust on the hulls. He might be regarded as one of the leaders of the English Impressionists. His drawings of naked fisher-boys tend to be more factual, but there is still a pre-occupation with light.

(Bourne Gallery)

TURNER, Joseph Mallord William (1775-1851)

View of Devonport, Torpoint and Saltash from Mount Edgcumbe, with Sailors Merrymaking. *Signed, watercolour, 6⅛ins. x 9½ins.*

This probably dates from about 1814.

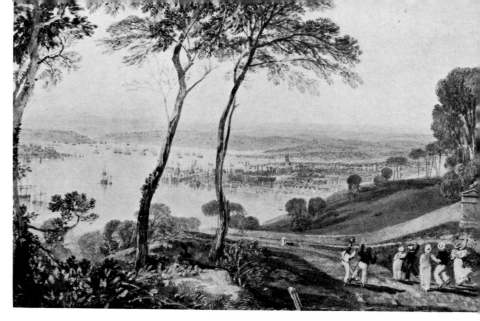

TURNER, Joseph Mallord William (1775-1851)

A Mackerel with Prawns. *Water and bodycolour and white chalk on grey paper, 5⅛ins. x 10ins.*

(Christie's)

(Christie's)

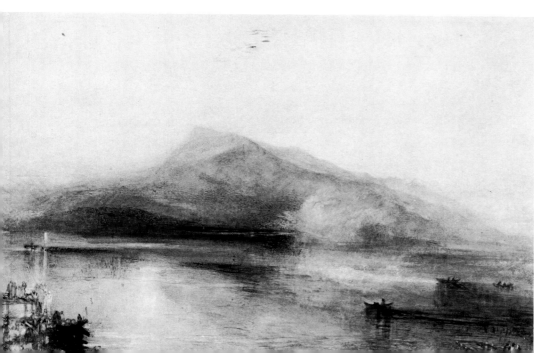

TURNER, Joseph Mallord William (1775-1851)

The Lake of Lucerne, showing the Rigi at Sunrise — 'The Dark Rigi'. *Water-colour, 12ins. x 8ins.*

(Sotheby's)

529

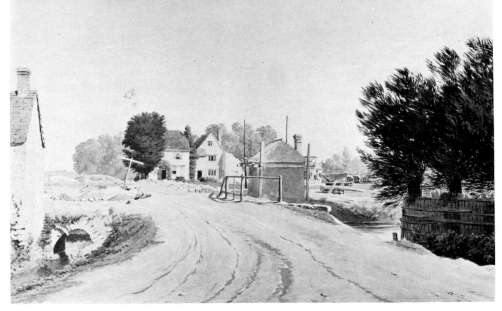

TURNER, William, of Oxford (1789-1862)

View at Rewley, Oxford. *Signed and inscribed, watercolour, 9¾ins. x 13¾ins.*

(Martyn Gregory)

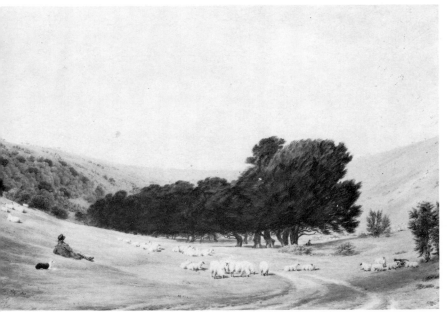

TURNER, William, of Oxford (1789-1862)

Kingley Bottom, Sussex, with Yew Trees at Dusk. *Signed and inscribed, watercolour, 14¾ins. x 21¼ins.*

Turner produced a series of large drawings in Sussex and the Portsmouth area in this manner. His earliest work such as the well-known 'Wychwood' in the VAM is by far the most imaginative and impressive. His draughtsmanship is always good.

(Sotheby's)

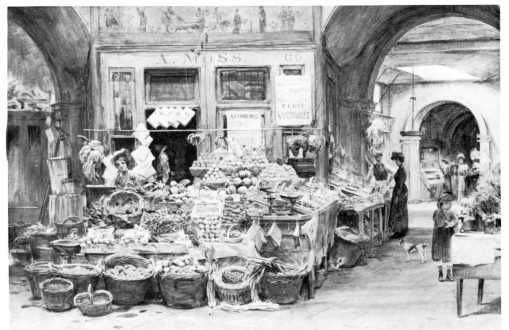

TYNDALE, Walter Frederick Roofe (1856-1943)

A Corner of Covent Garden. *Signed, watercolour, 10ins. x 14ins.*

A colourful and unusually precise example of Tyndale's work. He more often used the wet technique which is typical of his time.

(Dr. C.R. Beetles)

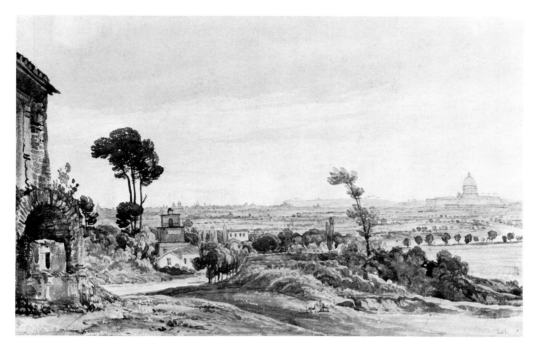

UTTERSON, Edward Vernon (c.1776-1852)

Rome from the Campagna. *Signed with initials, pencil and watercolour, 10ins. x 15½ins.*

The drawing and colouring of this example is unusually strong for Utterson, who was generally more effective with the pen.

(Dr. C.R. Beetles)

UNDERWOOD, Thomas Richard (1772-1836)

Hurstmonceaux, 1794. *Watercolour, 9¾ins. x 7½ins.*

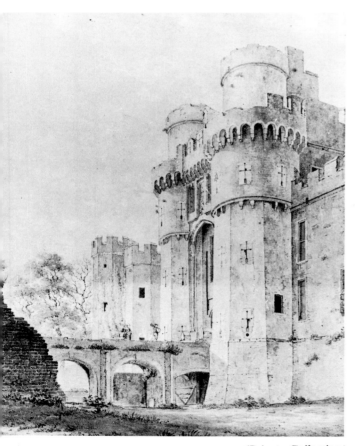

(Private Collection)

(Andrew Wyld)

UWINS, Thomas (1782-1857)

Hop Pickers and their Children in a Hop Garden. *Watercolour, 5ins. x 6⅜ins.*

Uwins' finished watercolours are very detailed and the figures are close to those of R. Westall in his less Fuseli-like moments. From 1817 one of his favourite subjects was the gathering of the vintage.

VARLEY, Cornelius (1781-1873)

A Distant View of Conway Castle. *Watercolour, 8⅜ins. x 11⅛ins.*

Varley's kinship with the style of his brother can be seen in the drawing of the trees in this watercolour, as well as the modernity of his composition. He also produced many cool, pencil portraits with the aid of his 'graphic telescope'.

UWINS, Thomas (1782-1857)

Hop Picking. *Watercolour, 7ins. x 4¾ins.*

VARLEY, Albert Fleetwood (1804-1876)

Drovers near a Windmill. *Signed, watercolour. 7½ins. x 10½ins.*

A.F. Varley seems to have owed as much to Cox in his middle period as to his father.

VARLEY, Cornelius (1781-1873)
Gnarled Branch with open Landscape
Beyond. *Watercolour, 9ins. x 15½ins.*

(Martyn Gregory)

VARLEY, John (1778-1842)
The Interior of Boston Hall, Lincoln.
*Signed and dated 1803, watercolour,
8ins. x 11½ins.*

At this period Varley produced many
drawings of barn interiors. As always
with him the figures are poor.

(Martyn Gregory)

VARLEY, John (1778-1842)
An Inn on the Chelsea Embankment. *Water-
colour, 4⅝ins. x 6¾ins.*

This watercolour exhibits many of the elements
of Varley's best known style, including the
stylised trees, the formalised clouds and the
blobby figures. The subject is one to which he
was often drawn.

(Christie's)

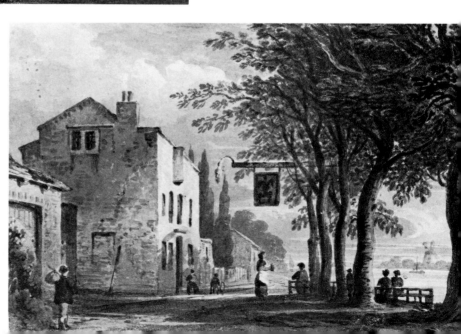

VARLEY, John (1778-1842)

Landscape with Mountains and Town in the Distance. *Signed and dated 1842, watercolour, 6¾ins. x 13⅝ins.*

This watercolour is entirely typical of Varley's later work in composition, technique and format. At this stage he was no longer painting portraits of places but generalised variations on a theme of landscape. The cracking which can be seen in the darker areas is caused by one of his experiments designed to make watercolours look more like oil paintings, perhaps by the admixture of gum arabic or honey.

(Private Collection)

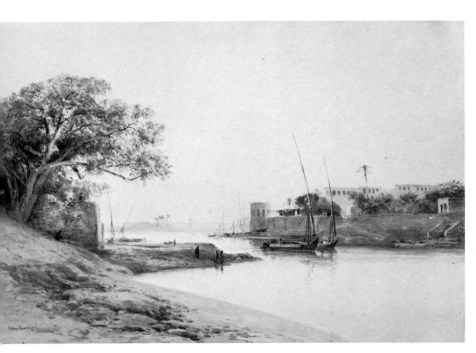

(Sotheby's)

VARLEY, John, Yr.

The South End of the Island of Rhodah, near Cairo. *Signed, watercolour, 20¾ins. x 30ins.*

VARLEY, William Fleetwood (1785-1856)

Castle Rock, Bristol Channel. *Signed and inscribed verso, watercolour, 8¾ins. x 12¾ins.*

W.F. Varley was a pupil of his two elder brothers but in general he was a less interesting artist. His views on the Thames, often with moored barges, can be very pleasing.

(Martyn Gregory)

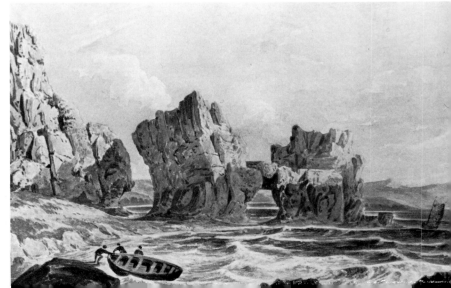

VICKERS, Alfred Gomersal (1810-1837)

Entering Harbour. *Pencil and watercolour, 6½ins. x 9⅝ins.*

In his marine painting Vickers was a follower of Bonington. He was also an excellent topographical draughtsman as is shown by his Russian drawings.

(Andrew Wyld)

(Sotheby's)

WAINEWRIGHT, Thomas Francis

Sheep on a Cliff. *Signed and dated 1861, watercolour, size unknown.*

Wainewright often painted sheep and cattle into the landscapes of other painters, such as C. Pearson and T.R.C. Dibdin.

WAITE, Robert Thorne (1842-1935)

The Downs near Brighton. *Signed, watercolour, 10½ins. x 14¼ins.*

(Christie's)

WAITE, Robert Thorne (1842-1935)
Christchurch Abbey. *Watercolour, 21ins. x 30ins.*

(Dudley Snelgrove Esq.)

WALKER, Anthony (1726-1765)
A Woman in Riding Dress. *Pen and grey ink and grey wash, 3¾ins. x 2⅜ins.*

(Bourne Gallery)

WALKER, Frederick (1840-1875)
The Harbour of Refuge, 1872. *Signed with initials, watercolour, 22¼ins. x 36¼ins.*

One could say that Walker's major works perhaps suffer from his painstaking and meticulous methods of work. They seem almost too careful and finished. He used both bodycolour and scraping for his highlights, and an excellent example of the latter is seen in the blade of the scythe in this illustration.

(Christie's)

WALKER, William Eyre (1847-1930)
At the Back of the Thunder. *Signed and dated 1900, watercolour, 24¼ins. x 37ins.*

(Sotheby's)

WALTERS, George Stanfield (1838-1924)

On the Lower Thames. *Signed and dated 1877, watercolour, 10ins. x 18ins.*

Walters sometimes worked on an even larger scale than this, and he had a penchant for pinks, russets and sunsets.

(Bourne Gallery)

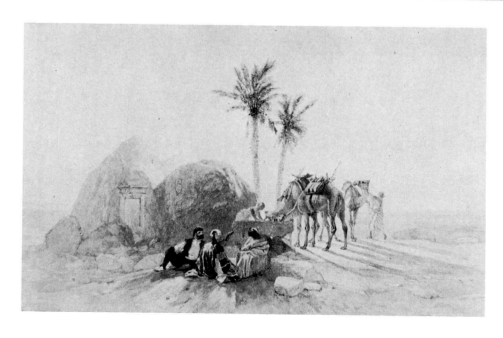

WALTON, Elijah (1833-1880)
An Oasis. *Watercolour, 9ins. x 14¾ins.*

(Beryl Kendall)

537

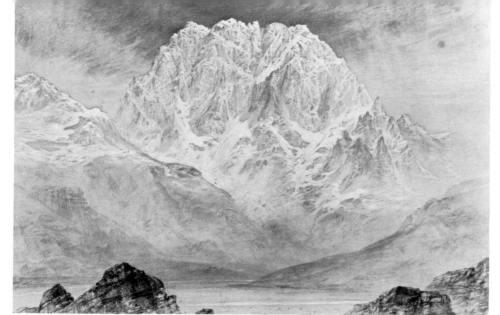

WALTON, Elijah (1833-1880)
The Ailefroide from the Glacier du Chardon, Dauphine. *Inscribed on reverse, watercolour, 9½ins. x 13½ins.*

(Spink & Son Ltd.)

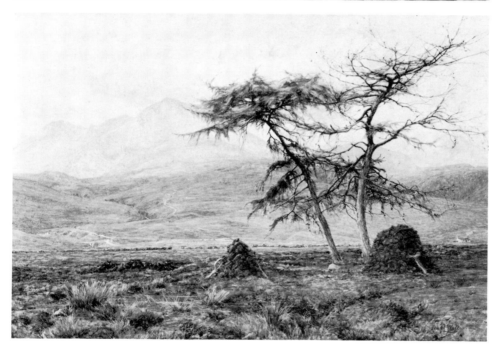

WALTON, Frank (1840-1928)
Ben Eay, Kinlochewe, Rossshire. *Signed and dated 1921, watercolour, 15¾ins. x 22½ins.*

(Sotheby's)

WARD, James (1769-1859)
Bulls Fighting in a Hilly Landscape. *Signed with monogram, pencil, pen and brown ink and watercolour, 4⅜ins. x 8¼ins.*

(Christie's)

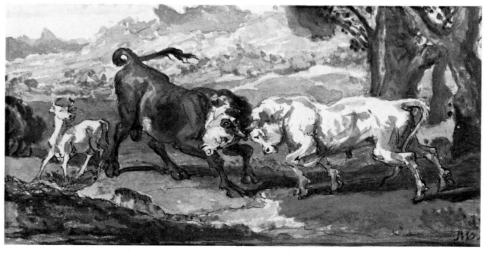

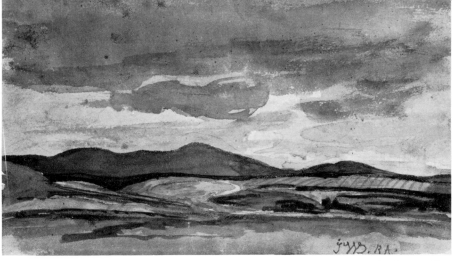

WARD, James (1769-1859)

Mountainous Landscape. *Signed with monogram, pencil and watercolour, 4½ins. x 7½ins.*

In his sketches Ward is often surprisingly free in a twentieth century manner. He was also probably the only man to show the movement of galloping horses correctly before the discovery of photography. The typical monogram is clearly seen here.

(Dudley Snelgrove Esq.)

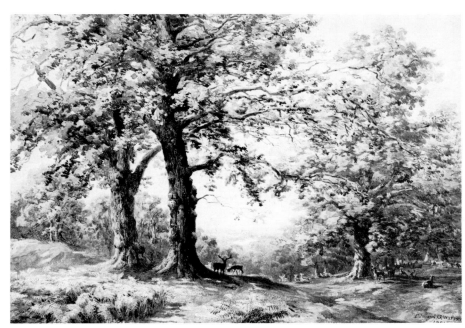

WARREN, Edmund George (1834-1909)

Richmond Park. *Signed and dated 1856, watercolour, 14ins. x 20ins.*

(Bourne Gallery)

WATERLOW, Sir Ernest Albert (1850-1919)

The Mill on the Heath. *Signed, watercolour, 14ins. x 21ins.*

(Bourne Gallery)

WATTS, William (1752-1851)

A Mausoleum. *Pen and brown ink and watercolour, 5¼ins. x 7¾ins.*

Watts was primarily an engraver for the work of others. His own drawings, generally of seats and parks, are a little weakly in the manner of his master P. Sandby.

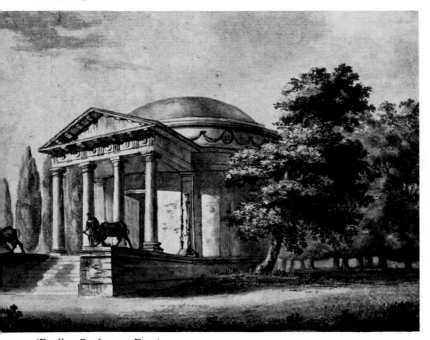

(Dudley Snelgrove Esq.)

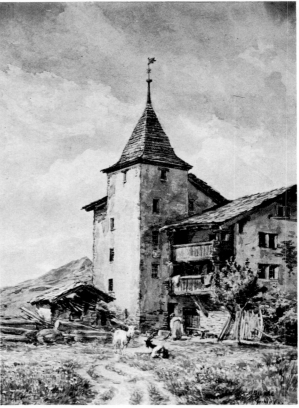

(Bourne Gallery)

WAY, Charles Jones (1834-)

Sierre — Rhone. *Signed and inscribed, watercolour, 13ins. x 9ins.*

(Bourne Gallery)

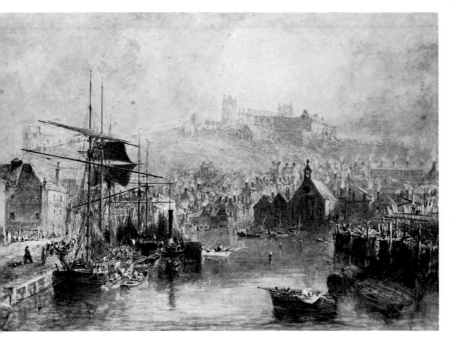

WEATHERILL, George (1810-1890)

View of Harbour of Whitby with Boats Moored to the Quayside. *Signed and dated 1867, pencil and watercolour heightened with white. 14½ins. x 21½ins.*

In his views of Whitby and other towns on the Yorkshire coast Weatherill makes effective use of the smoking chimneys of the cottages. His palette is generally rather low in tone.

(Phillips)

WEBB, James (1825-1895)
View of Cologne from the River. *Signed, inscribed and dated Aug 6 1869, pencil and watercolour, 9¾ins. x 13¾ins.*

Webb was primarily a marine painter but his landscape and urban work, which is usually less finished, is by no means negligible.

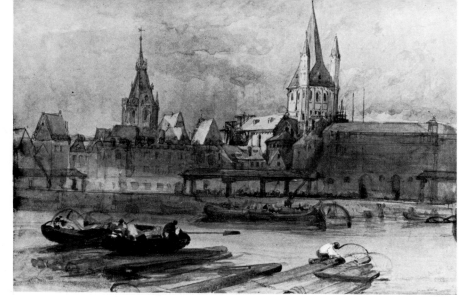

(Martyn Gregory)

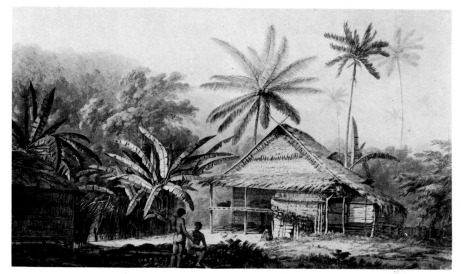

(Sotheby's)

WEBBER, John (c.1750-1793)
View on the Island of Cracatoa. *Watercolour, 14ins. x 23ins.*

In Webber's South-Sea work his drawing is often weaker than would appear from this example. In his English landscapes he used a characteristic range of grey, blue and yellow washes over careful and detailed pencil drawing.

WEBBER, John (c.1750-1793)
View of Belinzone with a Figure and Dog. *Signed and dated 1787 twice on extended paper, inscribed on original mount, watercolour, 12¾ins. x 18⅛ins.*

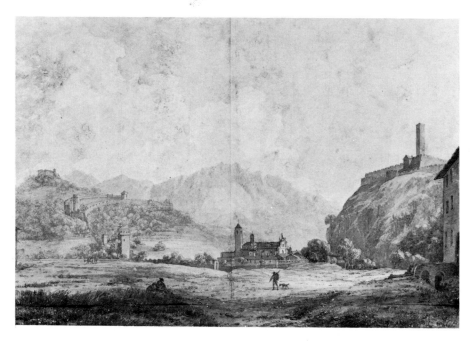

(Phillips)

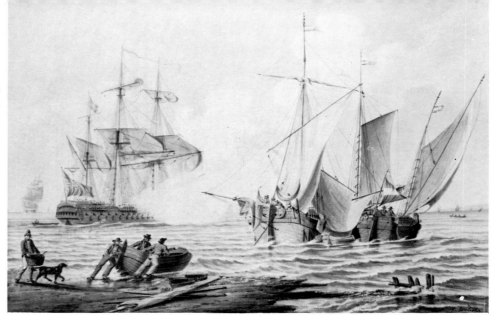

WEBSTER, George
Dutch Barge and a British Man-of-War near the Shore. *Signed, watercolour. size unknown.*

(Sotheby's)

WELLS, William Frederick (1762-1836)
Cottage at Knockholt, Kent. *Watercolour, 19ins. x 27ins.*

Wells was more of a man of ideas than a man of practice. He was the real originator and second President of the O.W.S., and he later suggested the idea of the *Liber Studiorum* to his friend Turner, but his own style was conventional. According to Williams his convention of rendering foliage was 'with a peculiar long, dark, narrow brush stroke'. He painted in Norway and Sweden in early life, as well as in Kent where he lived. Many of his watercolours have faded to uniform browns and greens.

(Brian Hancock)

WENLOCK, Constance, Lady (c.1853-1932)
Philae. *Signed, inscribed and dated 1908, watercolour, 22½ins. x 25½ins.*

(Sotheby's)

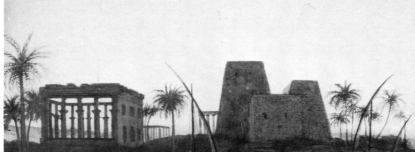

WEST, John

River Scene with Stone Bridge and Horsemen. *Grey wash, 11½ins. x 16¾ins.*

Williams' description of West's work as 'rather Japanesy' is amply borne out by this example.

WEST, Joseph Walter (1860-1933)

'Le Concert' — composition taken from a painting by Pannini in the Louvre. *Watercolour, 4ins. x 6ins.*

West's most typical productions are genre subjects often taken from Quaker life. He also produced delicate landscapes.

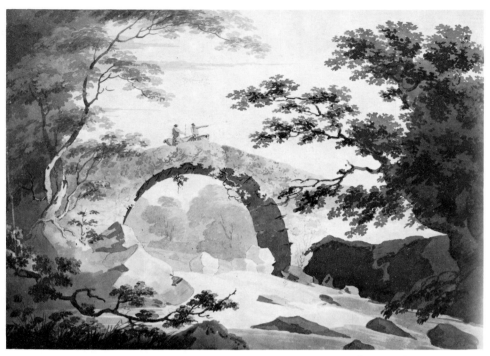

(Dudley Snelgrove Esq.)

(Andrew Wyld)

(Private Collection)

WESTALL, Richard (1765-1836)

The Wounded Lover. *Signed with initials and dated 1807, watercolour, 6¾ins. x 4⅝ins.*

As Williams says 'a good deal of Westall's work has, indeed, a strong element of the ludicrous in it'. He is a typical illustrator using the neo-classical conventions, which are sometimes assumed to originate with Blake, but in fact derive more directly from Fuseli. He uses firm outlines and flat planes of colour heightened with emotion. His figures are often highly finished in a stippled technique but his backgrounds are more free.

WESTALL, William (1781-1850)

A River Landscape. *Signed and dated 1820, watercolour, 9¼ins. x 14¼ins.*

Westall made much use of light green and his best English work is often on a small scale with neat rather old fashioned drawing.

(Sotheby's)

WESTALL, William (1781-1850)

Melrose Abbey. *Pencil and watercolour, 3½ins. x 5¾ins.*

(Agnew)

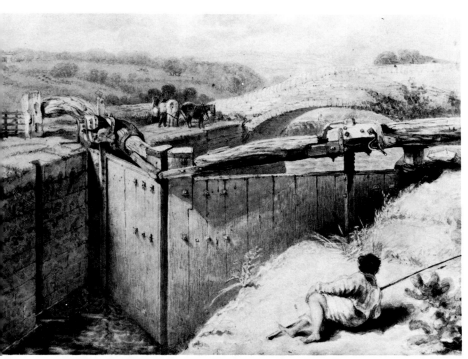

WESTALL, William (1781-1850)

Lock Gates near a Bridge. *Watercolour, 9⅞ins. x 13⅞ins.*

Unlike his elder brother Richard, Westall was primarily a landscape painter. He worked in Australia and the Far East and also in Madeira and Jamaica. Thereafter he painted very effective English views for engraving in the Annuals, usually on a small scale. The predominant colour in these is a light green.

(Andrew Wyld)

WHEATLEY, Francis (1747-1801)

A Cottage and Castle, perhaps St. Briavels. *Watercolour, 15½ins. x 22ins.*

Wheatley is best known for his figure drawing, in particular rustic subjects, somewhat in the manner of Ibbetson. He worked in both England and Ireland and his colouring is usually gentle, with much use of blues, yellowy browns and greys. He is often over pretty when his peasant figures are the main focus of interest. When his subjects, as here, are more generalised they have often tended to fade. Perhaps his strongest work comes from Ireland, when he concentrated on grey wash compositions of peasant fairs.

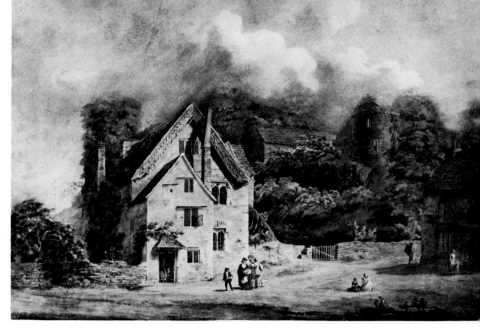

(Martyn Gregory)

(Private Collection)

WHEATLEY, William Walter (1811-1885)

The Manor House and Church at Mells. *Signed with initials, watercolour, 10¼ins. x 15ins.*

WHITE, John (1851-1933)

Over Beer Head. *Signed, watercolour, 8ins. x 13ins.*

White was best known for his Devonshire views and lived much of his life at Beer.

(Beryl Kendall)

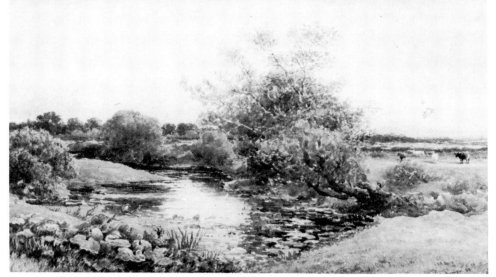

WHYMPER, Josiah Wood (1813-1903)

The River Meadow. *Signed and dated '88, watercolour, 11½ins. x 18ins.*

(Sotheby's)

WILLIAMS, Hugh William, 'Grecian' (1773-1829)

Hawthornden. *Signed and dated 1795, watercolour, 11ins. x 14¾ins.*

The early Scottish work of Williams is very much in the traditions of the 18th century with low colours, and much use of conventional techniques, such as dragging, loops for branches and a rudimentary split brush method for foliage.

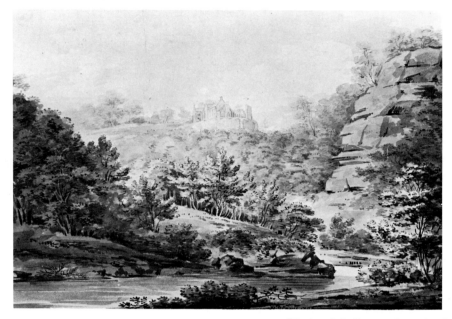

(National Galleries of Scotland)

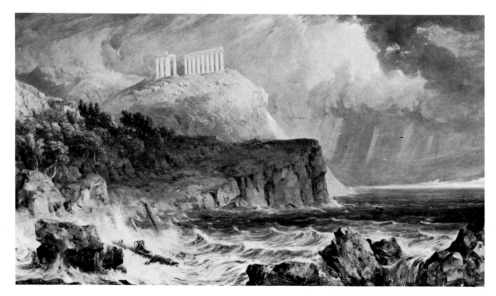

WILLIAMS, Hugh William 'Grecian' (1773-1829)

The Temple of Poseidon, Cape Sunion. *Watercolour, 29¾ins. x 50ins.*

After his return from Italy and Greece in 1818, Williams developed into a typical illustrator of the annuals. Up to this point his career had evolved rather in the manner of that of Turner, but he never developed beyond it.

(National Galleries of Scotland)

WILLIAMS, Penry (1798-1885)

Raphael's Tomb in the Pantheon, Rome. *Signed, pen and brown ink and sepia wash, 5⅝ins. x 6¾ins.*

WILLIAMSON, Daniel Alexander (1823-1903)

In the Shade. *Watercolour, 10½ins. x 15½ins.*

P.A. Williamson began as a disciple of the Pre-Raphaelites. He later developed, as here, along the Impressionist lines associated with H.M. Anthony and W.M. Fisher.

(Williamson Art Gallery, Wirral)

WILLIAMSON, Daniel Alexander (1823-1903)

Bracelet Moor, Furness. *Signed with monogram, watercolour, 13½ins. x 19½ins.*

In his later years Williamson based his style on those of Cox, as here, and Turner.

(Williamson Art Gallery, Wirral)

WILLIAMSON, Frederick (-1900)
A Derbyshire Dale. *Signed, watercolour, 9ins. x 14ins.*
Although Williamson was a typical landscape painter in the manner of the
1880s and '90s, his earlier work shows a Pre-Raphaelite concern with detail.

**WILSON, Charles Edward
(-c.1936)**
A Mute Appeal. *Signed,
watercolour, 9¾ins. x
6¾ins.*

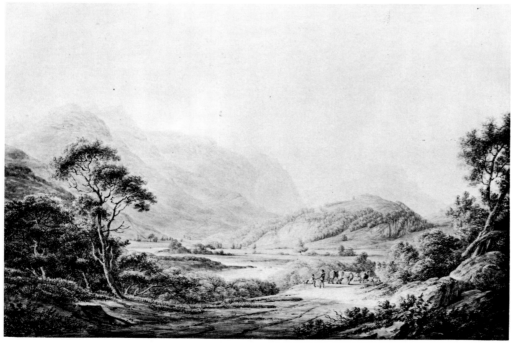

**WILSON, Andrew
(1780-1848)**
A Highland Valley. *Water-
colour, 16½ins. x 24½ins.*

WILSON, Richard (1714-1782)

The Circus of Flora, Rome, with an Artist Sketching in the Foreground. *Signed with initials, inscribed 'Circus' and with a label 'Circus of Flora' superimposed, and dated Romae 1754, No 8 on the mount and numbered 51 on the reverse, pencil heightened with white chalk on grey paper, 4½ins. x 6ins.*

Wilson was not a watercolourist but his chalk drawings influenced many artists of his own and the following generation who did work in wash and watercolour. His pupils included J. Farington and W. Hodges.

(Christie's)

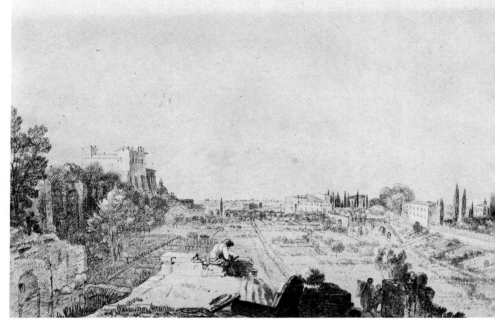

WIMBUSH, Henry B.

The Royal Exchange. *Signed, watercolour, 7½ins. x 11ins.*

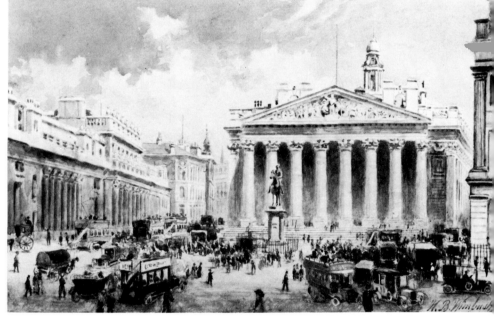

(Sotheby's Belgravia)

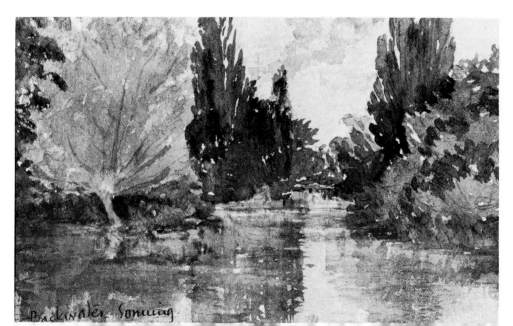

WIMPERIS, Edmund (-1946)

Backwater, Sonning. *Signed, watercolour, 4¾ins. x 6¾ins.*

A typical example of the work and signature of the younger Wimperis who mixed Impressionism with his father's Cox-like traditions. See under Wimperis, Edmund Morison, in Volume One.

(Private Collection)

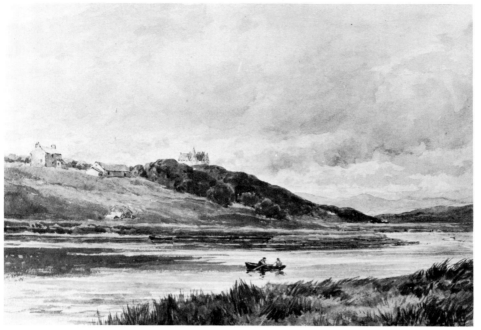

(Private Collection)

WIMPERIS, Edmund Morison (1835-1900)

The Ferry. *Signed with initials and dated '87, watercolour, 9½ins. x 13⅜ins.*

Wimperis began as a wood engraver under the painstaking influence of Birket Foster. Later he acquired greater breadth in the manner of T. Collier, with whom he sketched. His best work was done out of doors.

WINTER, William Tatton (1855-1928)

Mill near St. Ives. *Signed, watercolour, 12⅝ins. x 17⅜ins.*

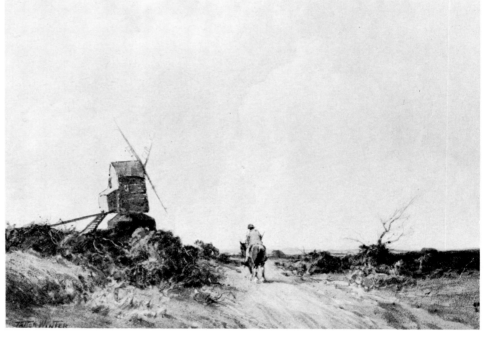

(Private Collection)

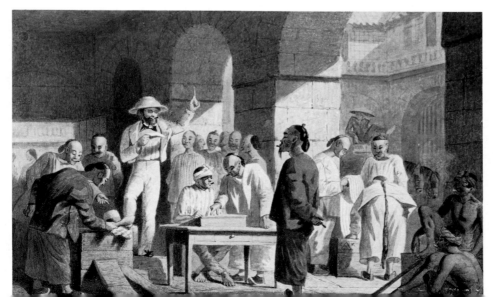

WIRGMAN, Charles (1832-1891)

A Sale of English Goods, Canton. *Watercolour, 8¼ins. x 12½ins.*

(Sotheby's)

WITHERINGTON, William Frederick (1785-1865)

A View of Old London Bridge with Construction Works in Progress. *Dated Oct 5 1822, pencil and watercolour, 7¾ins. x 11ins.*

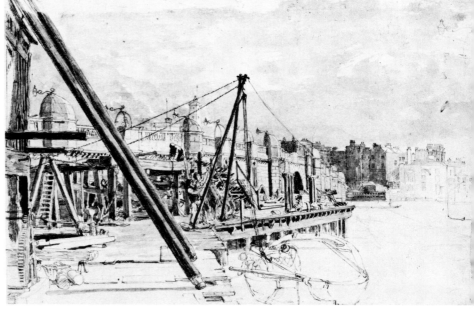

(Martyn Gregory)

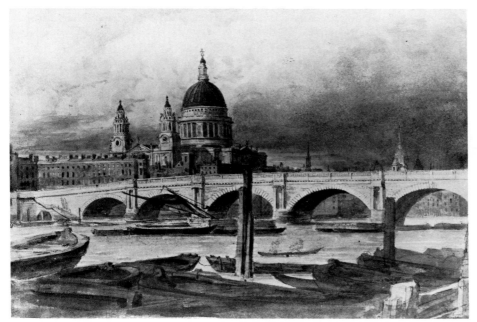

WITHERINGTON, William Frederick (1785-1865)

View of St Pauls and Old Black-friars Bridge. *Signed and inscribed verso, pencil and watercolour, 6½ins. x 9ins.*

(Martyn Gregory)

WOLF, Joseph (1820-1899)

A Sheet of Badger Studies. *Pencil, black chalk and watercolour, measurements unknown.*

(Sotheby's)

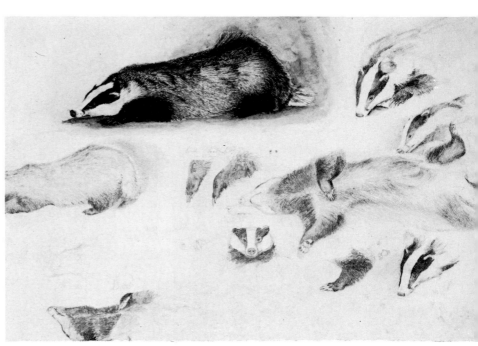

WOLF, Joseph (1820-1899)
Sea Birds Gathering on a Rock in Stormy
Weather. *Signed and dated 1875, water-
colour and bodycolour, 9ins. x 6ins.*

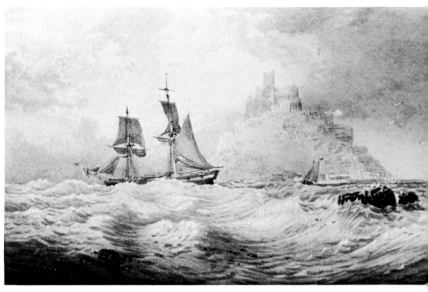

WOLFE, George (1834-1890)
Shipping off Mont St. Michel. *Signed, watercolour, 8½ins. x 13ins.*

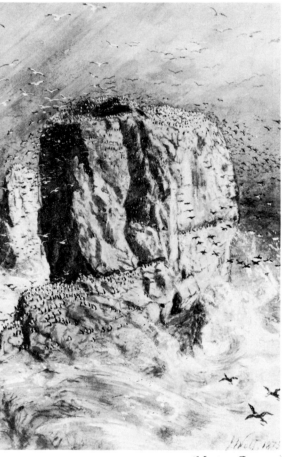

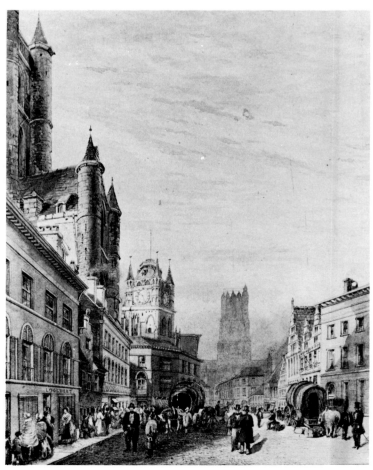

WOOD, Lewis John (1813-1901)
Ghent. *Watercolour, 9⅛ins. x 6⅞ins.*

WOODWARD, George Moutard (c.1760-1809)

Old Maids Consulting a Naturalist. *Signed and inscribed, pen and grey ink and watercolour, 6¼ins. x 7ins.*

The heavy black outlines are entirely typical.

(Dudley Snelgrove Esq.)

WRIGHT, John Masey (1777-1866)

Illustration for 'The Vicar of Wakefield'. *Signed, watercolour, 9ins. x 13ins.*

Wright's style is based on that of Stothard but without his delicacy and with a greater use of colour. His figures are usually outlined with the brush and his subjects in general literary. Individually they are charming but en masse stilted and repetitive.

(Bourne Gallery)

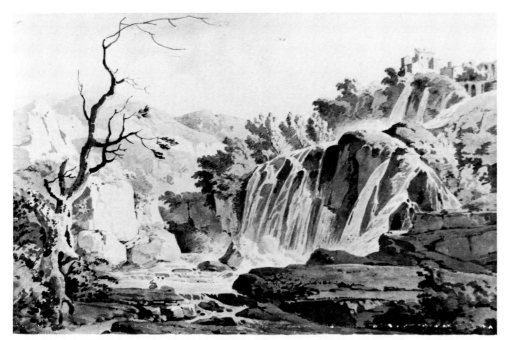

WRIGHT, Joseph, of Derby (1734-1797)

Falls of Tivoli c.1786. *Watercolour, 14½ins. x 20¼ins.*

Wright disliked watercolour and only used it while travelling in Italy with J. Downman. He worked in a conventional manner akin to that of W. Pars.

(Derby Museum and Art Gallery)

553

WRIGHT, Thomas, of Newark
Plumpton Rocks. *Inscribed and dated 1800, brown wash, 12¼ins. x 16¼ins.*

(Dudley Snelgrove Esq.)

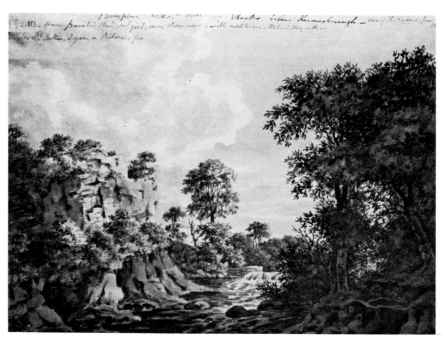

(Christie's)

WYLD, William (1806-1889)
View of the Riva Degli Schiavoni, Venice. *Signed, watercolour heightened with white, 15⅜ins. x 23¼ins.*
Wyld continued the work of his friends and mentors, Francia and Bonington, but although his later work is always extremely competent some of the inspiration has disappeared.

WYLLIE, William Lionel (1851-1931)
Queenborough, Swale. *Signed and inscribed, watercolour, 5¼ins. x 11¼ins.*

(Dr. C. Beetles)

YATES, Gideon

Lancaster from the Stone Quarries.
Signed and dated 1811, water-colour, 7ins. x 9½ins.

Although in Volume One I state that the London and Lancaster Yates do not appear to be the same person, a comparison of the signatures on these two drawings would indicate that they are indeed one.

(Sotheby's)

(Sotheby's)

YATES, Gideon

Southwark Bridge from Fish-monger's Hall. *Signed and dated 1837, watercolour, 6¼ins. x 10½ins.*

YATES, Lieutenant Thomas (1765-1796)

Man O'War, Frigates and Other Shipping Offshore. *Pen and ink and watercolour, 10ins. x 15ins.*

(Martyn Gregory)

YEOMAN, Arabella
Landscape after Francis Towne, 1801.
Pen and brown ink and watercolour,
8½ins. x 11¾ins.

(Dudley Snelgrove Esq.)

(Martyn Gregory)

YORKE, Admiral Hon.
Sir Joseph Sydney (1768-1831)
A Sketch of Torbay. *Inscribed and*
dated 27—29 July, 1798 verso, water-
colour, 5¾ins. x 10ins.

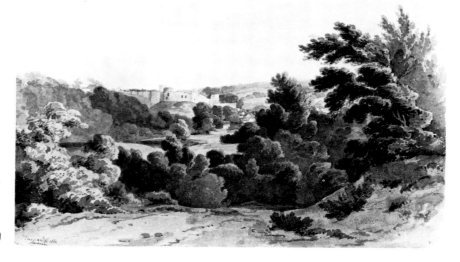

YOUNG, Tobias P. (-1824)
A Distant View of Barnard Castle,
Durham. *Inscribed in ink, watercolour,*
10¾ins. x 15ins.

(Andrew Wyld)

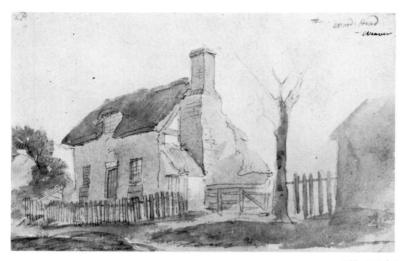

(Christie's)

ZIEGLER, Henry Bryan (1798-1874)

The Wood Head, Weaver. *Inscribed, pencil and watercolour, measurements unknown.*

**ZUCCARELLI, Francesco
(1702-1788)**

Landscape with Nymphs Bathing. *Signed with gourd, bodycolour, 15¼ins. x 21ins.*

The gourd, which is one of Zuccarelli's characteristic signatures is seen here by the naked nymph on the right. He also sometimes signed with a monogram.

(Fitzwilliam Museum, Cambridge)

**ZUCCHI, Antonio Pietro
(1726-1795)**

A Shepherd and Three Women Among Classical Ruins. *Signed, pen and black ink with grey and brown washes, heightened with white, size unknown.*

Very occasionally Zucchi used touches of colour on his drawings.

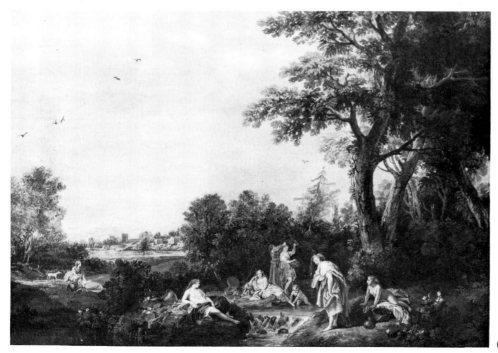

(Ashmolean Museum)